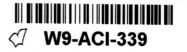
How
To
Draw
Animals

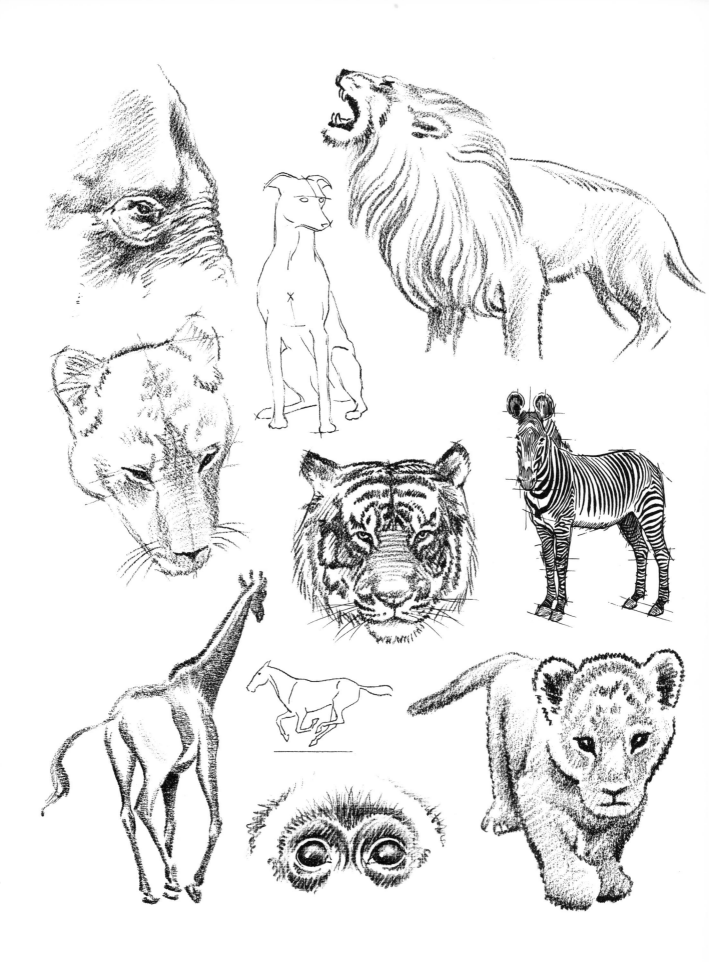

How To Draw Animals

by Jack Hamm

Publishers
GROSSET & DUNLAP
New York

Published Simultaneously in Canada

Library of Congress Catalog Card No.: 68–12740

ISBN: 0-448-01908-6 (Trade Edition)
ISBN: 0-448-03499-9 (Library Edition)

1977 PRINTING

Dedicated to
LON MONTGOMERY HAMM

PRINTED IN THE UNITED STATES OF AMERICA

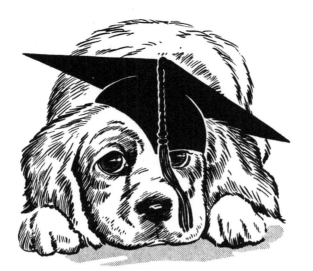

Preface

The purpose of this book is stated in the title. The "how" of anything envolves a *process*. It's not enough to place finished, real-life pictures of animals in front of oneself or a student wishing to learn how to draw animals. This has some value, but it's limited. Even trips to a zoo or animal farm, though highly recommended, can leave a student perplexed unless he goes all out in repeated and extended research efforts. Whereas such effort is not to be denounced —it is indeed praiseworthy—it is not good art economy to ignore rules and principles which will make the whole pursuit easier. There are certain things which all animals have in common. It is wise to understand these early in the game; then the game will be pleasurable and very likely successful.

There is a renewal of interest in animals in our world today. "Animals, it appears, hold as much fascination for viewers of television as anything to be found on the tube," begins a nation-wide press release in explaining why animal shows have such a high rating. Many TV script writers will often make room for an animal on regular shows just for "human interest." One of the first questions the planning department of an interview show will put to an invited guest in the animal business is, "Can you bring an actual subject with you?" Necks stretch and eyes turn as the living creature, whatever it is, makes his entrance.

All major cities, and even many small towns, have some kind of zoo. There is an awareness that animals need to be seen by our children as a part of their educational enlightenment and development. There is a "zoo baby boom" as a result of new and improved methods of breeding animals which attempt heretofore met with failure. Curators in over 300 big zoos in 70 different countries are happily busy 'round-the-clock taking care of their "new offspring." There is no question that the all-out-effort to save our once-nearly-extinct animals is beginning to pay off. Big city telephone directories, for the first time, are featuring the local zoo in full color on their covers.

Because more attention is being focused on animals all over the world, there are scores of new art assignments being handed out to tie in with this awakened interest. Candy and gum cards, cereal boxes as well as other types of containers, greeting cards, gifts and toys are featuring pictures and designs of life-like animals. Automobile manufacturers are naming their latest models after the swifter and more powerful animals. Advertising cam-

paigns are underway to associate the product with these engaging animal names. Public schools and colleges are including animal study as part of their art program. Today there is an increasing need to know *how to draw animals*.

It should be stated that this entire book has been composed with the artist and art student in mind and not for the zoologist or student of natural history. No attempt is made at exact grouping as to orders or species. There are scores of good books which deal with the scientific and historical aspect of the subject. For the really dedicated animal artist, these books may be profitably consulted. The writer is aware that the term "animal" should better be "mammal," but, again, lay-artists are more likely to use the former term.

Along the way in the book's preparation there has been great temptation to mention interesting animal habits and practices. Such would take valuable space needed for the appointed purpose. The artist is first of all concerned with the creature's appearance and how to more efficiently draw it. Before specific animals are dealt with, however, several pages of guide lines, methods and related-part comparisons are presented. These are very important for the animal artist if he would broaden his understanding of the matter.

Wherever possible the simplest terminology is used to describe the animal part, but often times, for the sake of accuracy, the scientific name has been included so there can be no mistake about it. This in no way interferes with the step-at-a-time diagrams which may be followed by even the youngest student. It is impossible to become an accomplished animal artist without a degree of familiarity with the bone and muscle make-up. One has to put something besides "stuffing" in the animals, or he will end up with a *stuffed* animal. It is a thousand times better to build on the creature's structural endowments.

Another temptation in this book has been to translate the actual animal into a private interpretation. It would be false and unfair to the student to offer some nonrepresentational concept. One can best veer from the norm if he knows what the norm is; so every effort has been made to draw the animal as he actually appears.

For the most part the locales of the animals have been omitted to further save space. Ordinarily this is not a requirement for the artist. Should they be needed, they may be found easily in the dictionary or encyclopedia.

There are more than 12,000 animals (mammals) in our world. No book contains them all. All the well-known wild and domesticated animal families are represented on these pages. An index further facilitates finding particular representatives. Our chief concern in the progression is *how to draw animals*.

JACK HAMM

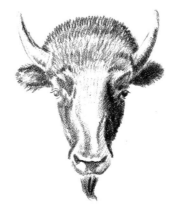

Contents

INTRODUCTION TO ANIMAL DRAWING

The Greyhound—In Seven Follow-
 Through Steps 1
Simplifying the Animal 2
The Three Body Basics 3
The ABC's of Animal Structure 4
Applying the ABC's 5
Important Fundamentals of Animal Feet 6
The Simplified Skeleton 7
Location of the Front "Knee" Joint . . . 8
Comparing Front Legs 9
Comparing Back Legs 10
Comparing Animal Muscles 11
Bone and Muscle Structure—Greyhound 12
Surface Anatomy—Greyhound; Front
 and Back Structural Views 13
Facts about Feet and Claws 14
Comparing Foot Bones and Likenesses
 in Animal Heads 15
The Animal Nose 16
The Animal Eye and the Animal Ear . . 17
Discusing Fast Action 18
More General Facts on the "Run" . . . 19

THE CAT FAMILY

Basics in Cat Structure 20
How Little Cats Resemble Big Cats . . . 21
Using the House Cat as a Model 22
Helps in Drawing the Lion 23
A Simple Approach to Cats 24
Tips on Drawing Cats 25
Notes on Lion Drawing 26
How a Lion Walks—Front 27
Lion Head—Seven Easy Steps 28
The Lion's Mane and Hair Growth . . . 29
Lion—Back View 30
How a Lion Walks—Side 31
Big Cat Facial Features 32
The Lion's Poise and Gracefulness . . . 33
Tiger Head—Eight Easy Steps and
 Facial Design Differences 34
Differences between a Tiger and Lion
 Head 35
The Tiger's Appearance and the Seated
 Tiger 36
The Proper Way to Stripe a Tiger—Side,
 Back and Top 37
The Tiger Face; Leopard—Tiger
 Compared 38
The Tiger in Action and the Leopard
 Sitting Upright 39
The Snarl, Growl and Roar 40

Inside the Big Cat's Mouths 41
A Comparison of Cat Heads 42
Lion and Tiger Profiles and the
 Foreshortened Head 43
Cat Body Shapes and Markings 44
Shapes and Markings (continued) . . . 45

THE BEAR FAMILY

Building on Simple Underdrawing . . . 46
The Bear's Body Simplified 47
The Major Bears Side-By-Side 48
Bear Heads—In Several Easy Steps . . . 49
Bear and Man Compared 50
Bear Characteristics Simplified 51
Bear Comparisons—Standing on Hind
 Legs 52
Bear Facts for the Artist and the
 Growling Bear 53
How a Bear Walks 54

THE HORSE FAMILY

The Horse, a Creature of Beauty 55
Taking Horse-Head Points One-By-One 56
Points (continued) 57
Guides in Good Horse Drawing 58
Helps on Surface Anatomy—the
 Influence of Hairtracts 59
Bone and Muscle Structure of the Horse 60
Surface Anatomy of the Horse and Parts
 of the Horse Named 61
Easy Follow-Through Steps in Drawing
 the Horse and "Foot Notes" 62
Considering the Front View Horse . . . 63
How a Horse Walks, Trots and Canters 64
The Horse in Action 65
How a Horse Runs 66
Right and Wrong Ways of Drawing the
 Running Horse 67
Helpful Facts about a Running Horse . . 68
The Jumping Horse 69
The Horse—Rear View and some Show-
 Through Bones and Muscles 70
Unusual Horse Positions 71
Additional Tips on Horses and Breed
 Heads Compared 72
The Zebra's Shape and Markings and
 the Quagga 73

THE ELEPHANT

Beginning Elephant Drawing 74
Elephant Head—In Seven Easy Steps . . 75
Simple Elephant Lines, the Indian and

CONTENTS

African Compared and Tusks 76
Elephant Ears 77
Elephant Feet and Legs 78
Leg Comparison 79
Elephant Trunk, Nose and Mouth . . . 80
Inside the Mouth, More Trunk Tips, the
 Elephant Eye and How an Elephant
 Holds His Head 81
The Elephant—Rear View 82
Elephant Antics 83
The Elephant Lying Down and Standing
 Up 84
How the Elephant Walks 85

THE DOG FAMILY

Wolf, Coyote and Fox Head—Step-at-A-
 Time 86
Wolf Construction and Hairtracts 87
Head and Body Comparisons 88
Drawing Dogs 89
Dogs and Relations 90
Dog-Like Animals 91

THE CAMEL

The Bactrian Camel 92
The Arabian or Dromedary Camel . . . 93

THE GIRAFFE

The Giraffe Head and the Giraffe
 Running 94
Notes on the Giraffe and the Okapi . . . 95

THE HIPPOPOTAMUS

How to Draw the Hippopotamus 96
Building on the Simplified Form 97

THE RHINOCEROS

How to Draw the Rhinoceros 96
Building on the Simplified Form 97

THE DEER FAMILY

The Deer—In Three Freehand Steps and
 Important Deer Parts 98
Deer Head Construction and Walking
 Positions of the Pronghorn Antelope 99
Sheep, Goats, Antelopes, Llamas, Etc. . 100

THE BUFFALO

ABC Construction of the Buffalo and the
 Buffalo Head 101

THE COW

Drawing the Cow 102
Simple Way to Draw a Steer and the
 Bones and Muscles of a Cow 103
Miscellaneous 'Split-Hoofed' Animals . . 104

THE PIG

Simple Underdrawing for the Pig and
 Wild Hogs 105

THE MONKEY AND APE FAMILY

The Monkey Simplified 106
Primate Heads in Easy Sequence 107
The Side-View Monkey Head and the
 Apes in Profile 108
Different Kinds of Chimpanzes and the
 Apes' Head Front View 109
Monkey Sketching 110
Side-View Walking Monkeys 111
Apes' Eyes and some Chimp Studies . . 112
Notes on the Gorilla 113

THE KANGAROO

Drawing the Kangaroo and the Wallaby 114

THE RABBIT

Drawing the Rabbit 114

ODD AND UNUSUAL ANIMALS

Various Sketches and Drawings 115

MISCELLANEOUS SMALL ANIMALS

Similarities and Differences in Small
 Animals 116
Small Animals (continued) 117

ANIMAL INTERPRETATION AND ABSTRACTION

Many and Varied Ways of Using Animal
 Information 118
Interpretations (continued) 119
Index of Animals 120

THE GREYHOUND — IN SEVEN FOLLOW-THROUGH STEPS

1

In fig. 1 are a few simple lines suggesting an animal. A child might do something like this before he learns to write his own name. Two legs, back, neck, head and tail. Using this as a starter, let's begin to make a change here and there which will turn these stiff lines into a sleek greyhound dog. At the same time we'll learn some valuable facts about animal anatomy.

2

No animal has a straight backbone. When the head is held in a normal position, the spine (A) curves down from the head to the tail in the manner shown.

3

Next to consider is the ribcage area (B), the bulkiest part of the animal. A portion of it extends beyond the front legs which bear more weight than do the rear legs (the neck and head being suspended in front is one reason for this). The ribcage takes up half or more of the body proper in nearly all animals.

4

In fig. 4 the attaching bones C and D (simplified here) for the legs are added. In the side view both the pelvic bone (C) and the shoulder-blade or scapula (D) slant down and out from the central part of the body. Whereas C runs through the hips, the two shoulder-blades occur on either side of the ribcage.

5

In nearly all animals, the forelegs are shorter overall than the back legs; they conform more to the straight line of fig. 1. They are more of the supporting pillars since they are closer to center than the rear legs. The bigger the central part of the beast (like the bison), the shorter the front legs. I and J are directly beneath each other. E (the femur) and H (the humerus) slant in from the outward slant of C and D (brought over from fig. 4). This is important to remember in animals. Notice the relationship of the back leg EFG to the straight line of fig. 1. This is the animal's "push-off" leg, more like a spring.

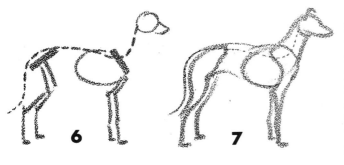

6 **7**

In fig. 6 the far legs have been added. In fig. 7 the main sections of the greyhound are roughly indicated in pencil. These represent the key parts which have a strong tendency to "show" in all animals. They are not difficult to learn as one might imagine. Get so you "see" animals in terms of these vital sections. Your understanding of their structure will be helped immeasurably.

SIMPLIFYING THE ANIMAL

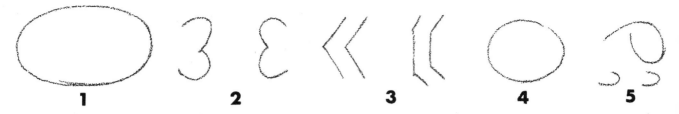

1 **2** **3** **4** **5**

Here is another very elemental approach to drawing animals. No particular animal is now in mind. Above are the parts we will use. The oval (fig. 1) represents the body without head and legs. To be sure, the oval needs to be modified later, yet there are some animals with lots of fur which appear to have oval-like bodies. Two "threes" are in fig. 2, one drawn backwards. These, for the time being, will be the simplified muscles of the hips and shoulders in our diagram. The parallel lines of fig. 3 will be the front and back of the legs closest to us. A deer would have thinner legs and a polar bear's would look thicker. Another oval (fig. 4) will represent the ribcage and will be drawn in the forward part of the body. The reversed "nine" of fig. 5 will serve as the neck and head, and a couple of sideways "U's" will be the feet.

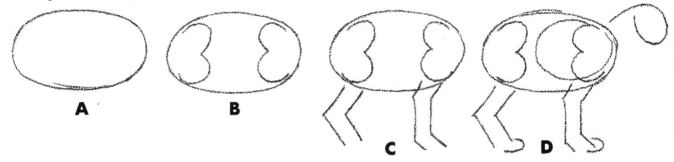

A **B** **C** **D**

Now, assemble these extremely simple parts. Begin with the oval (A), insert the "threes" as shown. Sometimes in a real animal the tops of the threes will jut out over the backline. Add the front and back legs as in fig. C. Lastly, insert the ribcage; draw the neck, head and feet fig. D).

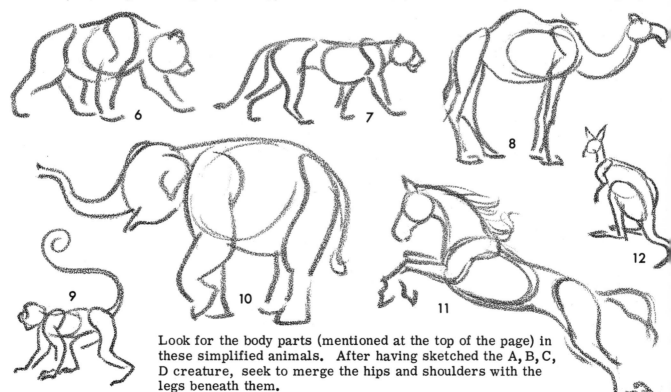

Look for the body parts (mentioned at the top of the page) in these simplified animals. After having sketched the A, B, C, D creature, seek to merge the hips and shoulders with the legs beneath them.

THE THREE BODY BASICS

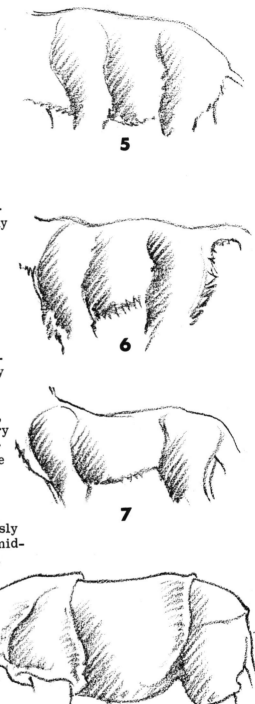

That which is illustrated on this page is especially significant. At first glance it appears as if most of the sketches are monotonously similar. One can hardly tell what some of these torsos are, for they have been stripped of identifying characteristics such as heads, necks, legs, feet, tails and fur markings.

There are certain body basics in the animal kingdom which are remarkably alike. An awareness of this fact can prove both helpful and bothersome. It can be helpful in that, once learned, a student has something on which to build. That's what we are after here. Bothersome, in that related animals can be so annoyingly similar. However, little interesting details, discussed as we move along, can make up the necessary differences in closely related animals. Knowledge of the foregoing can be pleasantly exciting.

First, observe the areas to which we have previously referred: forequarters, midsection and hindquarters. Whenever the student sees an animal of any kind, whether in photo, movies or real life, he should deliberately concentrate on these tandem parts, watching them closely as the subject moves about.

Fig. 1 is a jaguar without his telltale markings — could be any number of the big cats. Fig. 2 is the giraffe. No long neck or legs or giveaway coat pattern — just notice the body contour, especially the forequarters. Fig. 3, the cow, is easier; but there they appear, three unmistakable sections. Fig. 4 is a squirrel (enlarged); fig. 5 is a wild boar; fig. 6 is a Patas monkey; fig. 7 is a jackal. Everyone will recognize the Indian rhinoceros in fig. 8. Observe how his heavy hide is prominently folded to accomodate these three important body basics.

A

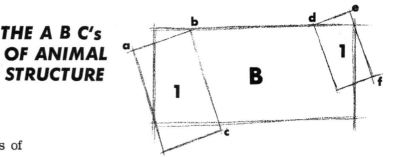

B

Without legs, neck and head the bodies of nearly 100% of all animals are twice as long as they are high. So, to learn a few more introductory facts concerning their general shape, sketch a rectangle about one by two in proportion.

Add two smaller rectangles (as we begin the sectional divisions mentioned on the previous pages): the larger one overlapping the rear and bottom, the smaller one extending over the top and front. These should be set at an angle and parallel to each other. "a-b" will be the back slant of the hips, "c" will be the kneecap (a little below the big rectangle), "d-e" will be the top of the shoulder blade and "f" point of the shoulder.

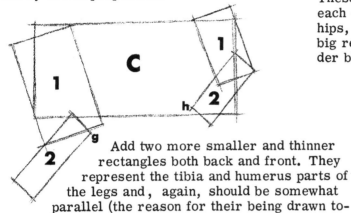

C

Add two more smaller and thinner rectangles both back and front. They represent the tibia and humerus parts of the legs and, again, should be somewhat parallel (the reason for their being drawn together here). Notice the bottom left corner of rectangle 1 cuts through the top of rectangle 2 about midway. "g" will be the bottom protrusion of the knee, and "h" will be the animal's elbow.

D

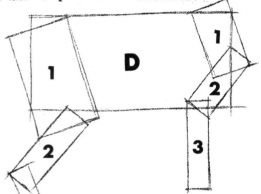

The number 3 rectangles are next and are narrower. They represent the meta-tarsus and radius segments (though we are chiefly concerned with the natural "1-2-3's" in our progression). The back 3 angles in; the front 3 is straight up and down.

E

F

Add the last vertical 4 of the front leg (the metacarpus), the foot blocks 5, the pelvic bone area 6, a suggestion of a tail 7, the neck 8, head 9, muzzle 10 and ear 11. Rectangles 8 & 9 are in line with the front 1. After doing F it is well to practice these "ABC's" a number of times.

Over these straight lines sketch curves in the manner shown at left. In order to get an idea of groundwork principles, we have drawn a composite of <u>several</u> animals, no special one.

APPLYING THE A B C's

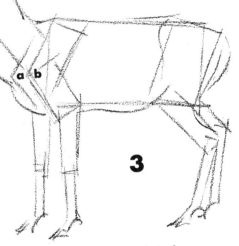

After one has acquired a working familiarity with the formal placement of these body parts (opposite page), it is time to experiment with them. Of course, we cannot expect to draw every animal over the same identical scaffolding. Nor can we dissect a given rectangle at a certain place each time we change animals. For one thing, the main trunk rectangle "A" will often be tilted (see horse fig. 1 & dog fig. 2). The two No. 1 rectangles in fig. B (page 4) will not always be parallel, but in most drawings the tendency for them to line up that way will be apparent. Look for that "1-2-3 follow-through" diagramed in D across the page. There's a swing to it. The stance of an animal such as the dog in fig. 2 may alter the hindquarters considerably.

A repeat of the shoulder rectangles (a & b in fig. 3) may help if the body at that point is turned to show 'thickness.' Seldom will a neck be finished off with straight, parallel lines; but roughing in a starting rectangle should call attention to the peculiarity of the particular subject. Don't expect these ABC's to work magic until you have either acquainted yourself with the animal in question or have him standing in front of you, in real life or in authentic copy. These exercises are for sideview subjects and not for semi-front views. Many calls come in for sideviews, however, and it should be the first learned by the student. The torsos of the deer and the cow lend themselves admirably to a box treatment. Animals which 'foldup' habitually, like the squirrel in fig. 4 may become involved if they are drawn too small. Nevertheless, with dimension in mind, the feel of one part being in front of the other can be assured by this method of practice. It is suggested that this procedure be done sketchily and not with hard, non-erasable lines.

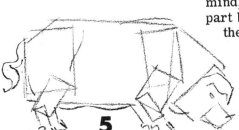

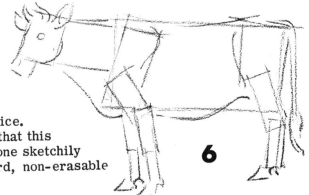

IMPORTANT FUNDAMENTALS OF ANIMAL FEET

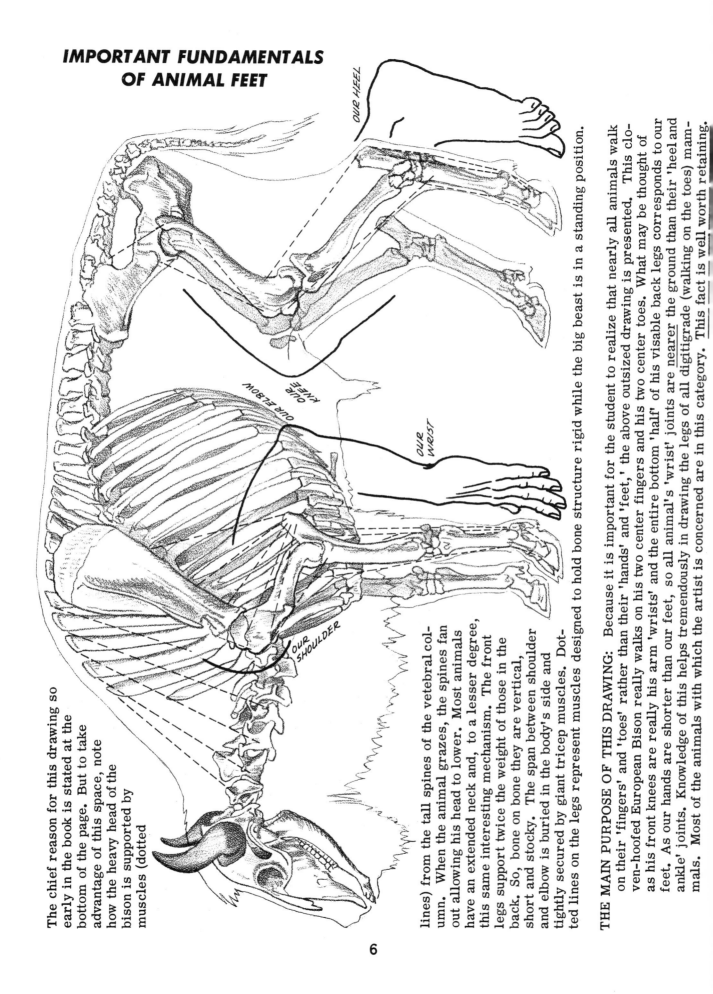

OUR HEEL

OUR ELBOW

OUR KNEE

OUR WRIST

OUR SHOULDER

The chief reason for this drawing so early in the book is stated at the bottom of the page. But to take advantage of this space, note how the heavy head of the bison is supported by muscles (dotted lines) from the tall spines of the vetebral column. When the animal grazes, the spines fan out allowing his head to lower. Most animals have an extended neck and, to a lesser degree, this same interesting mechanism. The front legs support twice the weight of those in the back. So, bone on bone they are vertical, short and stocky. The span between shoulder and elbow is buried in the body's side and tightly secured by giant tricep muscles. Dotted lines on the legs represent muscles designed to hold bone structure rigid while the big beast is in a standing position.

THE MAIN PURPOSE OF THIS DRAWING: Because it is important for the student to realize that nearly all animals walk on their 'fingers' and 'toes' rather than their 'hands' and 'feet,' the above outsized drawing is presented. This cloven-hoofed European Bison really walks on his two center fingers and his two center toes. What may be thought of as his front knees are really his arm 'wrists' and the entire bottom 'half' of his visable back legs corresponds to our feet. As our hands are shorter than our feet, so all animal's 'wrist' joints are nearer the ground than their 'heel and ankle' joints. Knowledge of this helps tremendously in drawing the legs of all digitigrade (walking on the toes) mammals. Most of the animals with which the artist is concerned are in this category. This fact is well worth retaining.

6

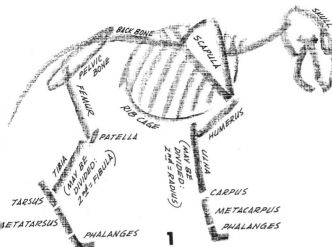

1

Labels on figure 1: SKULL, BACK BONE, SCAPULA, PELVIC BONE, FEMUR, RIB CAGE, HUMERUS, PATELLA, TIBIA, (MAY BE DIVIDED: 2ND = FIBULA), ULNA, (MAY BE DIVIDED: 2ND = RADIUS), CARPUS, TARSUS, METACARPUS, METATARSUS, PHALANGES, PHALANGES

THE SIMPLIFIED SKELETON

It is not necessary for the student to learn minute details of the entire skeletal system. Nor can he bypass the subject altogether and still hope to draw animals. Somewhere in between there is knowledge enough to do a good job. The more one examines and compares skeletons and the muscle structures about them, the more the light breaks through.

The simplified skeleton at left has the barest essentials. It is a generalized sketch of no particular animal. An expanded list of bone names is given in the greyhound on page 12. The student should learn at least the minimum number of names given above. Concerning the 'parentheses': above your own elbow and knee, you have one bone; below your own elbow and knee, you have two bones. Similarly, animals have one bone above and many have two below. But others have these two bones fused into one or nearly one. In figs. 2 & 3 they are unfused; in 4 & 5 they are partially fused. On this page are four reference skeletons, including: an animal which walks on the whole sole of his feet, the bear (fig. 2); an animal which walks on four toes, the wolf (fig. 3); the largest land animal, the elephant (fig. 4); and the tallest animal, the giraffe (fig. 5). There are four sets of 'show' bones in the torso that are positive requirements: the shoulder blade or scapula, the hip bone or pelvis, the rib cage, and the back bone or vertebrae. In comparing these skeletons (and the one on the opposite page) take note that: the scapula or shoulder blade is more or less triangular in shape, the front leg or arm bone (humerus) is attached to the lower part of the scapula, the pelvic bone goes around and through to the other side and has two decided humps corresponding to your own hip bones, the back leg bone (femur) is attached to the pelvic bone about 1/3 distance from the back of the pelvic bone.

Bear
2

Wolf
3

Elephant
4

Giraffe
5

7

LOCATION OF THE FRONT "KNEE" JOINT

The big arrow (at the right) is directed at an animal's elbow or point of the olecranon bone (corresponding to your own elbow -- feel it, then straighten your arm out: the next set of joints down your arm is your wrist. Also, the

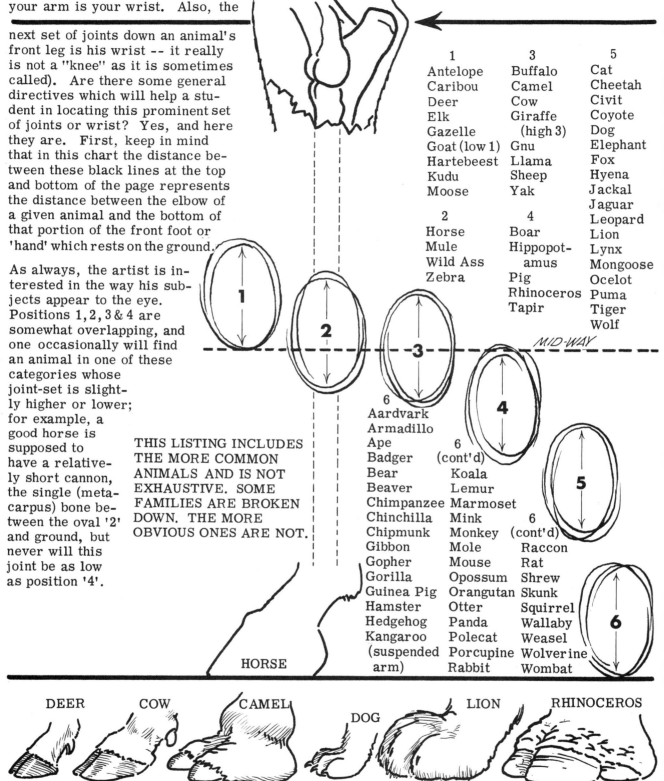

next set of joints down an animal's front leg is his wrist -- it really is not a "knee" as it is sometimes called). Are there some general directives which will help a student in locating this prominent set of joints or wrist? Yes, and here they are. First, keep in mind that in this chart the distance between these black lines at the top and bottom of the page represents the distance between the elbow of a given animal and the bottom of that portion of the front foot or 'hand' which rests on the ground.

As always, the artist is interested in the way his subjects appear to the eye. Positions 1, 2, 3 & 4 are somewhat overlapping, and one occasionally will find an animal in one of these categories whose joint-set is slightly higher or lower; for example, a good horse is supposed to have a relatively short cannon, the single (metacarpus) bone between the oval '2' and ground, but never will this joint be as low as position '4'.

THIS LISTING INCLUDES THE MORE COMMON ANIMALS AND IS NOT EXHAUSTIVE. SOME FAMILIES ARE BROKEN DOWN. THE MORE OBVIOUS ONES ARE NOT.

1
Antelope
Caribou
Deer
Elk
Gazelle
Goat (low 1)
Hartebeest
Kudu
Moose

2
Horse
Mule
Wild Ass
Zebra

3
Buffalo
Camel
Cow
Giraffe
 (high 3)
Gnu
Llama
Sheep
Yak

4
Boar
Hippopot-
 amus
Pig
Rhinoceros
Tapir

5
Cat
Cheetah
Civit
Coyote
Dog
Elephant
Fox
Hyena
Jackal
Jaguar
Leopard
Lion
Lynx
Mongoose
Ocelot
Puma
Tiger
Wolf

MID-WAY

6
Aardvark
Armadillo
Ape
Badger
Bear
Beaver
Chimpanzee
Chinchilla
Chipmunk
Gibbon
Gopher
Gorilla
Guinea Pig
Hamster
Hedgehog
Kangaroo
(suspended
arm)

6 (cont'd)
Koala
Lemur
Marmoset
Mink
Monkey
Mole
Mouse
Opossum
Orangutan
Otter
Panda
Polecat
Porcupine
Rabbit

6 (cont'd)
Raccon
Rat
Shrew
Skunk
Squirrel
Wallaby
Weasel
Wolverine
Wombat

HORSE

DEER COW CAMEL DOG LION RHINOCEROS

The sample leg in the center of this page is that of a horse with elbow and hoof. Across the bottom of these two pages are various animal feet. It would be impossible to have a sample leg whose height and width would comply to all animals. However, every leg has a 'mid-way' point (center dotted line

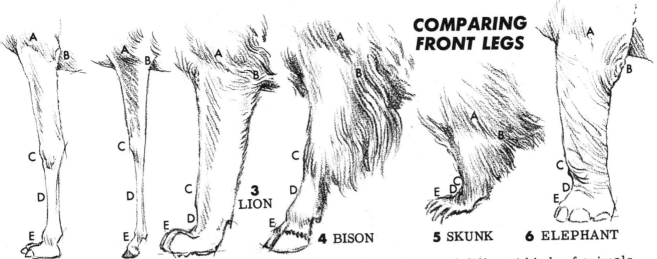

COMPARING FRONT LEGS

1 CAMEL **2** GAZELLE **3** LION **4** BISON **5** SKUNK **6** ELEPHANT

Above are the front legs of several different kinds of animals. They are not drawn proportionately but are reduced or enlarged to better fit the space and illustrate the point. As "DE", the 'true' knee of the back leg, is below the body (or stomach line) on page 10,"B" or the 'true' elbow of the front leg is usually just above the body (or chest line). One exception is the elephant which also has looser skin appearing to bag down somewhat at the elbow. Some dogs vary in this regard. These observations apply to animals in a standing position, which so often needs to be drawn. When an animal extends his front legs for action, the elbow then drops below the chest line. So, remember the two knee bumps ("DE" on page 10) are below and the one elbow bump ("B") is usually above the contour line of the body proper. For a good illustration of this turn to the horse section.

At the left is a general bone plan for the animals' front legs. Only one muscle, the triceps, is indicated here as it comes off the elbow bone. The reason for this is its show prominence in nearly all animals. As it cups on the side of the upper leg it invariably catches some shadow--not always, but more often than not. If a particular animal has lots of overhanging hair such as the bison (4) or skunk (5) above, the triceps may be blocked from view. Still, many good animal artists will let this under-structure be evidenced even when hair is in abundance.

POINT OF SHOULDER

SCAPULA (SHOULDER BLADE)

TRICEPS

A

B TRUE ELBOW

HUMERUS

OLECRANON

RADIUS

ULNA

IN SOME SPECIES THESE BONES FUSED

TRUE WRIST

C

CARPUS

METACARPUS

PHALANGES

D

E

MODIFIED 'HAND'

CLAWS OR HOOF (FINGER NAILS)

At right are notes on the 'true wrist' joints of the horse family, the deer family, the dog family and the giraffe. Observe joint shapes drawn at top of page.

NOTICEABLE SQUARING ON FRONT

POINT BEHIND

ONE PROTRUSION THEN IN

THINS OUT FASTER HERE

EXTREMELY KNOTTY

HORSE DEER DOG GIRAFFE

PIG

ELEPHANT

BEAR

MONKEY

SQUIRREL

WRIST HERE

parallel to heavy black lines, p. 8). The six approximate positions (ovals, p. 8) for the front leg joint ('knee' or 'wrist') are to be considered as being on the particular animal's leg in relation to the midway point. The bear's, squirrel's and monkey's foot above includes the joint (listed in column 6, p. 8).

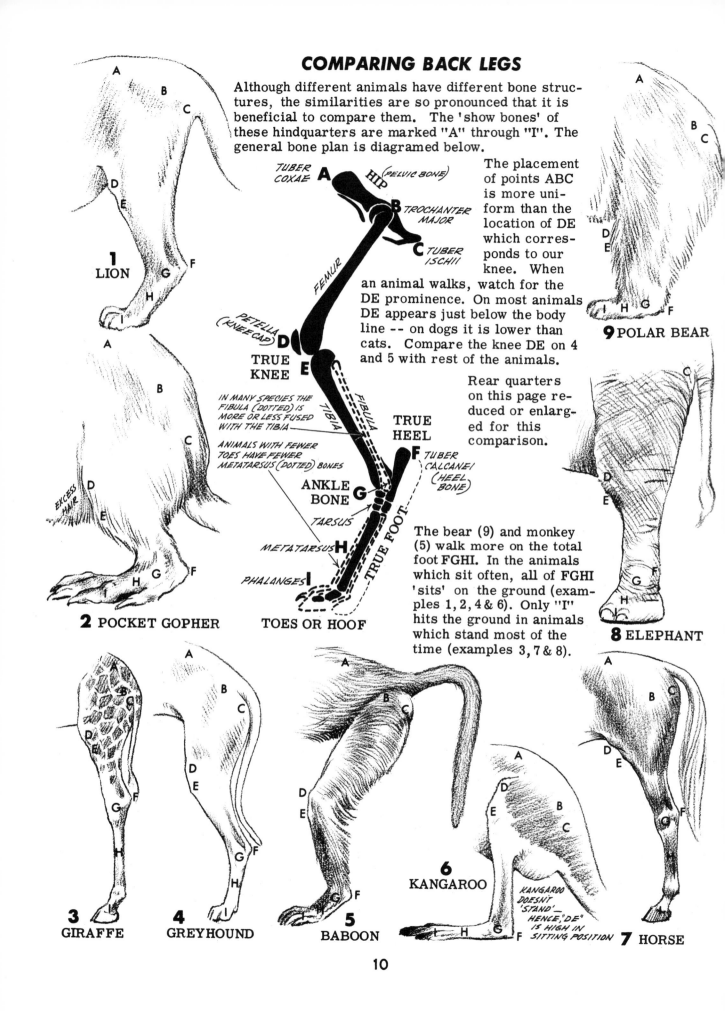

COMPARING BACK LEGS

Although different animals have different bone structures, the similarities are so pronounced that it is beneficial to compare them. The 'show bones' of these hindquarters are marked "A" through "I". The general bone plan is diagramed below.

A TUBER COXAE — HIP (PELVIC BONE)

B TROCHANTER MAJOR

C TUBER ISCHII

FEMUR

D PETELLA (KNEE CAP) — TRUE KNEE

E

IN MANY SPECIES THE FIBULA (DOTTED) IS MORE OR LESS FUSED WITH THE TIBIA

ANIMALS WITH FEWER TOES HAVE FEWER METATARSUS (DOTTED) BONES

TIBIA · FIBULA

TRUE HEEL

F TUBER CALCANEI (HEEL BONE)

ANKLE BONE **G** TARSUS

METATARSUS **H** TRUE FOOT

PHALANGES **I**

TOES OR HOOF

The placement of points ABC is more uniform than the location of DE which corresponds to our knee. When an animal walks, watch for the DE prominence. On most animals DE appears just below the body line -- on dogs it is lower than cats. Compare the knee DE on 4 and 5 with rest of the animals.

Rear quarters on this page reduced or enlarged for this comparison.

The bear (9) and monkey (5) walk more on the total foot FGHI. In the animals which sit often, all of FGHI 'sits' on the ground (examples 1, 2, 4 & 6). Only "I" hits the ground in animals which stand most of the time (examples 3, 7 & 8).

1 LION

2 POCKET GOPHER
EXCESS HAIR

9 POLAR BEAR

8 ELEPHANT

3 GIRAFFE

4 GREYHOUND

5 BABOON

6 KANGAROO
KANGAROO DOESN'T 'STAND'— HENCE 'DE' IS HIGH IN SITTING POSITION

7 HORSE

COMPARING ANIMAL MUSCLES

The muscle arrangement in the animal kingdom is much the same. For the artist he need not know all the technical names. After the three body basics are learned (page 3), it is well to go beneath the surface for a closer look. Though all external muscles may express themselves under given circumstances, the beginner should familiarize himself with a few 'give-away' places that are likely to show on most all short-haired animals. As a starter look at the four places in each animal (marked with a black line) in the second column. Where one muscle comes against another there is often a noticeable indention. Even with the long-haired animals, extra power may be portrayed in a drawing by permitting bold under-structure to influence the lay of the hair.

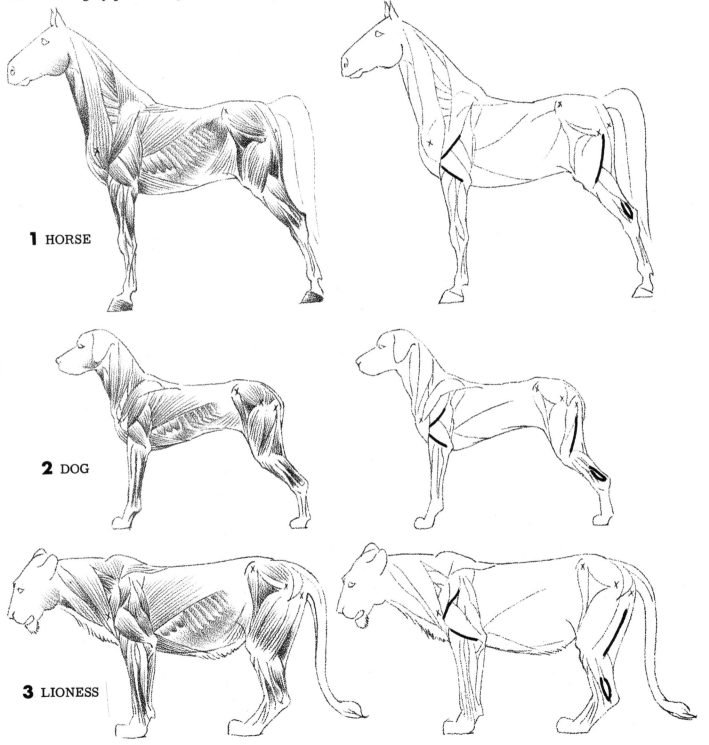

1 HORSE

2 DOG

3 LIONESS

BONE STRUCTURE — GREYHOUND

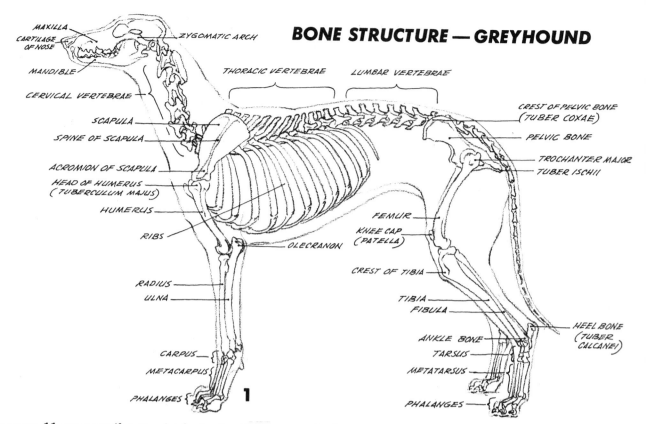

MAXILLA
CARTILAGE OF NOSE
ZYGOMATIC ARCH
MANDIBLE
CERVICAL VERTEBRAE
THORACIC VERTEBRAE
LUMBAR VERTEBRAE
SCAPULA
SPINE OF SCAPULA
ACROMION OF SCAPULA
HEAD OF HUMERUS (TUBERCULUM MAJUS)
HUMERUS
RIBS
CREST OF PELVIC BONE (TUBER COXAE)
PELVIC BONE
TROCHANTER MAJOR
TUBER ISCHII
FEMUR
KNEE CAP (PATELLA)
OLECRANON
CREST OF TIBIA
RADIUS
ULNA
TIBIA
FIBULA
HEEL BONE (TUBER CALCANEI)
ANKLE BONE
TARSUS
METATARSUS
CARPUS
METACARPUS
PHALANGES
PHALANGES

1

On page **11** we saw the marked similarity in muscle formation as it occurs in various animals. Although it is not necessary to be able to identify by name all the bones and muscles, it is advantageous to refer to them repeatedly. Wherever there is a "show" place on the surface, find out what makes it that way beneath. This will <u>simplify</u> surface drawing, the part that cannot be escaped.

MUSCLE STRUCTURE — GREYHOUND

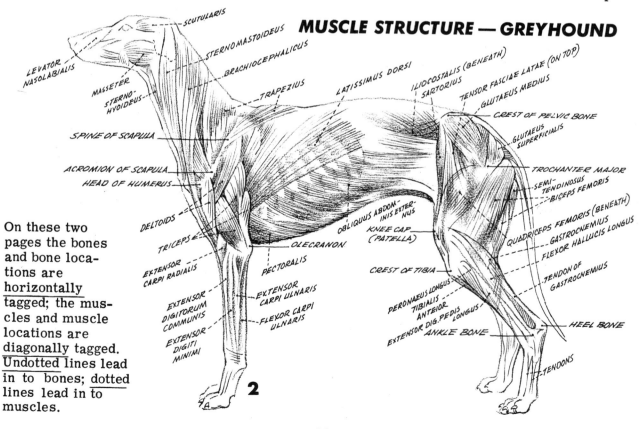

SCUTULARIS
STERNOMASTOIDEUS
LEVATOR NASOLABIALIS
BRACHIOCEPHALICUS
MASSETER
STERNO-HYOIDEUS
TRAPEZIUS
LATISSIMUS DORSI
ILIOCOSTALIS (BENEATH)
SARTORIUS
TENSOR FASCIAE LATAE (ON TOP)
GLUTAEUS MEDIUS
CREST OF PELVIC BONE
GLUTAEUS SUPERFICIALIS
SPINE OF SCAPULA
ACROMION OF SCAPULA
HEAD OF HUMERUS
TROCHANTER MAJOR
SEMI-TENDINOSUS
BICEPS FEMORIS
DELTOIDS
OBLIQUUS ABDOMINIS EXTERNUS
QUADRICEPS FEMORIS (BENEATH)
GASTROCNEMIUS
FLEXOR HALLUCIS LONGUS
TRICEPS
KNEE CAP (PATELLA)
OLECRANON
EXTENSOR CARPI RADIALIS
PECTORALIS
CREST OF TIBIA
TENDON OF GASTROCNEMIUS
EXTENSOR CARPI ULNARIS
PERONAEUS LONGUS
TIBIALIS ANTEIOR
EXTENSOR DIGITORUM COMMUNIS
FLEXOR CARPI ULNARIS
EXTENSOR DIG.PEDIS LONGUS
HEEL BONE
ANKLE BONE
EXTENSOR DIGITI MINIMI
TENDONS

On these two pages the bones and bone locations are horizontally tagged; the muscles and muscle locations are diagonally tagged. <u>Undotted</u> lines lead in to bones; dotted lines lead in <u>to</u> muscles.

2

SURFACE ANATOMY — GREYHOUND

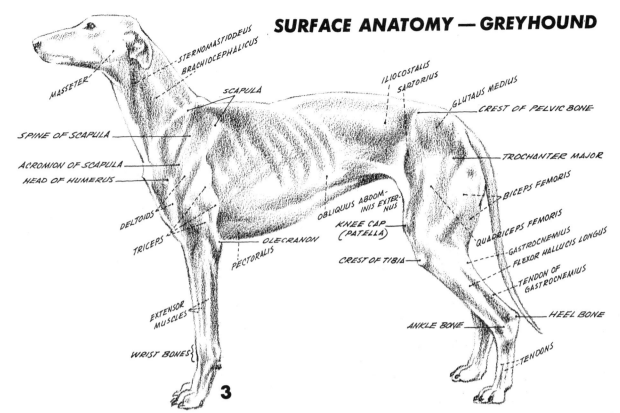

The exterior of the greyhound beautifully illustrates bone and muscle "happenings." Compare fig. 3 with figs. 1 & 2. Refer back to these pages when studying other animals throughout this book. When a change of contour is detected or a highlight or shadow appears on the surface, TRACK DOWN the reason with the help of the greyhound!

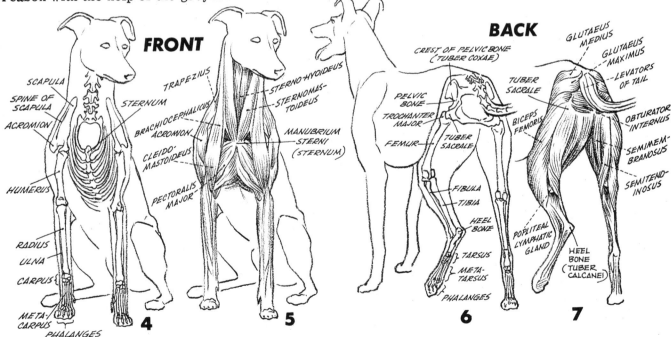

Observe that the scapulas (or shoulder blades) in fig. 4 are not attached by a bone-link to the sternum. There is no collar-bone in most animals. The scapulas lie more or less flat to the sides of the shoulders, and they define themselves well in surface anatomy (see figs. 1, 2 & 3). The next time you pet a dog or cat feel the scapulas, humerus heads (front points of the shoulders), sternum bone, pelvic bone crests and femur attachments. Note the radiating muscles from the sternum in fig. 5 -- these are especially prominent under the skin of the horse.

13

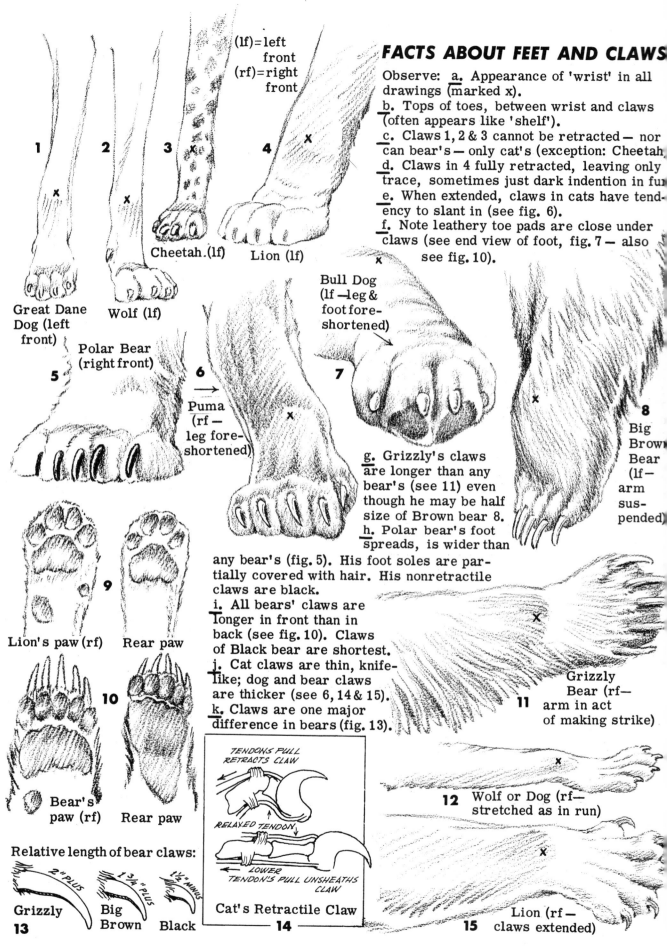

(lf)=left front
(rf)=right front

FACTS ABOUT FEET AND CLAWS

Observe: a. Appearance of 'wrist' in all drawings (marked x).

b. Tops of toes, between wrist and claws (often appears like 'shelf').

c. Claws 1, 2 & 3 cannot be retracted — nor can bear's — only cat's (exception: Cheetah).

d. Claws in 4 fully retracted, leaving only trace, sometimes just dark indention in fur.

e. When extended, claws in cats have tendency to slant in (see fig. 6).

f. Note leathery toe pads are close under claws (see end view of foot, fig. 7 — also see fig. 10).

g. Grizzly's claws are longer than any bear's (see 11) even though he may be half size of Brown bear 8.

h. Polar bear's foot spreads, is wider than any bear's (fig. 5). His foot soles are partially covered with hair. His nonretractile claws are black.

i. All bears' claws are longer in front than in back (see fig. 10). Claws of Black bear are shortest.

j. Cat claws are thin, knife-like; dog and bear claws are thicker (see 6, 14 & 15).

k. Claws are one major difference in bears (fig. 13).

1 Great Dane Dog (left front)

2 Wolf (lf)

3 Cheetah. (lf)

4 Lion (lf)

5 Polar Bear (right front)

6 Puma (rf — leg foreshortened)

7 Bull Dog (lf — leg & foot foreshortened)

8 Big Brown Bear (lf — arm suspended)

9 Lion's paw (rf) Rear paw

10 Bear's paw (rf) Rear paw

11 Grizzly Bear (rf — arm in act of making strike)

12 Wolf or Dog (rf — stretched as in run)

Relative length of bear claws:

2" PLUS 1 3/4 " PLUS 1 1/2 " MINUS

13 Grizzly Big Brown Black

TENDONS PULL RETRACTS CLAW

RELAXED TENDON

LOWER TENDON'S PULL UNSHEATHS CLAW

14 Cat's Retractile Claw

15 Lion (rf — claws extended)

COMPARING FOOT BONES

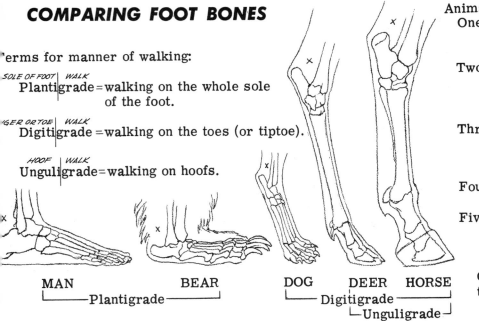

Terms for manner of walking:

SOLE OF FOOT | WALK
Plantigrade = walking on the whole sole of the foot.

GER OR TOE | WALK
Digitigrade = walking on the toes (or tiptoe).

HOOF | WALK
Unguligrade = walking on hoofs.

MAN BEAR DOG DEER HORSE
└──── Plantigrade ────┘ └──── Digitigrade ────┘
 └── Unguligrade ──┘

Animals which walk with:
One useable digit (third finger or middle toe) are horses, zebras, etc.
Two useable digits (even-toed ungulates) are cattle, deer, sheep, pigs, giraffes, etc.
Three useable digits (odd-toed ungulates — excluding one-toed) are tapirs, rhinoceroses.
Four useable digits are hippopotamuses.
Five (or four) useable digits are most monkeys, many carnivores (flesh-eating mammals), rodents, etc.
Consider the foregoing with the information on page 8.

In conjunction with foot and leg notes on previous pages, and in order to further the understanding concerning the manner of animal locomotion, the drawings above are presented. Thus far there has been a purposeful interplay between the parts and the whole in approaching the subject of animal construction. Progressively, we have seen that much of the true foot of most animals is up in the air, off the ground. Now, think of your own heel bone. Take another running look at "F" through all the legs on page 10. Feel the achilles tendon coming up and off the back of your own heel, especially the hollow just inside. This hollow appears on most all animals where heavy fur does not cover it up. The "x's" indicate where it is in the drawings above. The black-lined loop showed it in the back legs of the second column of animals on page 11.

LIKENESSES IN ANIMAL HEADS

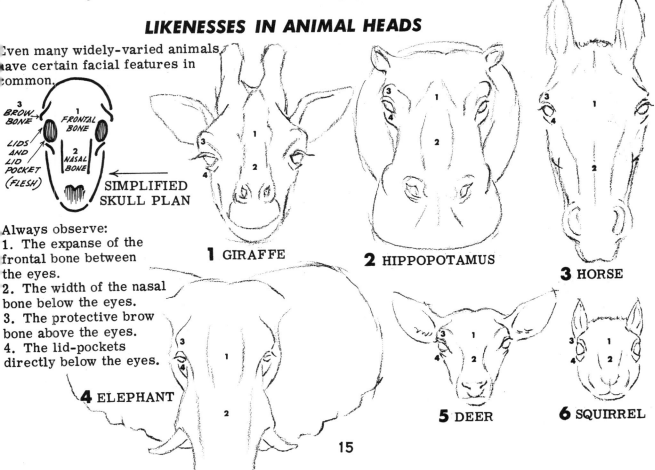

Even many widely-varied animals have certain facial features in common.

3 BROW BONE
1 FRONTAL BONE
LIDS AND LID POCKET (FLESH)
2 NASAL BONE
SIMPLIFIED SKULL PLAN

Always observe:
1. The expanse of the frontal bone between the eyes.
2. The width of the nasal bone below the eyes.
3. The protective brow bone above the eyes.
4. The lid-pockets directly below the eyes.

1 GIRAFFE

2 HIPPOPOTAMUS

3 HORSE

4 ELEPHANT

5 DEER

6 SQUIRREL

15

THE ANIMAL NOSE

As we proceed in our study, we discover more and more that in the animal world there are certain things which many have in common. It is well to learn these things first, then seek out the individual differences. So that the resemblances may be appreciated, however, it is needful to itemize what we're talking about. At this stage the student should not spend hours drawing individual noses or eyes or ears. But when a sameness is revealed, tuck it away in your memory. Let it come to your aid as your pencil crosses the spot where the particular feature must appear.

3 COW

At left notice the black "comma" taken from the bottom of the human nose. This simple comma may be modified, but it is to be found in nearly all animal noses. Notice how the commas are laid on their sides with the tails pointed up and back toward the eyes. Trace this observation in the French Poodle's nose (2) and throughout the rest of the noses on this page. The tail of this comma is more of a slit-opening in animals (see arrows, figs. 11 & 12) than in our own nose. These slits will flare during heavy breathing after a run or when creature is angry (also see p. 72, figs. B1 & B2). The minimal comma is the pig 7; the maximal, the moose 5. The septum between the nostrils is often grooved, or at least indented. This "valley" usually starts on the upper lip. The nose pad takes on fine hair at its extremities, then graduates into full hair on the face. A secretion keeps the nose pad moist in many animals causing highlights to appear. Dog's and bear's noses are somewhat flat on the front with more of an 'edge' at the top. Compare the cat's nose 14 with the tiger's and lion's, p. 32. The camel 15 can close his nose to keep out dust; the sea lion 16 can close his to keep out water.

NOSTRIL WING

2 FRENCH POODLE

4 HORSE

5 MOOSE

6 RACCOON **7 PIG** **8 ORANGUTAN**

9 KODIAK BEAR

10 HIPPOPOTAMUS

11 POLAR BEAR **12 COLLIE DOG** **13 WALLAROO** **14 HOUSE CAT** **15 CAMEL** **16 SEA LION**

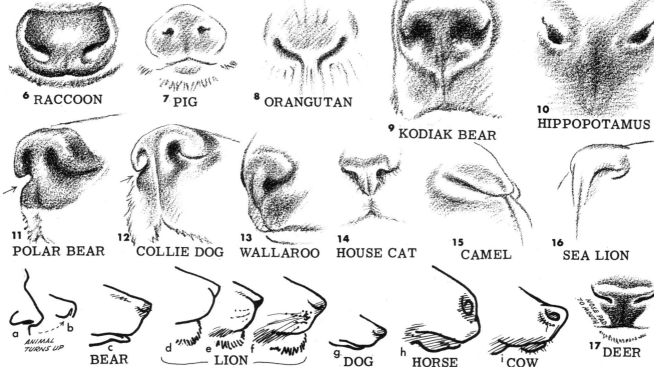

ANIMAL TURNS UP

BEAR **LION** **DOG** **HORSE** **COW**

NOSE PAD TO MOUTH

17 DEER

OPEN

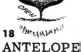

18 ANTELOPE

In drawing the side view animal nose, think of the human nose turned up (a & b). Notice this in the bear (c). The 'puff' of the cat-like cheek may cut along the nose and a mere line may suffice (d). The nose tip may be darkened (e) or grayed (f). Consult pages 42 and 43. From the right side the figure "6" may be imagined in the nose (h & i). Reverse the "6" for the left side. Remember the difference in the nose pads and upper lips of the deer (17) and antelope (18).

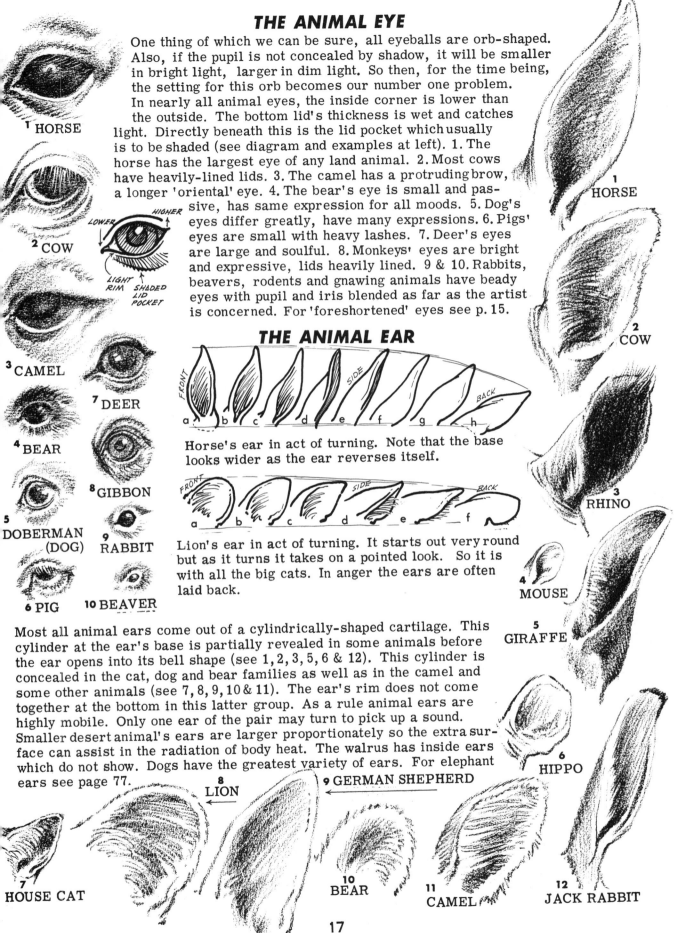

THE ANIMAL EYE

One thing of which we can be sure, all eyeballs are orb-shaped. Also, if the pupil is not concealed by shadow, it will be smaller in bright light, larger in dim light. So then, for the time being, the setting for this orb becomes our number one problem. In nearly all animal eyes, the inside corner is lower than the outside. The bottom lid's thickness is wet and catches light. Directly beneath this is the lid pocket which usually is to be shaded (see diagram and examples at left). 1. The horse has the largest eye of any land animal. 2. Most cows have heavily-lined lids. 3. The camel has a protruding brow, a longer 'oriental' eye. 4. The bear's eye is small and passive, has same expression for all moods. 5. Dog's eyes differ greatly, have many expressions. 6. Pigs' eyes are small with heavy lashes. 7. Deer's eyes are large and soulful. 8. Monkeys' eyes are bright and expressive, lids heavily lined. 9 & 10. Rabbits, beavers, rodents and gnawing animals have beady eyes with pupil and iris blended as far as the artist is concerned. For 'foreshortened' eyes see p. 15.

1 HORSE

2 COW

LOWER HIGHER

LIGHT RIM SHADED LID POCKET

3 CAMEL

7 DEER

4 BEAR

8 GIBBON

5 DOBERMAN (DOG)

9 RABBIT

6 PIG

10 BEAVER

THE ANIMAL EAR

FRONT SIDE BACK

a b c d e f g h

Horse's ear in act of turning. Note that the base looks wider as the ear reverses itself.

FRONT SIDE BACK

a b c d e f

Lion's ear in act of turning. It starts out very round but as it turns it takes on a pointed look. So it is with all the big cats. In anger the ears are often laid back.

Most all animal ears come out of a cylindrically-shaped cartilage. This cylinder at the ear's base is partially revealed in some animals before the ear opens into its bell shape (see 1, 2, 3, 5, 6 & 12). This cylinder is concealed in the cat, dog and bear families as well as in the camel and some other animals (see 7, 8, 9, 10 & 11). The ear's rim does not come together at the bottom in this latter group. As a rule animal ears are highly mobile. Only one ear of the pair may turn to pick up a sound. Smaller desert animal's ears are larger proportionately so the extra surface can assist in the radiation of body heat. The walrus has inside ears which do not show. Dogs have the greatest variety of ears. For elephant ears see page 77.

1 HORSE

2 COW

3 RHINO

4 MOUSE

5 GIRAFFE

6 HIPPO

7 HOUSE CAT

8 LION

9 GERMAN SHEPHERD

10 BEAR

11 CAMEL

12 JACK RABBIT

DISCUSSING FAST ACTION

1

2 PUMA

3 WEASEL

4 RABBIT

5 WOLF

6 BEAR

7 KUDU

Collectively we should look at a representative group of animals in fast motion before we take up individual animals. Elsewhere in this book are more drawings dealing with locomotion problems. Action is demanded in many of the artist's assignments. It helps to know some of the things which should and should not be done. If an animal goes into a 'spread suspension' (examples this page); that is, if his legs are at times fully extended and at the same time are not in contact with the ground, this becomes a good position to record for high speed. When he gathers his feet under him as tightly as is natural, and is at the same time suspended in mid-air (examples next page); this, too, is a good position portraying high speed. To be sure, other positions are assumed in the run. If more than two animals of the same kind are to be pictured, then intermediate stages may be shown for the sake of variety -- and accuracy, since it is very unlikely several animals would be in an identical pose. These intermediate stages do not look as fast, however, even though in real life they may be.

Most wild animals are drawn going over rough terrain at which time more leaping is done than when traveling on a smooth surface. Practically all animals are able to leap -- the elephant cannot. The hippopotamus and rhinoceros are not likely to leap, for they simply crush most of what is in the way. Despite their great bulk, they can run amazingly fast on occasion. The positions on this page may be considered phases in the run; although, having taken off on both back feet simultaneously, the better chance is, the animal will light on one or the other of this front feet and not on both of them at the same time. At the peak of this brief suspension, he may have the two legs in each pair more-or-less parallel. Fig. 1 at the top is the basic pattern for this position. (Notice the horse is NOT pictured here -- see pp. 68 & 69)

18

MORE GENERAL FACTS ON THE "RUN"

1a

1b GREYHOUND

2 CHEETAH

3 GAZELLE

4 HORSE

5 RABBIT

6 FOX

7 PUMA

On this page are some of the fastest animals alive (with the exception of the puma 7 and bear 8 which are capable of limited bursts of speed). However, the main purpose of this discussion is the 'gathering' of the feet in mid-air prior to ground contact for another push-off. In the run the greyhound (1b) is one of the most rhythmic. To have the four legs in the 1b position, which the greyhound may momentarily assume in running, is foreign to most all animals. The horse never gets into this position when running or fast galloping, nor does he ever go into the complete spread suspension shown on the opposite page (check pp. 66 & 67). He does gather his feet, but not in the manner of 1b -- see fig. 4. With all animals, the front legs are more likely to be one slightly behind the other when the back legs are drawn under the body in a parallel manner (see figs. 2, 3 & 7) -- and they are more convincing that way.

The rabbit's and fox's legs may go into a full parallel "X" cross (figs. 5 & 6), but the bear is too bulky. Only in desperation will his legs assume anything like the fig. 8 alignment. For the most part, when a deer (or other animal which habitually leaps in his run) is to be drawn, it is wise to have two legs extended and two folded (figs. 9a & c) or all gathered (9b). To put a shadow on the ground indicating space under the animal is not a bad idea. It should be pointed out that, when the legs are gathered as illustrated on this page, the back feet are always on the outside and the front feet are on the inside. Further, the bottoms of the back feet are fairly parallel to the ground; whereas the front feet are in a 'flipped' position with soles turned up.

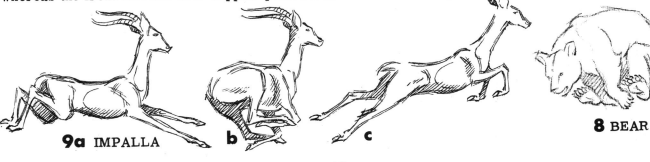

9a IMPALLA **b** **c**

8 BEAR

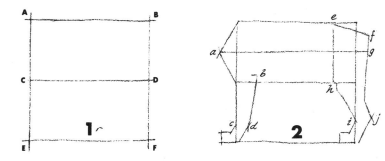

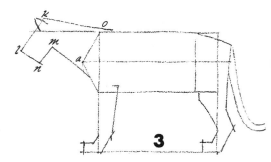

BASICS IN CAT STRUCTURE

The cat family has bodies which are longer than high. They are very uniform in their basic structural make-up from little house cats to giant tigers. Cats are cats whether large or small, in the jungle or in the living room of your home -- as far as general shape and body movements are concerned. This is not true of the dog family which takes on a variety of odd shapes. Even the longer-legged cheetah and the more box-like lynx vary little from the standard cat design.

The big maned lion and the brightly colored tiger are different only in their 'dressing.' If both are skinned and laid side-by-side, only an expert can tell them apart. So, learn 'standard' cat make-up, and then adapt it whenever the need arises.

There is something to be learned in beginning with the square, fig. 1, then extending the outline on either side as in fig. 2. The point of the shoulder, 2-a, in most animals, not just the cat, is in line with a middle division, a-g, drawn through the body. It protrudes from the top half of the original square and, in the case of the cat, this point may be considered directly above the front toes when the animal is standing erect with feet together. This 'knob' (a) is the end of the humerus bone, fig. 4.

In fig. 2 the elbow (b) is above the chest line, and when the tapering waist is brought up as in fig. 5, the knee (h) is below the CD line of fig. 1. Directly above the knee (h) the top of the hips (e) or pelvis is located. Then there is a slant in all animals where the pelvic bone tilts downward (see fig. 4). The front of the foreleg is in line with A-E of fig. 1, but the other perpendicular B-F cuts through the back leg. Both c & i of the front and back legs may be drawn on the original square of fig. 1.

It is true that a cat isn't always going to stop his legs in the same position. Nor will all four appendages be static like a table's legs. However, for now, it is well to grasp the simplicity of this stance. Notice the feet in relation with the square of fig. 1. It is quite natural for many animals to hold their heads so that k-1 of fig. 3 is more or less parallel with the shoulder line o-a of fig. 3.

Fig. 5 is a lioness, and fig. 6 is a male lion. Fig. 7 is a tiger drawn upon the same cat frame of fig. 5.

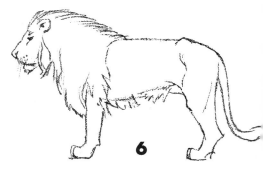

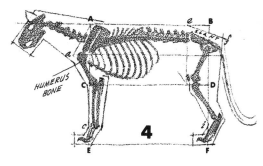

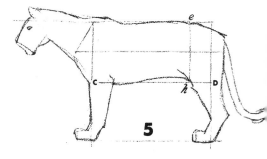

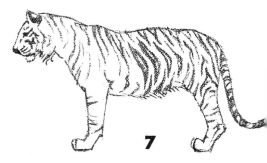

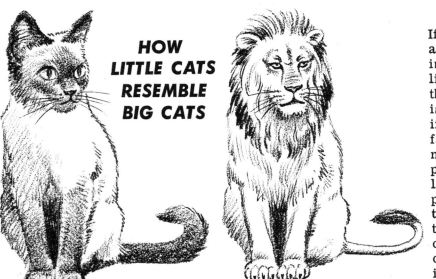

HOW LITTLE CATS RESEMBLE BIG CATS

If you have a pet cat running around your house, you have within drawing distance a miniature lion or leopard or any other of the great cats. The similarity is amazingly striking, especially if the cat is short-haired. At the far left is a medium-sized siamese cat blown up to lion-like proportions, or a lion sitting alongside reduced to cat-like proportions -- as you wish. Actually, the cat was drawn first, then the lion was drawn on the cat's frame. This particular cat, like many pampered pets, is a little on the fat side; so it would be best to narrow the body width slightly for a sleek looking lion. But for the purpose of proving the point, Leo the lion has been made as fat. The head and tail are the chief differences, yet, in kind, they too possess decidedly cat characteristics.

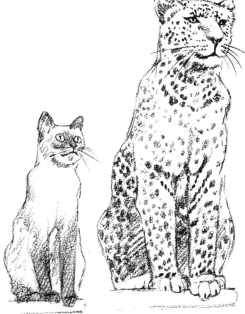

At left is the same cat in another sitting posture. This time the creature is drawn smaller and more to scale. By enlarging the animal exactly, changing the head to some extent, and adding spots we have a leopard. We might have built a jaguar, tiger, or puma on the frame just as readily. It is good practice to very lightly sketch your cat, then let him be the foundation for a powerful beast of the jungle.

Below, the lioness' head and cat's head are equated for study. Notice the difference in ear shape. The large cats have rounder ears. Both animals' ears if turned to the side would appear more pointed. By contrast the small cat's eyes are huge. Small cats (bobcats on down) have contractile eyes capable of becoming mere slits in bright light or big and round in poor light. All big cats have circular eyes; the pupils being reduced to spots not slits in stronger light. All big cats and most small cats have the distinctive dark coloration trailing out of the in-

side eye corners onto the nose. The house cat's nostrils are more petite, and the 'roof' of the nose is considerably shorter and more narrow. The muzzle across the whiskers is not as bulbous. The chin is smaller. In all, the facial features are closer together and daintier save for the big eyes. The lion head is more rectangular. The house cat may snarl, but only the larger cats seem to furrow their brows when displeased.

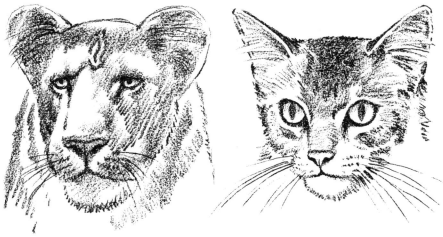

Here is a lioness at right con-
structed on an enlarged cat's
frame. The house cat at left
is changed but little in provid-
ing the basic outline. Though
quite agile, the lion is not as
graceful as the other impor-
tant members of the cat family.
Lions posses a ponderous
frame, so therefore it is well
to widen the cat's legs some in

1

2

3

the enlargement process (not the tail,which needs a tuft however).
Square up the head, and give the eyes some authority. The feet
need to be made thick and "ploppy." Be sure to observe the du-
plication in the bone and muscle structure. At right are simple
profiles of a cat and a lioness. A major difference is the jutting
chin of the lion, which really is mostly fur, but gives the air of
proud dignity nonetheless. Most cats have a little more concav-
ity just under the brow, and their shorter nose is tiny.

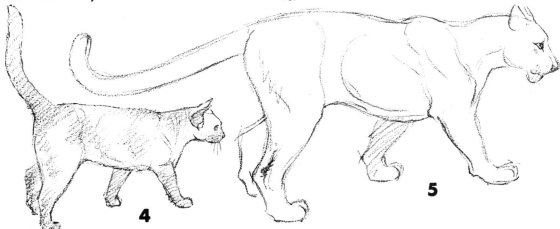

4

5

Above is the puma (also called couger, panther and mountain lion). He is drawn over the 'expand-
ed' house cat at the left. The head is not as bold as the lion and is smaller. The body is more
supple. The tail has no tuft and is held lower than a house cat. The big cats are more likely to
drag their tails when walking. In excitement or anger they may flail their tails or twitch them when
mildly aroused.

HELPS IN DRAWING THE LION

In the drawing at the right notice that the big body bones in the forequarters and hindquarters make parentheses "()." This is true of all the vertebrates (animals having backbones) whose upper arms are 'attached' to the body.

6

UPPER ARM ATTACHED TO BODY

7

At the left observe some similarities in distances: "a" is equal to "b," "A" is equal to "B" and 1, 2, 3, 4, 5 & 6 are equal. Compare this diagram with the skeleton below.

At the right is the completed female lion. She appears quite chunky when contrasted with her sleeker relatives in the rest of the big cat family. Some lions get very pot-bellied because of less exercise.

8

At left is a lion's skeleton fitted into a male lion's outline. Check out all the evidences of this bone work in the lioness directly above.

9

23

A SIMPLE APPROACH TO CATS

1
Before starting to sketch any animal, in your mind's eye quickly run around an overall confinement line above the base; i. e. , the area upon which the subject rests. See what overhangs the foundation assuming this weight.

2
Sketch very lightly the sectional parts as they relate one to the other. Think of these parts within the whole. Don't get 'hung up' on detail. Erase freely if a replacement line is needed. Lightly-drawn lines in the beginning make improvement possible.

3
Always be on the lookout for planes. Think of your subject as being solid even though it is a soft, furry cat. In this instance, especially notice the overhang of bone, flesh and fur at the shoulders.

4
At this stage of the game, fig. 3 is more important than the completed sketch at the right. Too many beginning students want to hurry with the "paint job" before the house is adequately put together. Rove around over your work checking one part against another. What about your proportions? Do they look right? Most papers you can see through. Reverse it, hold it to the light. Mistaken proportions are often revealed this way. Make the necessary adjustments.

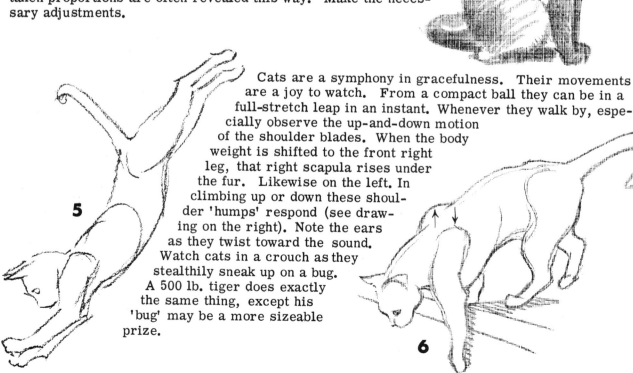

5

Cats are a symphony in gracefulness. Their movements are a joy to watch. From a compact ball they can be in a full-stretch leap in an instant. Whenever they walk by, especially observe the up-and-down motion of the shoulder blades. When the body weight is shifted to the front right leg, that right scapula rises under the fur. Likewise on the left. In climbing up or down these shoulder 'humps' respond (see drawing on the right). Note the ears as they twist toward the sound. Watch cats in a crouch as they stealthily sneak up on a bug. A 500 lb. tiger does exactly the same thing, except his 'bug' may be a more sizeable prize.

6

TIPS ON DRAWING CATS

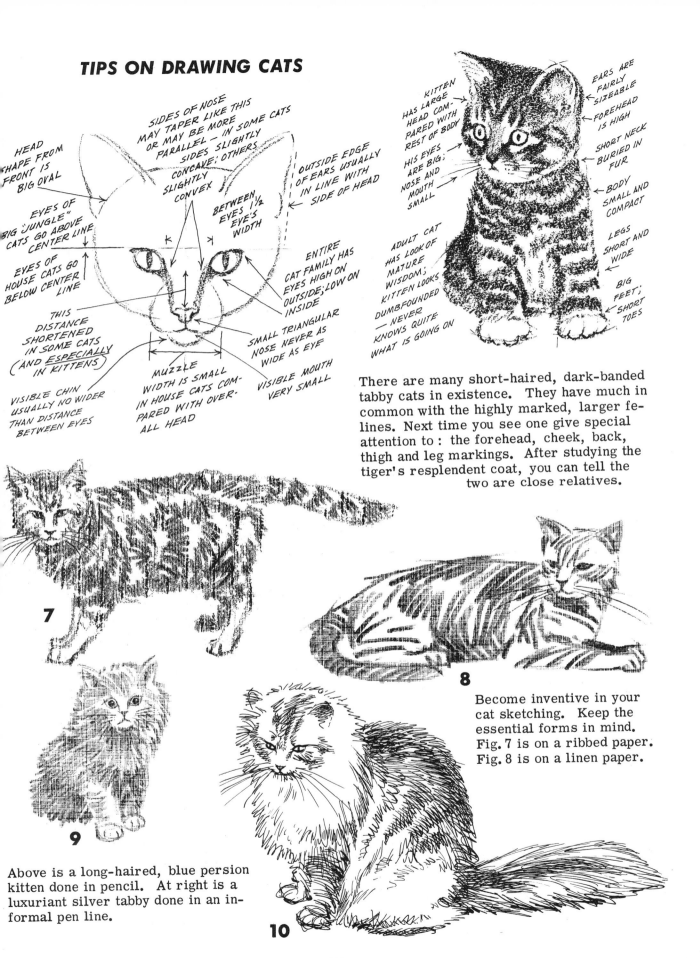

HEAD SHAPE FROM FRONT IS BIG OVAL

SIDES OF NOSE MAY TAPER LIKE THIS OR MAY BE MORE PARALLEL — IN SOME CATS SIDES SLIGHTLY CONCAVE; OTHERS SLIGHTLY CONVEX

OUTSIDE EDGE OF EARS USUALLY IN LINE WITH SIDE OF HEAD

BETWEEN EYES 1½ EYE'S WIDTH

EYES OF BIG "JUNGLE" CATS GO ABOVE CENTER LINE

EYES OF HOUSE CATS GO BELOW CENTER LINE

ENTIRE CAT FAMILY HAS EYES HIGH ON OUTSIDE; LOW ON INSIDE

THIS DISTANCE SHORTENED IN SOME CATS (AND ESPECIALLY IN KITTENS)

VISIBLE CHIN USUALLY NO WIDER THAN DISTANCE BETWEEN EYES

MUZZLE WIDTH IS SMALL IN HOUSE CATS COMPARED WITH OVERALL HEAD

SMALL TRIANGULAR NOSE NEVER AS WIDE AS EYE

VISIBLE MOUTH VERY SMALL

KITTEN HAS LARGE HEAD COMPARED WITH REST OF BODY

HIS EYES ARE BIG; NOSE AND MOUTH SMALL

ADULT CAT HAS LOOK OF MATURE WISDOM; KITTEN LOOKS DUMBFOUNDED — NEVER KNOWS QUITE WHAT IS GOING ON

EARS ARE FAIRLY SIZEABLE

FOREHEAD IS HIGH

SHORT NECK BURIED IN FUR

BODY SMALL AND COMPACT

LEGS SHORT AND WIDE

BIG FEET; SHORT TOES

There are many short-haired, dark-banded tabby cats in existence. They have much in common with the highly marked, larger felines. Next time you see one give special attention to: the forehead, cheek, back, thigh and leg markings. After studying the tiger's resplendent coat, you can tell the two are close relatives.

7

8

Become inventive in your cat sketching. Keep the essential forms in mind. Fig. 7 is on a ribbed paper. Fig. 8 is on a linen paper.

9

10

Above is a long-haired, blue persion kitten done in pencil. At right is a luxuriant silver tabby done in an informal pen line.

NOTES ON LION DRAWING

Few animals are more loosely skinned than the felines. The skin on the larger and heavier beasts seems to be attached rubber-like to the perfectly coordinated muscle structure beneath. This loose covering enables the unusually-flexible spine extreme curvature in

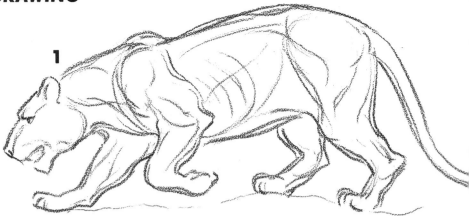

every direction. The multiple lines of fig. 1 express this adaptably-pliable characteristic.

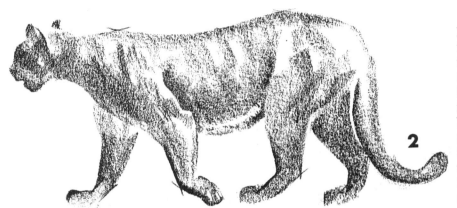

Pumas or mountain lions have the smallest heads, in proportion to their gangling bodies, of any of the great cats. Especially is this true as they turn away from the observer (perspective being involved). Their hair is short-cropped, yellowish brown to gray in color with whitish under-parts. Their tails are thick, the ends widening, but no tuft.

The puma has a long stride. Though he may look thick from the side, from the front he is no wider than his whiskers. All cats are rather surprisingly thin from the front; thus they slip the more easily through narrow places (see diagrams following dealing with the front view walk).

The "black panther" is really an odd variation of the leopard. Fig. 4 is a 'stylized' concept, a brush and ink drawing with a white stipple.

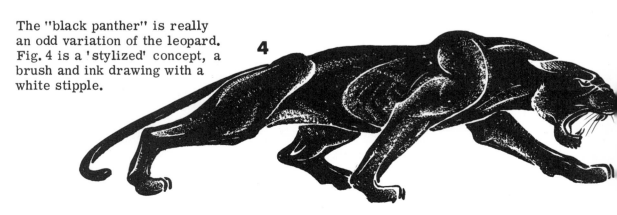

HOW A LION WALKS — FRONT

1 **2** **3** **4**

The 'cat walk' from the front is illustrated here in eight sequences. In fig. 1 the left foot is on its way forward for a step. As soon as it comes off the ground it angles <u>inward</u> at the 'wrist.' There are several reasons for this: the sheathed claws and rather tender toes are protected, being kept under the body. Also, the cat may tread a more narrow path in underbrush. The house cat walks this way too, but the tiny feet are difficult to notice. Since the left foot now has no weight upon it, the shoulder on that side drops. The shoulder blade on the right goes up over the <u>weight-bearing</u> leg. The left foot will barely miss touching the right foot as it passes. In fig. 3 the outside of the left foot is making touch contact with the ground (still at an angle). In fig. 4 the left foot begins to assume part of the body's weight, and the shoulder tops begin to level. In fig. 5 the weight of the cat's forequarters is evenly distributed momentarily; the shoulders are straight across. The toes are <u>slanted out</u> slightly. Bears go through the same motions except their front toes are slanted <u>in</u> slightly when their forefeet come to rest on the ground.

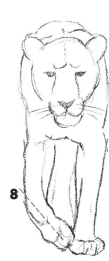

6 **7** **8**

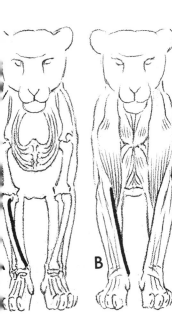

In fig. 6 the right foot lifts, placing weight upon other leg (notice the shoulder line). In fig. 7 it starts forward angling in as the left foot did in fig. 1. In fig. 8 it is ready to be softly 'plopped' on the ground. The big male lion in fig. 9 is in the same position. Fig. A at left shows the bone influence and fig. B the muscle influence (black lines) resulting in a prominent surface line on front of leg (see arrow fig. C). It goes from inside of 'wrist' to leg's 'root' in nearly all animals. WATCH FOR IT! RECORD IT!

B

C

9

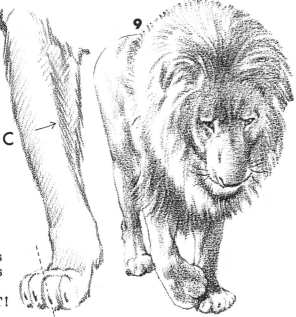

27

LION HEAD — SEVEN EASY STEPS

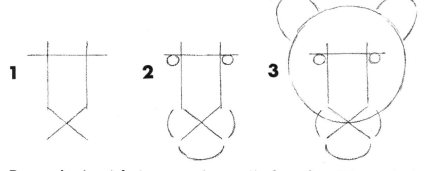

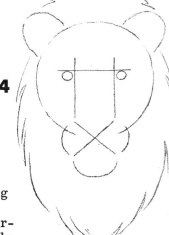

1. Draw a horizontal, two crossing verticals and an X beneath, leaving an enclosure slightly deeper than wide.
2. Then draw two small eye circles below horizontal and outside of verticals. Place parentheses-like markings () on either side of X directly below circles. Add curved chin line.
3. Draw large circle crossing center of X, with circle's center even with bottom of eyes. Add looping ears extending out from circle almost as far as chin line.
4. Sketch mane's outline behind ears and on either side of cheeks. Let hair cup in and converge informally below chin.

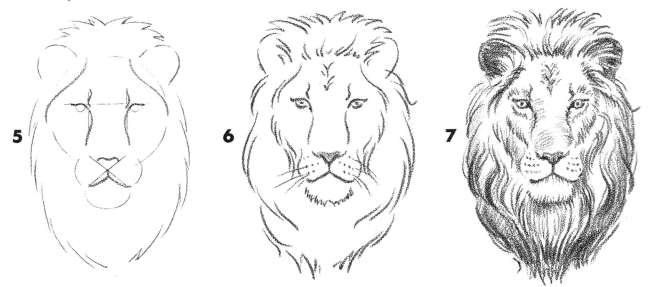

5. Draw eyelid lines coming off of original horizontal line. Let them curve in and cross to inside of verticals. Continue these lines down sides of nose making them swell slightly as they approach the X. Top of nose pad goes above X's center; while mouth line sweeps out below X. Place furrow lines above eyes and indicate loose hair strands in front of ears.
6. Add pupil spots, bottom eyelids, forehead furrows, nostrils, whiskers and additional mane strands about the face.
7. Shade in face and mane over linear outline of fig. 6.

The most intelligent and best looking lion heads have a fairly wide face. Lions are individuals and their countenances can vary just like people's. Lion trainers in circuses would choose lion A over lion B pictured at the right.

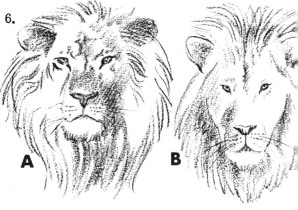

THE LION'S MANE AND HAIR GROWTH

The grandeur and dignity of the male lion may be attributed chiefly to his magnificant mane. This decorative neck and shoulder mantle doesn't develop fully until the animal's third year. Some lions have manes of coarse hair; others have fine, fluffy hair. Lions in captivity usually have fuller manes. Lions in the wilds sometimes have less abundant manes. Perhaps this is due to frequent passage through brambled thickets. Yet, no doubt heredity is a factor. In the same litter, brothers may be differently maned. Light sandy-colored lions may have less mane; darker hued lions more. Some manes are the same color as the body; others nearly all black and others two-toned, the lighter tone by the face. The lion at the left has a multi-toned mane, black toward outer edges. Some manes cover the ears entirely. The pattern of the hair tract is illustrated in fig. 3. A young male or sparsely-maned lion will reveal a 'cowlick' or whorl of hair at the upper shoulder blade (see x). The hair grows out and around this vortex. Long, handsome manes rise and fall over the shoulder however. Examine points A to I in diagram 3. Note rise of hair at forehead A, the sideburns B and the chin fluff C. Hair under the neck between B & D may be very heavy. In some lions only fringes of hair appear at the elbow G and flank H. Some lions are mostly neck-maned and are clean of hair at the shoulder (x), yet behind, from E to G, there may be an outcropping strip of hair.

(Sidenote on fig. 2's paw: in an arm sweep, lion may expand paw twice size by flexing toes. Ulna and radius, forearm bones, are parallel so arm looks wider)

Some lions are devoid of tufts at the flank H (fig. 3), and others have an underlying fringe of hair traveling from under the armpit along the belly sides clear to the flank (observe figs. 1 & 4). For some reason menagerie lions are redder in color; whereas many wild lions are a pale yellow, even a silvery grey. You will express a regal, kingly air in your lion when you draw him with a luxuriant mane.

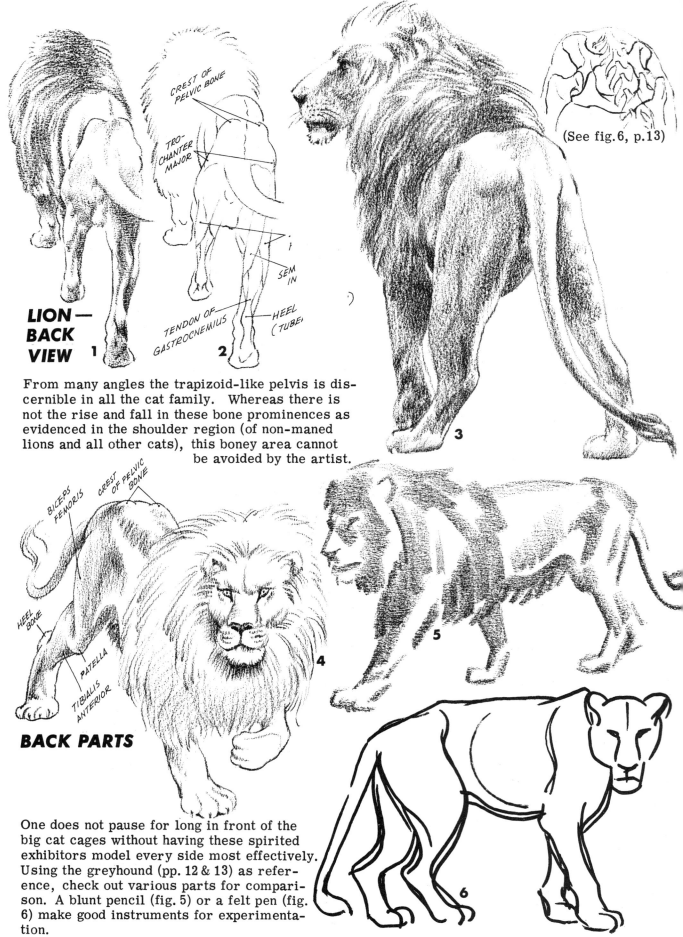

CREST OF PELVIC BONE

TRO-
CHANTER
MAJOR

SEM
IN

TENDON OF
GASTROCNEMIUS

HEEL
(TUBE

**LION —
BACK
VIEW** 1

2

3

(See fig. 6, p.13)

From many angles the trapizoid-like pelvis is discernible in all the cat family. Whereas there is not the rise and fall in these bone prominences as evidenced in the shoulder region (of non-maned lions and all other cats), this boney area cannot be avoided by the artist.

BICEPS FEMORIS

CREST OF PELVIC BONE

HEEL BONE

PATELLA

TIBIALIS ANTERIOR

4

5

BACK PARTS

One does not pause for long in front of the big cat cages without having these spirited exhibitors model every side most effectively. Using the greyhound (pp. 12 & 13) as reference, check out various parts for comparison. A blunt pencil (fig. 5) or a felt pen (fig. 6) make good instruments for experimentation.

6

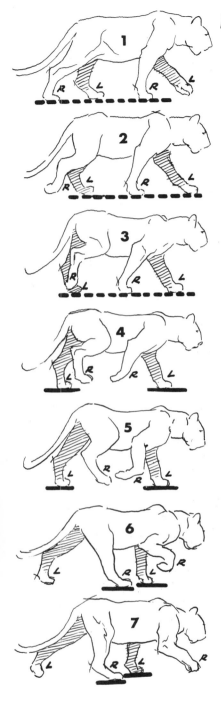

HOW A LION WALKS—SIDE

The members of the cat family progress by the walk, the trot and the gallop (for footfalls which may apply, see pp. 70 & 71). Any of these may be interspersed with the 'leap' depending on distractions and terrain -- at least, it is obvious, the hind limbs often act in unison when cats are in a hurry (fig. 7, p. 19). We hear of animals "pacing," that is, two legs on the same side moving forward together. No animal does this 100% of the time. Take the walk of the lioness as an example. Since fig. 13 is like fig. 1, this means our subject has taken one stride to that point. Several of the phases have been omitted intentionally, particularly when the near front leg is covering up the other front leg; this phase is never wanted by the artist (phase omissions between figs. 5 & 6, 12 & 13).

It will be noted that whenever the animal has three feet on the ground a dotted base is used. Single black lines indicate only two feet on the ground. A salient fact demonstrated here, and one which every artist should know, is this: whenever an animal has two feet off the ground, and they are the ones tucked under the body, the supporting feet are on the _same_ side (see figs. 4 & 5, 11 & 12). Additionally, when an animal has two feet off the ground, and they are the ones farthest forward and backward, the supporting feet are on _opposite_ sides of the body (figs. 6 & 7).

Attention is called to the shoulder blades. The one above the weight-bearing leg pushes up, and the one above the lifted front leg drops. When the weight is equally divided, the shoulder blades are level (see also p. 27).

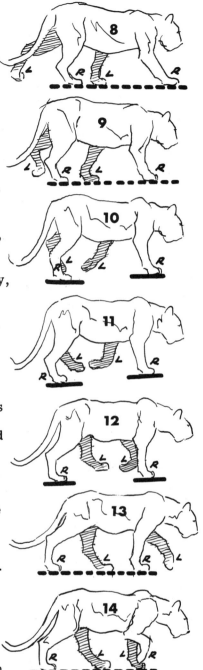

At the right is a walking figure of a lion. Arrows a & b represent the outer reaches of the feet. Arrows c & d show the inner reaches of the feet. The several leg positions suggested can be found in the sequence 1 through 14 on this page. It is rather surprising how far forward the 'upper arm' is thrown -- marked e. See also fig. 5 on the opposite page. All cats seem to walk effortlessly. Doubtless one reason is that they are noiseless in the process. The felines surpass all other animals in gracefulness of movement.

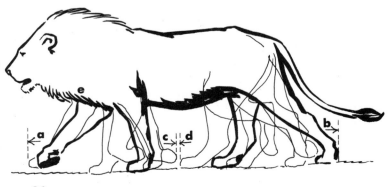

BIG CAT FACIAL FEATURES

1 LION'S EYE OPEN AND CLOSED

2

FLEXING "SNARL MUSCLES"

BONE RIDGES UNDER THIN SKIN

3

MOUTH APPEARS TO RISE AT CENTER

LIPS DON'T SHOW; ONLY SHADOW AT MOUTH LINE

The impressive eye of the lion is tucked away under a stately brow. His very look seems to express little doubt that he is undisputed king of all he surveys. If one manages to be before an actual subject, examine the eye carefully, then notice all the lines which surround it. A lion has several furrow lines radiating into the brow which give him a look of authority. At left are random notes comparing the lion's, tiger's and leopard's eye. There are two approaches to drawing these cat eyes: one is to make a circle then cut off the top with the brow line followed by the corner lines; the other is to draw the brow line and the inside corner line, then fit in the circle. In either event, cats seldom have a lazy-looking lid above the eye such as we draw on some human beings.

EYE DEEPER SET, MORE WATERY LOOKING, LID THICKER

LIGHT AREA MAY BE WIDER

DARK AREA; LIGHT AREA

COLORATION HERE MORE NARROW, SLANTS DOWN, MAY EXTEND FARTHER

4 LION

VIVID CONTRAST HERE, UNIQUE DESIGN BLACK ON WHITE

LIGHT AREA MAY BE THINNER BUT MORE PRONOUNCED

EYE CORNER USUALLY GOES INTO STRIPE

COLORATION HERE WIDER, SLANTS IN MORE

5 TIGER

EYE INSIDE SELDOM COMPLETE CIRCLE; EYES OFTEN SHOW INSIDE AS COMPLETE CIRCLE AS LID LIFTS

COLORATION HERE SHORTER

6 LEOPARD

NARROW LIGHT STRIP

Below are the tiger's and lion's noses side-by-side. The difference in the width of the septum (dotted line) is more pronounced in some cats than others. The contrast in the follicle streaks of the whiskers is to be remembered.

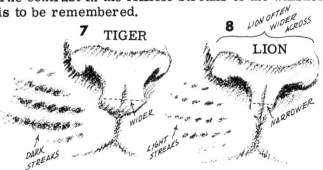

7 TIGER

WIDER

DARK STREAKS

LIGHT STREAKS

8 *LION OFTEN WIDER ACROSS*

LION

NARROWER

At right is a sketch calling attention to the slick black of the lips. In some big cats it is flesh-colored or mottled (see notes under fig. 3, above right).

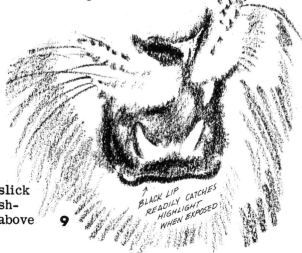

9

BLACK LIP READILY CATCHES HIGHLIGHT WHEN EXPOSED

32

THE LION'S POISE AND GRACEFULNESS

The proud, independent regality of the lioness is something to behold. The big-boned cats, such as this one, extend their front legs when the chest is lowered to the ground. The smaller the cat, the more likely he is to retract the front legs so only the paws show under the chest. The flatness assumed by the stomach and hind parts should be noted. Even big cats when lying down with the side of the head on the ground look surprisingly flat all through the body. This applies to all the dog family too, as well as many other animals.

The springing cat (fig. 2) goes into quite a stretch. The tail, used in balancing, often times looks poker-straight. When these lithe creatures spot a quarry, they can walk though nearly flat on the ground (fig. 3). In this drawing the body is light-lined. Observe the a-b-c of the front shoulder-leg fold. These parts look something like a full rubber hose being squelched. Here the back right leg is flattened, and the back left leg is partially up propelling the body forward.

Fig. 4 is a top view of a lioness with muscles tightened and in the act of a racing charge.

TIGER HEAD — EIGHT EASY STEPS

 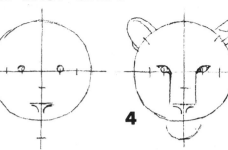 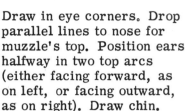

1 Lightly sketch a circle. Divide it as shown.

2 Then mark off each half of the horizontal line in thirds. Do the same with the bottom half of the vertical. Add another 1/3 mark under circle.

3 Spot in the eyes and nostrils.

4 Draw in eye corners. Drop parallel lines to nose for muzzle's top. Position ears halfway in two top arcs (either facing forward, as on left, or facing outward, as on right). Draw chin.

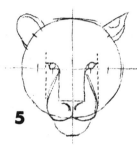 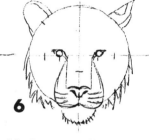

5 Sketch in bulbous muzzle in line with outside of eyes. Extend each half slightly below circle.

6 Add shaggy ruff behind cheeks. Indicate streaks from which whiskers will come. These streaks are darker in tiger than lion.

7 With very light lines decide on pattern for facial stripes. Spot in pupils. Add whiskers.

8 Darken stripes and shade muzzle.

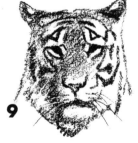

9 Many tiger "personalities" may be built on this scheme as at left and below. This is a straight-on view of a tiger head. If the head is to be tilted downward, then the eyes would be placed below the starting horizontal line (fig. 3) and the nose would likewise be lower. The bottom of the muzzle (or upper lip) would be considerably below circle in fig. 5. Concerning the ears, most mammals can turn them independently if a sound occurs to one side or the other (as drawn 4 through 7), but in a drawing, as a rule, they look better uniformly placed as in the other sketches on these two pages.

FACIAL DESIGN DIFFERENCES

Examine and compare the faces of the tigers 8 & 9, also 10 to 14 at the right. Notice the differences in the facial patterns. First, look at markings above eyes, then on cheeks. Tigers 12, 13 & 14 have shaggier ruffs back of cheeks. Check out the eyes and ears. Notice bits of shading on mouths and noses. There is no doubt that the tiger is one of the most beautifully marked creatures on the face of the earth.

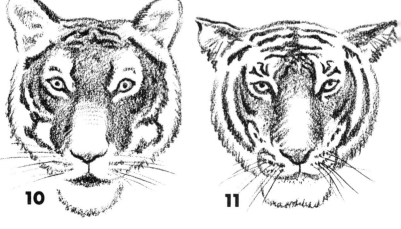

10 **11**

 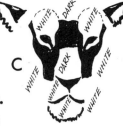 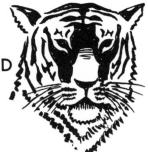

The above is not meant as steps in drawing. If we back up from <u>D</u>, we have isolated in <u>A</u> a portion of the face's ground color which is shaped like a "W." This area (a rusty orange color) usually appears darker. The roof of the nose is that same color, but since it faces up it often catches more light; likewise the top of the head. It's sur<u>prising</u> how many "W's" are discernable in good pictures of tigers. Some are darker than others.

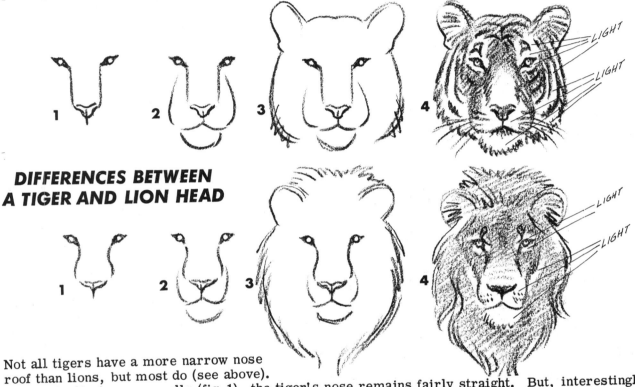

DIFFERENCES BETWEEN A TIGER AND LION HEAD

Not all tigers have a more narrow nose roof than lions, but most do (see above). Where the lion's nose swells (fig. 1), the tiger's nose remains fairly straight. But, interestingly enough, the reverse may be true of the muzzle on either side of the nose: where the tiger's muzzle swells (fig. 2), the lion's is more narrow. The lion's mane makes him look more massive. The collar ruff back of the tiger's cheeks is a rudimentary mane. Many of the tawny-yellow cats have a light crescent beneath the eye beside the dark 'tear drop' which trails onto the nose.

'TEARDROP' LIGHT CRESCENT

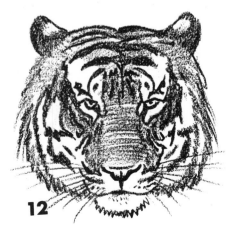 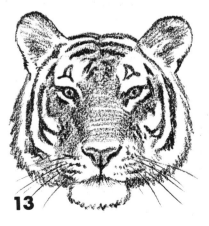 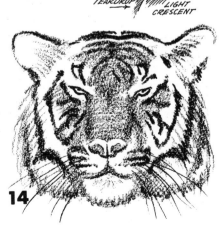

12 13 14

35

THE TIGER'S APPEARANCE

Tigers stand high on the list when it comes to the number of animals with which an artist needs to be familiar. It seems there are more divergences of opinion on the tiger, his size, his strength, his markings than perhaps any other of the big cats. Some authorities have him growing to be 13' long and 700 lbs. heavy. A 10' tiger (counting tail) is a mighty big one. Many naturalists say the heaviest tigers exceed the largest lions in weight. The fact is, even a 500 lb. tiger is a giant.

It may be helpful for the artist to know that tigers in northern regions of Asia (northern China, Siberia, Korea) are larger with thicker fur. Grown tigers in southern regions (Sumatra, Java, Bali) are smaller, around 250 lbs., with shorter coats. Southern tigers in warmer climates are more brilliant in color as a rule. Midway geographically, Indian tigers vary in size; the Bengal can be a

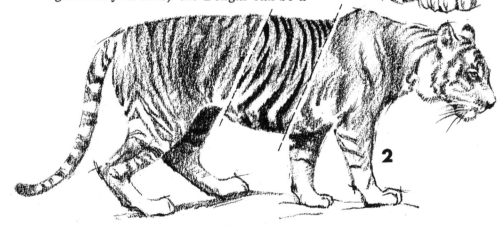

monster. Where the temperature changes, a big cat in winter may have an inch or so longer fur than he'll have in summer. A younger tiger will be richer colored than one in old age who has lost much of his sheen. What was once a sparkling rust-orange in a tiger will, in his later years, appear faded. Also what used to be white will be grayish. It is true, on some of the all around darker southern tigers, that which is normally white may appear buff.

When making a sketch of a tiger, like any other subject, one must decide on the density of stroke, whether the work be in pencil or some other medium. Above in fig. 2 is a tiger with a heavier stripe treatment in the center section. This could have been used throughout. Whether the pencil is lightly or heavily used, the stripes should look like fur rather than metal or stone. Develop underdrawing lightly in either case however.

At right each of the seated tigers has a different kind of stripe. Sometimes it's a mystery to know what to do with stripes on that back leg when it's folded up. At the loop of the knee, tuck the belly stripe in, then stagger the next stripe on the leg. Observe the chest. Some tigers have a stripe down the chest's center (fig. A). Others do not (figs. B & C). Some have dark-striped collars like fig. C. Notice the front legs. They are plain in A, sparingly ringed in B and in C there are a few slashes, confined mostly to the inside of the legs. Also note facial designs.

THE SEATED TIGER

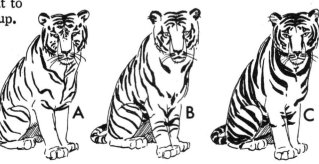

THE PROPER WAY TO STRIPE A TIGER

As simple as one might think placing tiger's stripes would be, some particular observations may be of help. The number, shape and thickness of the stripes vary on individual animals. On most tigers the general direction taken by the stripes on the sides conforms with the slant of the ribs beneath (see figs. 1, 3, 4 & 5). Yet a loose-skinned, heavily-furred type may have lanky flanks and belly sag which tend to stretch out these curves (see fig. 2) -- this does incline toward a 'flat' look, especially from a straight side view.

Fig. 1 has a thick "boomerang" stripe angling under the stomach. On the spine are split stripes tapering off between the side markings. No animal ever has continuous stripes going around the body. They are always broken somewhere; a few may be mere dashes. The thick side stripes of fig. 3 are like a bow (of a bow and arrow). Both 1 & 2 have the lower shoulders more or less devoid of stripes. If there is a plain area, that's where it will be, and many big tigers have it. Some huge tigers have little more than pin stripes (fig. 5). Fig. 4's widest stripes are a little like twisted teardrops.

Some few tigers have altogether plain front legs such as 4 & 5. Most have elongated dashes of black on the inside or outside however. There are always partial rings on the back legs. In order for the vertical hip stripes to "get into" the flow of these rings, there has to be a change of direction on the thigh. Sometimes this is accomplished by a triangle (fig. 1 or 3); other times by several flimsy triangles (fig. 2). The change at this thigh juncture may be jagged (fig. 4) or crooked like lightning in the case of a thinly striped cat (fig. 5). Tiger tails may be irregularly ringed with the heavier rings often coming at the end. Notice the neck stripes and ear backs. The stripes on one side of the body will never be repeated exactly on the other side. No two tigers have the same design.

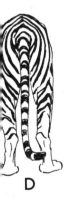

BACK AND TOP

There are times when one has to draw a tiger partially or altogether from the rear (see fig. D). The stripes 'oval' informally around the tail's root and slant in toward the inside top of the legs. These rings continue down the tail. Each leg will be marked differently. If the view is somewhat from above, the spine line will tend to show. There is a perceptive demarcation there. See three ways of treating this in figs. E, F & G. Fig. E has the dorsal line as if there were a fold in the paper. In F it appears like there was a 'pull' frontwards of the skin itself on this ridge. In G there is a spasmodic alteration in the stripes down this center line. Observe closely the stripes on the neck as they relate to those on the forehead.

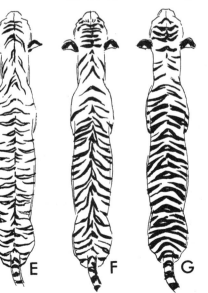

37

THE TIGER FACE

There are always crossways branch markings on crown. They may break or go completely across. Usually they join an up-and-down stem in center.

Directly above and between eyes the fur has short, dark markings tilted up toward center.

Top of long nose is plainest part of face.

Pinkish nose-pad usually has dark rim outline on top, but not always.

Slight swell in septum of nose is wider than that of lion.

Backside of ear is black except for white "flash" which may vary in size. When open ear faces forward, black edging may show.

There is always rather large "sunspot" of white above eye upon which scores of little designs may occur. These are somewhat of a trademark for individual tiger.

Outside corner of eye usually trails into a stripe marking.

Below eye there is always a curved margin of white under which a dark coloration always appears.

Inside corner of eye always slants downward merging into darker fur which blends into muzzle.

Cheek markings may vary greatly in pattern according to individual tiger.

White upper lip has whisker roots set in four noticeably dark streaks nearly parallel (lion has lighter or no streaks).

White ruff on neck is more likely to appear on northern varieties of tigers in colder climates or on old males. It corresponds to mane on lion.

1

LEOPARD COMPARED

Not as much shag on face as tiger. No ruff behind cheeks.

Greenish eyes.

May have very dark whisker streaks.

Mouth angles downward from center more sharply than in tiger or lion.

Velvet feel to jowls and chin. Fur a powder-puff texture.

Yellow coat, white under parts, black spots.

Spots come clear to toes.

Though there are fewer size and shape differences in leopards than in tigers, those which are found in high, dry areas are bigger than those which inhabit low, damp places. The former are paler in color than the latter which are darker overall with larger spots. Most leopards have more total yellow than black. Some few of them are born entirely black.

2

1A

1B

THE TIGER
IN ACTION

In the sketch of a big cat going into a spring, remember the principle of perspective. The forward part of the tiger's body is larger than the rest proportionately. Circle upon circle is smaller as we travel through the figure from front to back. Notice the wrists of the forearms and the unsheathed claws. Check out the facial contortion with the factors on p. 40.

THE LEOPARD
SITTING
UPRIGHT

The haunches of any animal sitting upright appear smaller than one might imagine. Actually, they're but a 1/4 distance from head-top to floor.

2A

2B

In the graceful leopard at the right observe the three body sections first mentioned on pages 2 & 3 of this book.

3

39

THE SNARL, GROWL AND ROAR

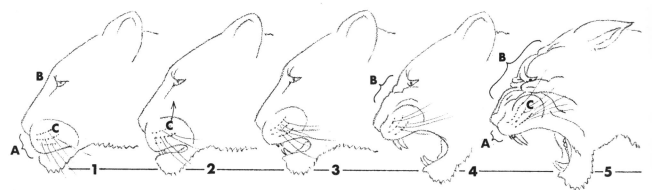

Often an artist is called upon to draw the big cats in a ferocious mood. The five roaring cats are: lion, tiger, leopard, jajuar and snow leopard (according to anatomical classification -- though no one has heard the snow leopard roar). Even though other cats don't roar, they express themselves with a variety of chilling sounds. THE MUSCLE REACTION ABOVE APPLIES TO ANY CAT (even your pet tabby), but we'll use the lioness since her face is plain, not botched with spots and relatively free from long hair. Actually, her maned husband is a lot noisier. The contorted face of an animal doesn't mean it is sounding off at all, but usually it becomes vocal when really disturbed.

1 The first part to react is "C", the muzzle, which is pulled toward the eye as indicated in fig. 2. Notice how much more narrow "A" is in fig. 5 than in fig. 1. This contraction permits teeth to show.

2 The line above "C" denotes a section in our sequence. Actually, there is no line in evidence here until fig. 4. The lips are often ajar in a big cat, and this black rim prompts a shadow through the facial fur. A good point to remember. One doesn't need to draw lips in the profile, just shadow.

3 Muzzle is still rising prior to affecting skin above it. Bottom teeth show first.

4 Mouth opens wider, but this isn't what casues contortion on upper face. Most of this can occur with mouth closed. Muzzle pushes skin into noticeable folds, and formerly smooth nose bridge "B" starts to wrinkle.

5 "A" narrows to the limit. "C" rises to its limit. The follicle rows on "C" are twisted toward eye -- this causes whiskers to point up and out. Longitudinal furrows may show on nose. Crossway furrows show in front of and below eye. Brow tightens. All of "B" is subject to change. Lines behind "C" appear, but "C" itself is not wrinkled. Ears probably lay back with this intense expression.

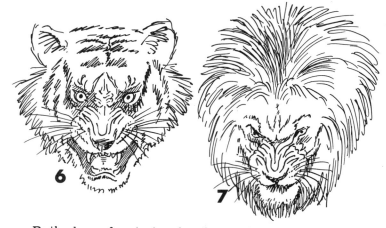

Sketch at right is full one-sided snarl front view. Mouth doesn't have to be lifted that much; a snarl can be barely perceptable. Here nose tilts but wrinkles are only in general eye area. High muzzle points whiskers upward. Observe straight across set of bottom lip. Normally nose's center crease would be perpendicular to bottom lip, but snarl pulls it to one side.

Both above front view heads are foreshortened a little so we can look down on nose. Notice pullback and spread of muzzle in tiger (6) and lion (7). The oblique wrinkles slant in and down from eyes into "U" wrinkle on top of nose. The action here is symmetrical, though it doesn't have to be (See fig. 8). No doubt the lion (7) is displeased, even though his mouth is closed.

40

9

Expression of leopard at left is not intense. He is simply 'serving notice.' Base rows of whiskers are lifted some nevertheless. Seldom are there more than a dozen whisker strands to show. On a small drawing a half dozen may be enough. Here eyes are not 'flashing' since pupils are not fully exposed. Nose is moderately wrinkled.

INSIDE THE BIG CATS' MOUTHS

UPPER CANINE TEETH
SPACE
6 UPPER INCISOR TEETH
LOWER CANINE TEETH
6 LOWER INCISOR TEETH
NO SPACE

11

Young lion at right has longer upper incisor teeth. Most incisors in cats are shorter. The canine teeth are always long. Lower canine teeth are closer together and fit between (and in front of) upper canines when mouth is closed. Notice tongues and dark lip rims in these four drawings.

10

Lion above has transverse wrinkles at top of nose. Cat's faces are more flexible than any other carnivore's. Lion at right is yawning. The muzzle is relaxed. Base rows of whiskers are slanted down, not up. Nose is smooth. Upper canine teeth barely show. Lower lip is not taut.

12

(See note top opposite page)

1. The Jaguar's head is slightly larger than leopard of same size. Body's unique rosettes not to be found on face. Facial spotting similar to leopard's.

2. Cheetah's head more rounded and small in proportion to body. Unusual cheek stripe falls from inside eye to mouth. Spots dribble from outside eye.

3. Clouded Leopard's head is more elongated. Has pronounced jagged stripes on side of face. Few spots on forehead. Has longest fangs of any cat in proportion to size.

4. Ocelot's cheek markings more parallel. May have two vertical streaks coming down forehead. Few random spots by stripes.

5. Leopard's face heavily spotted. Markings more evenly spaced than in other cats. Hexagonal-shaped rosettes usually take up immediately behind head. May have necklaces of spots on throat.

6. Margay is small relative of Ocelot. Rarely are they same size. Head is rounder. Markings are more sharply defined than in most cats. Spots are not linked as much as on Ocelots.

7. Snow Leopard or Ounce has rather short muzzle compared with entire head. Face is furrier and usually more sparsely spotted than Leopard's. Ears are black-trimmed with white spot behind. Animal has light ruff around cheeks and throat.

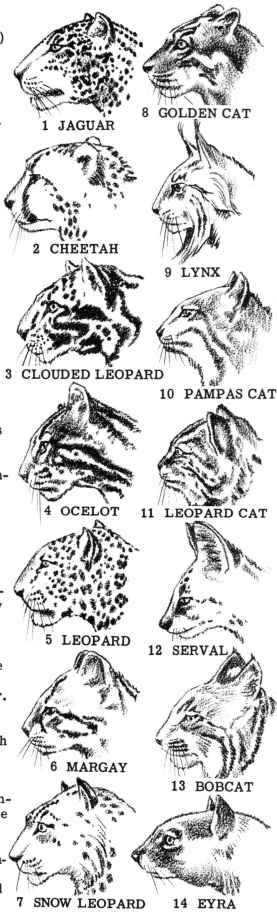

1 JAGUAR
8 GOLDEN CAT
2 CHEETAH
9 LYNX
3 CLOUDED LEOPARD
10 PAMPAS CAT
4 OCELOT
11 LEOPARD CAT
5 LEOPARD
12 SERVAL
6 MARGAY
13 BOBCAT
7 SNOW LEOPARD
14 EYRA

8. Golden Cat's head is comparatively small. Has an elaborately patterned face in contrast with rather plain body coat. This is only cat so different in head and body. Large eyes are surrounded by white, black and gray stripes. Body is golden color.

9. Lynx has exceptionally wide face ruffs with tips almost meeting below chin. When animal hisses, ruffs fan still more. Ears are tipped with long tufts. Cheek ruffs usually have dark bar markings.

10. Pampas Cat's close-cropped head looks small on shaggy body. Faint reddish-brown stripes laid over silvery-gray face give features delicate appearance. Back of ears are darker brown.

11. Different Leopard Cats have great variation in coat markings. Their spots are quite elongated. On their forehead four definite longitudinal stripes often appear. They have petite muzzles and small chins.

12. Serval's head is very small at end of long, thin neck. Muzzle tapers to thick nose pad. Ears stand up close together and are outlandishly big. Face is not as spotted as rest of body.

13. Bobcat head is similar to Lynx except ear tufts are shorter. Has flared ruff on jowls, but not as pronounced as Lynx. Whiskers extend from black follicle stripes.

14. Eyra, sometimes called Otter Cat or Jaguarundi. Least cat-like of all true cats. Looks somewhat like an over-sized weasel. Eye is circular and not capable of contracting to slits like most small members of the cat family.

A COMPARISON OF CAT HEADS

(The cats' heads on the opposite page are not drawn to scale. They have been reduced or enlarged so that characteristics and markings might be better compared. For example; the head of the Jaguar is larger and the head of the Serval is smaller than each appears here. One factor which the artist should take into consideration is that the average cat in direct profile is more likely to have a forehead contour like this: with the 'hump' coming above and in front of the eye. If, however, that same cat turns his head ever so slightly -- yet, still to be regarded as profile -- then the far brow may influence the nose bridge like this: Check figures 1. Jaguar and 7. Snow Leopard. All cats of a particular species do not have precisely the same shaped head any more than humans, yet there are general characteristics and markings which may be found. It is this which we are after. Among these points of interest, one thing in particular the student might notice on these heads is the shading or coloration which comes out of the inside corner of the eye onto the face; also, the fact that some kind of marking often is attached to the outside corner.)

LION AND TIGER PROFILES

For all intents and purposes, the artist may draw his tiger and lion head on the same outline (see lioness and tiger below). The lion may have a little more chin whisker than the tiger. The big male lion's brow and nose roof may be exactly the same as his mate, except at times it is a little 'lumpier' (see example at right). His features may be drawn bolder and coarser.

FORESHORTENED HEAD

Think of the cat head in two sections: A & B ⟶
Always sketch A first, then follow with B. Indicate center division of forehead, and always show center crease connecting nose and mouth. Figs. 4 & 5, the lioness and 6 & 7, the leopard.

EYE CORNER SLIDES INTO NOSE HERE

CENTER LINE

NOSE ROOF NOSE PAD

MUZZLE SWELLS HERE

MOUTH FALLS OUT FROM CENTER CREASE

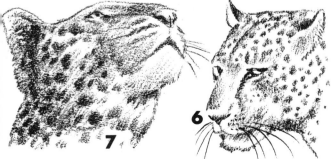

CAT BODY SHAPES AND MARKINGS

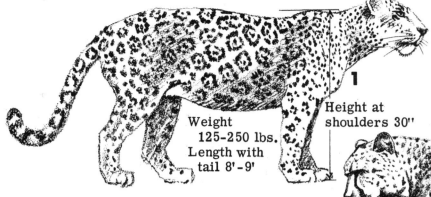

1. Jaguar is largest American cat. Stockily built, short legs, heavy chest. Large rosette markings with one or several interior spots. Some animals have more tightly arranged rosettes. Skin adheres rather closely compared to tigers and lions. Black spots overlaid on yellowish white or rich tan.

Weight 125-250 lbs. Length with tail 8'-9'

Height at shoulders 30"

2. Cheetah is fastest animal on four legs (to 70 mph). Extremely long limbs, gangly body. Rather small head. Blunt claws partly retractile, more like dog's. Sometimes single black spots are more openly spaced than this drawing. Tail banded toward end. Sandy color behind spots.

Wt. 100 lbs.
L. 7'
H. 30"

Wt. 40-50 lbs. L. 6 1/2' H. 21"

3. Clouded Leopard. Huge irregular cloud patches blended toward edges. Designs outlined in dark gray and olive brown. Body background color grayish to yellow with white below. Thickly furred tail is irregularly ringed and unusually long.

4. Ocelot. Slender, well-proportioned body about twice size of house cat. Highly ornamental coats. Tandem markings often like chains. Smoky pearl to grayish yellow with black overlaid. Like many of the cats, nose is pink, upper cheeks, chin and undersides nearly white.

Wt. 25-35 lbs.
L. 3'
H. 16-18"

5. Leopard. Exceedingly fast in movements; perhaps more so than any mammal. Immensely strong. Most treacherous of all predatory creatures. Thickly dotted with black spots. Some markings larger on some leopards. Spots may vary from solids to rosettes (no centers like jaguar). Basal color is tawny yellow above and whitish below. One of litter many come out black all over (sometimes called 'black panther'), yet in certain reflective light spots can still be seen.

Wt. 160-190 lbs.
L. 5'-8'
H. 20"-28"

6. The Margay has slender body, extra long tail. Body spots no certain shape. Vertical marks on shoulder. Neck and back have dark brownish stripes. Coat may be bright cream yellow or reddish to grayish color.

7. Snow Leopard. Most gentle of large cats. Long soft fur. Rather large diffused rosette-shaped spots; central area may be somewhat darker than outside ground color. Pale whitish gray body tinged with yellow. White underparts. Drags heavily furred tail behind.

9. Lynx. Small head. Compact body. Long legs. Large feet. Short stubby tail always black on end. Color smoky gray mixed with cream. Faint mottling marks on body. Ear tufts may be 2" long.

t. 20-25 lbs.
. 3'
. 17"
→

6

Wt. 15-35 lbs.
↓

Wt. 40-50 lbs.
L. 7'
H. 24"
→

7

9
L. 2-3 1/2'
H. 20-24"

Golden Cat. ot especially erce, but none of ts on these pages n be really 'tamed.' as striking combina- on of facial design ith unmarked body. olor smooth gold- n brown with white nderparts. There a gray variety f same cat.

rt. 45 lbs
. 4'
. 21"

8

10. Pampas Cat. About size of house cat. Small head. Thick tail. Furry legs with pronounced brown bar markings. Silver gray color. Faint reddish brown stripes in coat.

10

Wt. 5-10 lbs.
L. 2'
H. 10"

11. Leopard Cat. Size of domestic cat. Spotted body. Ringed tail. Pale tawny color to white beneath.

12. Serval. Medium-sized cat. Frame rather long and gaunt. Short tail. Yellowish gray. Black spots.

11

12

. Bobcat. Slightly smaller an Lynx. Fur fairly long d thick. Short ringed il with white tip. he coat is

14. Eyra. Built long and low. Often grows twice size of house cat. Has way of arching back in slink-like movement. Coat is devoid of markings. May be brownish red or solid gray. Has white throat. Consult cat head notes on p. 42.

reddish brown growing lighter toward underparts. Sometimes dark streaks and spots intermingle coat. Sure way to tell Bobcat from Lynx is to compare the tails.

13

14

BUILDING ON SIMPLE UNDERDRAWING

Whenever the student looks at an animal, he should think in terms of some kind of foundational lines. On this page are rounded beginnings. On the opposite page are angular beginnings. The foundational lines which seem to best run through the figure should be experimentally tried in practice. Bears can assume funnier positions than perhaps any other animal. Here's one of them.

1. From the circle, oval and arcs we proceed to --

2. A smaller oval set in front of the head for the bear's muzzle, then ovals for the feet and a horse-shoe shape for the chest and interior arms.

3. Here more definition is added, but it is still kept simple. We have felt out divisional shapes in the limbs, and have suggested facial features.

4. Next, values are added to show dimension. Light has been conceived as coming from overhead right; hence, shadows are to the left. It never hurts to outline a shadow in practice.

5. Now that we are certain of our preliminary work, it is safe to strengthen our sketch with darker lines. A diagonal overlay has been used throughout -- this is recommended as one good method for practice sketching.

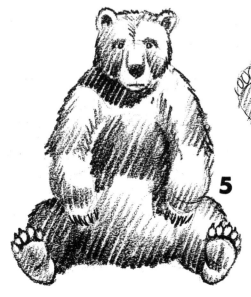

46

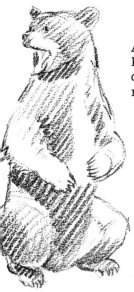

THE BEAR'S BODY SIMPLIFIED

At left are various sketches of a black bear. Each of these was built up with light under-drawing. Consider the ABC sequence in the right column.

A. Three trapizoid shapes, the center one slightly larger than the outer ones, make a good side view beginning for a bear. Standing on all fours, this powerful beast always looks impossible to upset -- and few there are who would try.

B. The heavy neck seems to run through the head onto the squared-off snout. The top of the circle forms the brow, the bottom the jaw. Lower than halfway indicate the midsection and add the front part of the feet.

C. Round out the harsh angles, but retain the pillar-like strength through the limbs.
 The ears come off the back of the circle. The eye is just be-low the neck and nose line.

D. Though a bear's fur coat is quite thick, don't lose the feeling of the rock-like form beneath. Hair tufts under the chin and behind the legs help break up the straight lines.

E. The muzzle of the black bear is much lighter than the rest of the face. His hip region is pronounced. His shoulders are evi-dent, but never humped. The fur is coarse. The far legs may be dark-ened as in shadow.

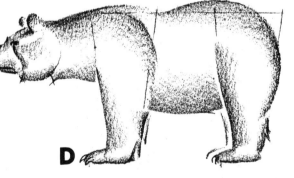

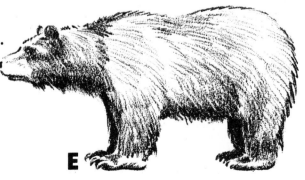

THE MAJOR BEARS SIDE-BY-SIDE

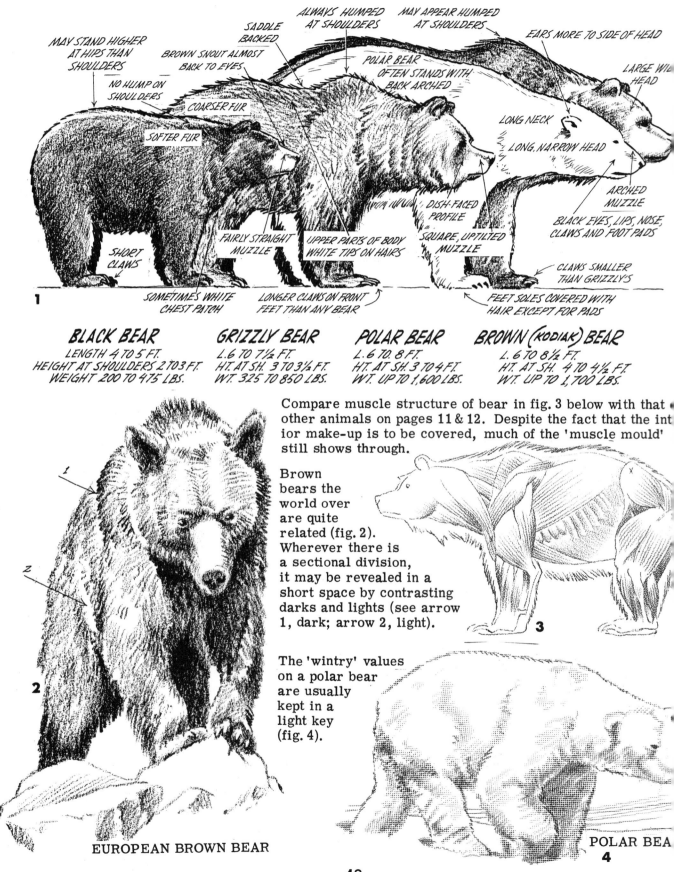

MAY STAND HIGHER AT HIPS THAN SHOULDERS

NO HUMP ON SHOULDERS

BROWN SNOUT ALMOST BACK TO EYES

COARSER FUR

SOFTER FUR

SADDLE BACKED

ALWAYS HUMPED AT SHOULDERS

MAY APPEAR HUMPED AT SHOULDERS

POLAR BEAR OFTEN STANDS WITH BACK ARCHED

EARS MORE TO SIDE OF HEAD

LARGE WIDE HEAD

LONG NECK

LONG, NARROW HEAD

ARCHED MUZZLE

BLACK EYES, LIPS, NOSE, CLAWS AND FOOT PADS

DISH-FACED PROFILE

SQUARE, UPTILTED MUZZLE

CLAWS SMALLER THAN GRIZZLY'S

SHORT CLAWS

FAIRLY STRAIGHT MUZZLE

UPPER PARTS OF BODY WHITE TIPS ON HAIRS

SOMETIMES WHITE CHEST PATCH

LONGER CLAWS ON FRONT FEET THAN ANY BEAR

FEET SOLES COVERED WITH HAIR EXCEPT FOR PADS

BLACK BEAR
LENGTH 4 TO 5 FT.
HEIGHT AT SHOULDERS 2 TO 3 FT.
WEIGHT 200 TO 475 LBS.

GRIZZLY BEAR
L. 6 TO 7½ FT.
HT. AT SH. 3 TO 3½ FT.
WT. 325 TO 850 LBS.

POLAR BEAR
L. 6 TO 8 FT.
HT. AT SH. 3 TO 4 FT.
WT. UP TO 1,600 LBS.

BROWN (KODIAK) BEAR
L. 6 TO 8½ FT.
HT. AT SH. 4 TO 4½ FT.
WT. UP TO 1,700 LBS.

Compare muscle structure of bear in fig. 3 below with that of other animals on pages 11 & 12. Despite the fact that the interior make-up is to be covered, much of the 'muscle mould' still shows through.

Brown bears the world over are quite related (fig. 2). Wherever there is a sectional division, it may be revealed in a short space by contrasting darks and lights (see arrow 1, dark; arrow 2, light).

The 'wintry' values on a polar bear are usually kept in a light key (fig. 4).

EUROPEAN BROWN BEAR

POLAR BEAR

BEAR HEADS—IN SEVERAL EASY STEPS

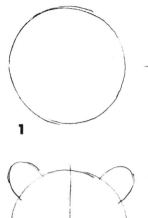

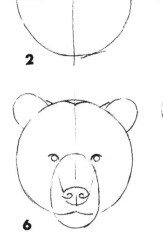

BLACK BEAR

1 **2** **3** **4**

5 **6** **7** **8**

A₁ **B₁**

GRIZZLY BEAR

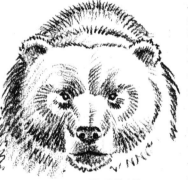

A₂ **B₂**

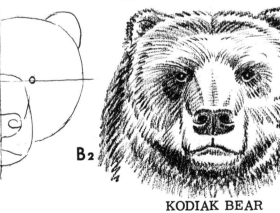

KODIAK BEAR

Above is a sketch of a black bear in eight steps. The distance between the eyes in fig. 3 is the same as the distance on the outside of the eyes (1/3 the head's width). This pretty well holds true in all the bears. Observe that in all these heads the oval shape for the muzzle starts at a little above center and goes below the overall head shape. The head shapes for the grizzly and kodiak bear are broader; that for the polar and malayan bear is more heart-shaped. Notice that the nose lines inside the muzzle start in the vicinity of the eye and slant inward toward the nostrils. The hair tracts shoot away from the forehead's center and revolve around the eyes. The kodiak has something of a 'hog-like' nose coming off a broader muzzle. The polar bear has the thinnest muzzle, and his ears set lower on the sides of his head. Attention is called to principles of the eye and nose brought out on pages 16 & 17. Concerning the mouths of these bears see how the lip lines fall away from center. Remember to keep under-drawing light and subject to change.

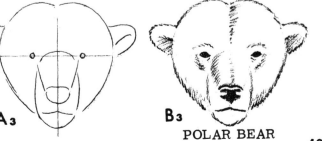

A₃ **B₃**

POLAR BEAR

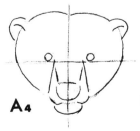

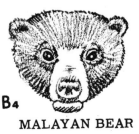

A₄ **B₄**

MALAYAN BEAR

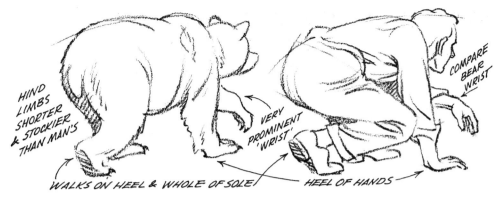

HIND LIMBS SHORTER & STOCKIER THAN MAN'S

VERY PROMINENT 'WRIST'

COMPARE BEAR WRIST

WALKS ON HEEL & WHOLE OF SOLE

HEEL OF HANDS

BEAR AND MAN COMPARED

It is interesting to compare the bear with man. Inasmuch as the bear is a plantigrade animal (see p. 15), some benefits derive from it.

The notations about these sketches point out similarities as well as differences. Keep in mind that the shoulder blades of the man are on his back; whereas the shoulder blades of all quadrupeds are on the sides of their shoulders. Hence, from the front the man would be broader through the shoulders. Yet, the bear's muscle attachments resulting from this arrangement give great striking power.

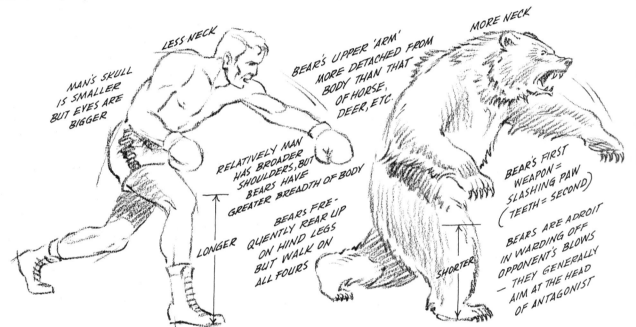

MAN'S SKULL IS SMALLER BUT EYES ARE BIGGER

LESS NECK

BEAR'S UPPER 'ARM' MORE DETACHED FROM BODY THAN THAT OF HORSE, DEER, ETC.

MORE NECK

RELATIVELY MAN HAS BROADER SHOULDERS, BUT BEARS HAVE GREATER BREADTH OF BODY

BEARS FREQUENTLY REAR UP ON HIND LEGS BUT WALK ON ALL FOURS

LONGER

SHORTER

BEAR'S FIRST WEAPON = SLASHING PAW (TEETH = SECOND)

BEARS ARE ADROIT IN WARDING OFF OPPONENT'S BLOWS — THEY GENERALLY AIM AT THE HEAD OF ANTAGONIST

Next to the great apes, the bear can get into more man-like positions than any other animal. Normally his movements are slower and more lumbering than man except at a time when the element of surprise enters in. A large bear will possess the strength of ten men.

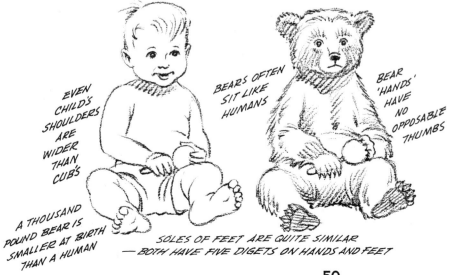

EVEN CHILD'S SHOULDERS ARE WIDER THAN CUB'S

BEARS OFTEN SIT LIKE HUMANS

BEAR 'HANDS' HAVE NO OPPOSABLE THUMBS

A THOUSAND POUND BEAR IS SMALLER AT BIRTH THAN A HUMAN

SOLES OF FEET ARE QUITE SIMILAR — BOTH HAVE FIVE DIGETS ON HANDS AND FEET

At the zoo watch the bears roll and tumble, especially at play. Usually they are quite cooperative in turning many poses for the artist's study. In the wilds the mother bear cavorts with her cubs in a delightful way. In our national parks it is wise to keep distance between oneself and Mrs. Bear if she has cubs anywhere nearby.

BEAR CHARACTERISTICS SIMPLIFIED

After deciding upon the central bulk of the bear's body (a modified oval shape), draw the neck & head, legs & feet. These forms are essentially quite plain and simple. Keep in mind the bear is a thick and burly creature. Of all large, land animals the bear can be the "roundest," especially when in full coat. Interesting nicks and subtle angles in the contour can furnish needed relief and add strength to this roundness. Check out the notations listed below:

1 BLACK BEAR

2 BLACK BEAR

3 BROWN BEAR

4 POLAR BEAR

5 GRIZZLY BEAR

General characteristics:
1. Distance from belly-line to ground is short.
2. Leg lines taper coming down to feet (not so much in polar bear).
3. In rear view tail is only few inches long, fig. 2.
4. On any of these bears, hair clusters often occur and may appear at following points: A. At elbows, 2a, 5a; B. Above and behind heel of front foot, 1b, 3b, 5b; C. Above and in front of back foot, 3c, 5c; D. At throat or base of neck, 4d.
5. A shadow line often reaches from shoulder blade to elbow, 1e, 2e, 3e, 4e, 5e.
6. A shadow or 'valley' line may appear in thick fur between midsection and hindquarters, 1f, 2f, 3f, 4f, 5f.
7. A slight flattening may occur above thigh in semi-front view, 3g, 4g, 5g.

Individual characteristics:
1. More pointed snout on black bear; blockier snout on brown and grizzly; arched snout on polar bear.
2. Longer neck on polar bear.
3. Hump at shoulders on brown and grizzly bears.
4. A little more overall height at shoulders in brown and grizzly bears; a little more height over rear quarters in black and polar bears.
5. Wider feet in polar bear.

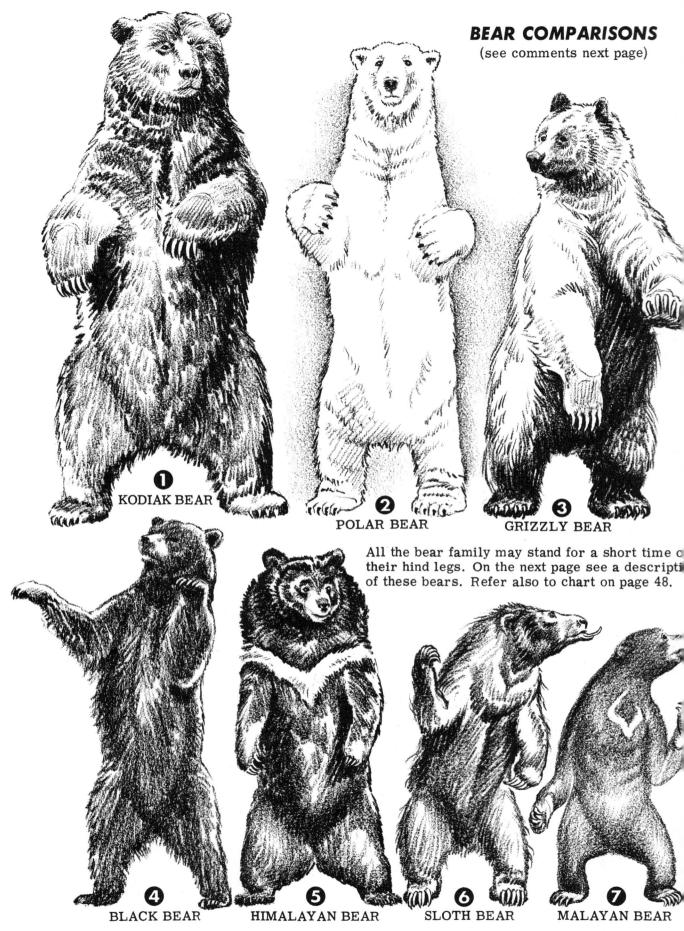

BEAR COMPARISONS
(see comments next page)

1 KODIAK BEAR

2 POLAR BEAR

3 GRIZZLY BEAR

All the bear family may stand for a short time o
their hind legs. On the next page see a descripti
of these bears. Refer also to chart on page 48.

4 BLACK BEAR

5 HIMALAYAN BEAR

6 SLOTH BEAR

7 MALAYAN BEAR

BEAR FACTS FOR THE ARTIST

Bears are extremely variable. Within a single species or even within the members of the same family, there may be differences in skull formation and facial characteristics. Experience shows that when a big brown (or Kodiak) bear and a grizzly of the same size are walking side-by-side, it is often difficult to tell them apart. A brown does grow bigger, and at close range the several variations noted on p. 48 will show up. The polar bear's looks are unmistakable, however, but he may rival the big brown in weight and size. The following notations corresponding to the numbers across the page may help:

1 KODIAK (or big brown) — may stand over 9' tall; has huge keg-like head; is largest, living, land carnivore; has less color variation than grizzly or black bear, but still may be tan, cinnamon, blue or jet black.

2 POLAR (or ice bear) — surprisingly tall when standing; shoulders appear low-set under long neck; body quite narrow from front; a better swimmer (though all bears swim); has large "snow-shoe" feet; has keener vision than other bears; white (more often yellowish white) fur is well oiled to shed water; he kills by biting, not with a slashing forefoot.

3 GRIZZLY — perhaps most ferocious; face usually has definite 'scooped-out' look; fur may be in ringed waves around parts of neck and body; shoulder hump sometimes partially maned; colored various shades of brown: yellowish, grayish, blackish with grizzled or silver tipped hairs.

4 BLACK bear — may be deceptively friendly; coat hair generally more even in length than above-mentioned bears; behind his tan-colored nose he may be black, brown, cinnamon, blue, yellow, white, rust or even silver (cubs may vary in same litter).

5 HIMALAYAN (Tibetan or moon bear) — has flared ruffs of long, coarse, black hair about neck with whitish crescent across chest; upper lip may be white; rather large ears; has small, black claws.

6 SLOTH (or 'honey bear') — has long, nearly naked snout and highly extendable bottom lip; long, coarse, black hair is most unkempt in appearance; muzzle is yellowish; has whitish blaze on chest; big feet have enormous white claws.

7 MAYLAYAN (sun bear or 'bruang') — small, bandy-legged bear; very short, sleek, black hair with odd yellowish mark on chest; light gray-tan colored muzzle; small ears.

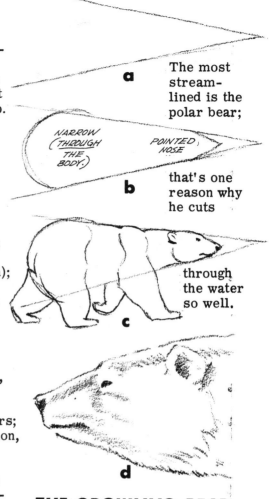

a The most streamlined is the polar bear;

NARROW (THROUGH THE BODY.) POINTED NOSE

b that's one reason why he cuts

c through the water so well.

d

THE GROWLING BEAR

Like a dog, an angry bear's nose tip will rise and pull back (more so than any member of the cat family). An angry cat's cheek will contort below eye (moreso than dog or bear) -- see figs. B, C & D below; page 40 for big cat anger.

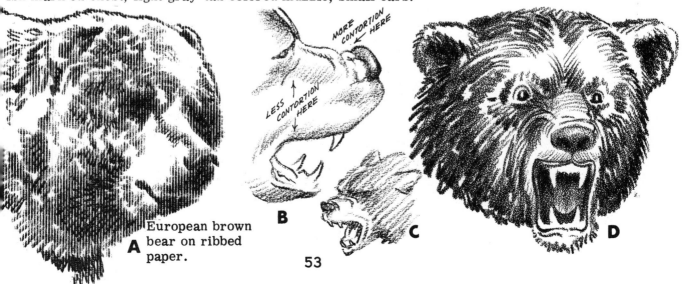

A European brown bear on ribbed paper.

MORE CONTORTION HERE

LESS CONTORTION HERE

B

C

D

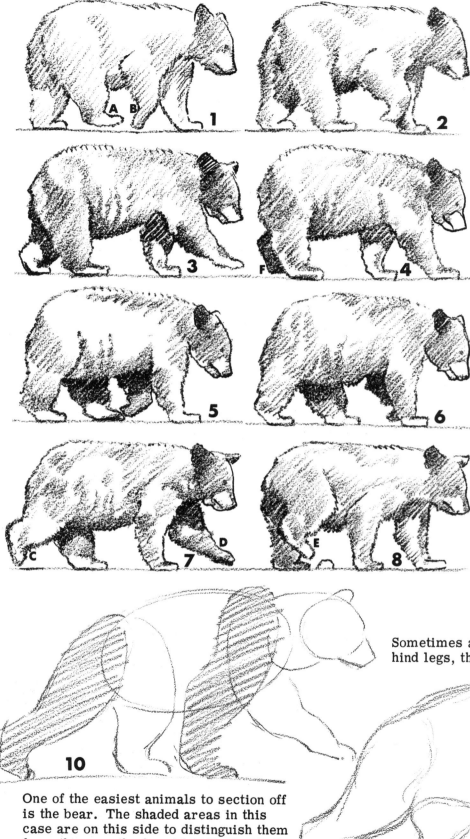

HOW A BEAR WALKS

This black bear at the left is walking rather slowly, which is the normal gait of contented bears — it's kind of a waddling shuffle. In the process three feet are usually on the ground. However, as in most other animals, when the two inmost feet are off the ground (A & B of fig. 1), the two supporting feet are always on the same side of the body; if the frontmost and backmost feet are off the ground (C & D of fig. 7), the two supporting feet are always on opposite sides of the body. If the bear leads off with his right front foot (fig. 2), brings it forward (fig. 3), sets it down (fig. 4); then the opposite back foot (fig. 4) is lifted, brought forward and placed down (fig. 5). In the meantime, the left front foot (fig. 5) begins the same follow-through. Sometimes an obstruction will cause a foot to be lifted higher, E of fig. 8, than F of fig. 4.

Sometimes a bear will rise partially on his hind legs, then settle back on all fours (fig. 9).

One of the easiest animals to section off is the bear. The shaded areas in this case are on this side to distinguish them from those on the far side. Start with the simple oval. It helps to divide your drawings in this manner.

54

THE HORSE, A CREATURE OF BEAUTY

Few men have looked into the large soulful eyes of a horse without wondering what this stately animal was thinking about. Though, in his labors, man has put the horse to use more than any other creature, he still remains worlds apart from the horse's 'mental' functionings. The mystery seems compounded by the head's massive size and its steel-like armor plate. These unusual physical characteristics contain perhaps more beautiful lines than any other living animal.

A horse's head is often the first to be attempted by the amateur artist. What are the basics? The following pages simplify the problem.

TAKING HORSE-HEAD POINTS ONE-BY-ONE

As a rule the first line to be set down in drawing a horse's head is that running off the forehead (1). Nearly always this line is slanted at 45° provided the horse is standing normally. Having drawn line 1, draw line 2. The heavier the horse (draft variety), the more parallel and farther apart lines 1 and 2 will be. Line 3 may be less than 1/2 of line 4 in a light riding horse or more than 1/2 of line 4 in a heavy draft horse. (Sketch lightly)

Next, sketch a little triangle in front of the above line 3. Line 6 of that triangle extends to join line 7 to make the chin. Notice that, as underdrawing, short line 7 may be parallel with line 5. About midway along the remainder of the original line 2, draw arc 8. This is to be the bottom of the prominent cheek bone of the lower jaw. This curve drops below straight line 2 about as far as does the little chin triangle.

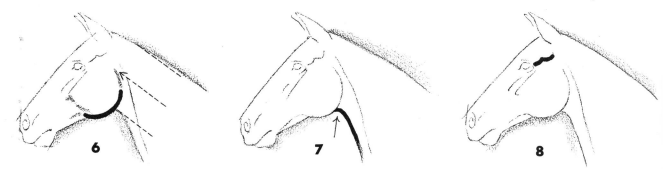

Fig. 3, all the distances represented by black lines here are very much the same. It is not necessary to mathematically measure these each time. Just being aware of them helps the eye in making a quick judgment.

Fig. 4, the front tip of the nose above the lips is approximately halfway between a and b.

Fig. 5, the visible chin protrusion of the horse is without bone, is flexible, and comes back as far as the mouth corner. This overall chin as compared with the rest of the head is relatively small.

Fig. 6, the most prominent bone in a profile horse head is the lower jaw. If its back line were continued, it would line up perfectly with the root of the ear (see also fig. 10). The visible part of this curve ends at the arrow which is the halfway point at the neck's top.

Fig. 7, here is a subtle curve as the lower neck line rounds behind the jaw bone. This change of direction should never be a sharp angle.

Fig. 8, this 'double scallop' line is exceptionally prominent in all horses. Every good horse head under normal lighting conditions will show shadow here. It is the zygomatic arch, a fixed bone just above and behind the eye (see fig. 10).

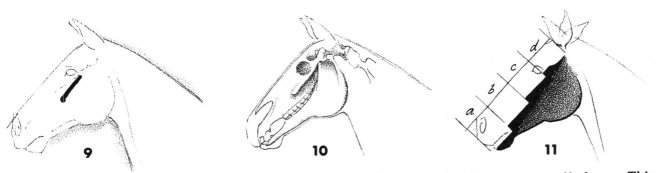

Fig. 9, second only to the jaw bone in prominence is the facial crest ridge or zygomatic bone. This is highly conspicuous (consult fig. 10). It is a continuation of, but steps down a little from, the scallop mentioned in fig. 8. Get so you watch for this ridge whenever you're around a horse or see a picture of a horse.

Fig. 10, this is the skull fitted into the head's outline. No animal has more obvious bone embossment in his head than the horse.

Fig. 11, here is the 'change of plane' stairway where shadow is likely to occur. A little time spent pondering this will never be regretted. (Also notice the mobility of the ear.)

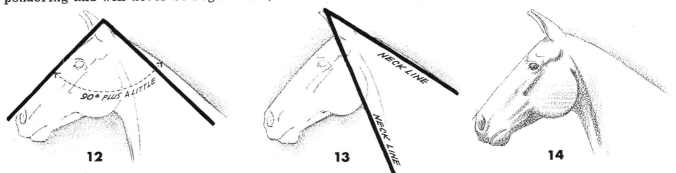

Fig. 12, the normal carriage of a horse's head in relation to the back of his neck (breeds vary slightly).

Fig. 13, the neck lines in relation to a horse's ears when they are facing forward.

Fig. 14, the completed head simply set down, following the points mentioned in the preceding observations.

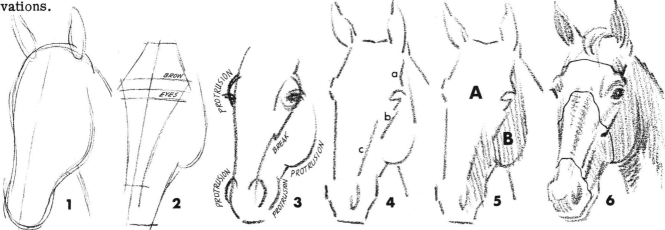

It helps to sketch experimentally on horses' heads:

1. Try drawing around the overall shape with general confinement lines.

2. The greatest expanse is through the forehead between the eyes. The lengthy nose narrows rapidly.

3. Here's what sticks out in the semi-front view.

4. Reckoning with lines a, b & c is a <u>must</u>.

5. Though there are a number of subtle changes of plane in the horse's head, the two major ones are A & B.

6. The longitudinal variations follow the indentions cross-sectioned by the superimposed pen lines.

GUIDES IN GOOD HORSE DRAWING

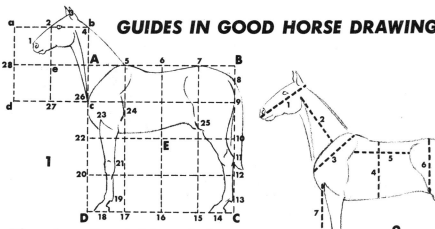

There is no "magic" formula for drawing a good horse, but there are many factors which will help the student in the process. The body of every horse will not fit into a square such as ABCD of fig. 1. Most are a little longer; very few are higher. The average saddle horse does not hold his head quite this high; many high-spirited and show horses hold their heads this high -- some higher. Follow the numbering from 1 to 28. Notice where the various points come in relation to the dotted lines.

2. At first it helps to compare distances using the head's length as the unit of measure. (See fig. 2)

3. The forequarters (A) and hindquarters (B) of a horse are beautiful shapes in themselves. It helps to isolate and practice these. Observe their flow of line (also the nick 'a' and double protrusion 'b').

4. Here is a most helpful fact, and it applies to nearly all mammals. The front joint A is below the back joint B. Notice these in relation to dotted line a-b (refer to p.6).

5. Most horses carry their heads so A is parallel with shoulders B. 'Parenthesis' a (the withers) is usually parallel with 'parenthesis' b (bottom of triceps).

6. The elbow A (olecranon) is above the belly line; the stifle B (patella or kneecap) is below.

7. In most horses there is a flow of line A down the back of the neck onto the front of the back legs, also down the front of the neck B onto the forearm.

8. For the most part, the hair tracts flow down and back (see arrows). The major swirls are in the flank area in a side view horse. These affect the surface shading very much (next page).

58

HELPS ON SURFACE ANATOMY

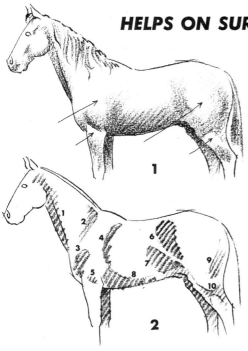

1

2

One of the big problems in drawing or painting horses is their surface anatomy. As a link between the simple facts on the opposite page and subsequent discussions on inner structure, the following aids are itemized with illustrations:

1. Light-colored horses exposed to overhead lighting may have a very subtle tint to shade graduation. Watch for light at arrows.

2. In this drawing are 10 key places where a change in tone may occur. This does not mean there are no other places, but to know these helps.

3

4

5

3 to 5 are suggested gradations for: light (3), middle-toned (4) and dark-colored (5) horses. To be sure, the source of light, muscle-trim, reflective quality of the hair, etc. have much to do with the appearance. Notice the shoulders: in 3, light; in 4, a double-streak treatment; in 5, heavy shadow. Observe the 'lowlights' in 3 and the 'highlights' in 5. Watch for "islands" of shade in front of the hip points (see arrows 3a, 4a, 5a as well as on the big stallion, fig. 6).

Where the 'croup' or 'rump' rounds down on the upper thigh (arrows 3b, 4b & 5b) there may be a value change. At arrows 3c, 4c & 5c there is a slight but evident change of plane which often means a little difference in shading.

Taking a look at fig. 7, there are three relatively smooth, plain areas numbered 1, 2 & 3; then there are three areas where muscle or hair-track streaks are to be found, 4, 5 & 6.

6

In the sketch of the big shire stallion above check out the various points stressed on this page.

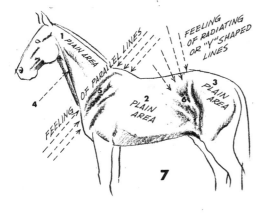

7

BONE STRUCTURE OF THE HORSE

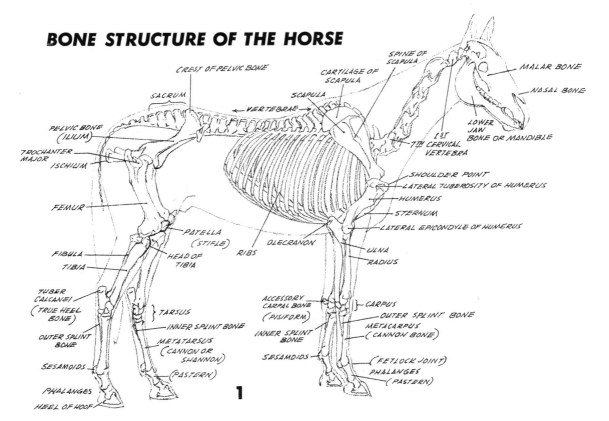

1

Why the inclusion of figs. 1 and 2 in a book for artists? Especially, why the technical name tags to the various bones and muscles? The names could have been omitted easily enough, for to memorize them all is not nearly as important as simply to know where the "show" bones and muscles are located. If, however, the student is really interested in drawing a good horse, he not only must know <u>where</u> contour and mass take place, but, if his "where" is to be relied upon, he must know <u>what</u> makes it take place. If he checks on <u>what</u> makes it take place, he will remember it better if the "what" has a name. Even a 'glancing' name acquaintance is helpful in understanding the obvious surface expression on the horse fig. 3, next page.

MUSCLES

2

The deep muscles of of the hind quarters are identified but only suggested here. They are shown without the superficial muscles over them on page 11.

Prefix Glossary:

Tensor — a muscle that stretches a part.

Extensor — a muscle that extends or straightens a limb or part.

Flexor — a muscle that bends a limb or part.

Posterior — situated behind.

Anterior — before or toward the front.

Dorsal — situated near or on the back.

Ventral — pertaining to the lower.

Externus — near the outside.

Internus — further enclosed.

SURFACE ANATOMY OF THE HORSE

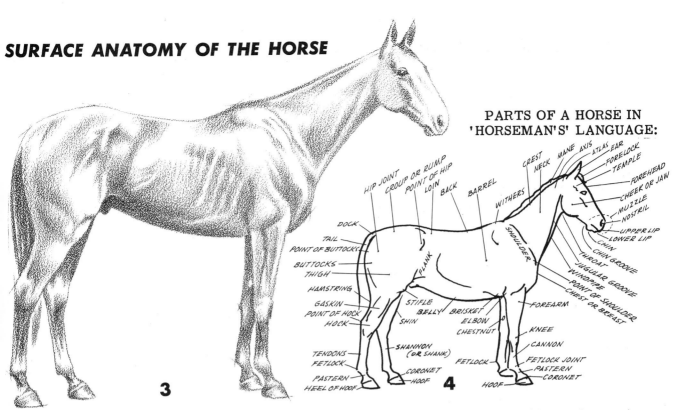

PARTS OF A HORSE IN 'HORSEMAN'S' LANGUAGE:

Labels (fig. 4): CREST, MANE, NECK, AXIS, ATLAS, EAR, FORELOCK, TEMPLE, FOREHEAD, CHEEK OR JAW, MUZZLE, NOSTRIL, UPPER LIP, LOWER LIP, CHIN, CHIN GROOVE, THROAT, JUGULAR GROOVE, WINDPIPE, POINT OF SHOULDER, CHEST OR BREAST, FOREARM, KNEE, CANNON, FETLOCK JOINT, PASTERN, CORONET, HOOF, FETLOCK, CHESTNUT, ELBOW, BRISKET, BELLY, STIFLE, SHIN, SHANNON (OR SHANK), CORONET, HOOF, HEEL OF HOOF, PASTERN, FETLOCK, TENDONS, HOCK, POINT OF HOCK, GASKIN, HAMSTRING, THIGH, BUTTOCKS, POINT OF BUTTOCKS, TAIL, DOCK, FLANK, WITHERS, BARREL, BACK, LOIN, POINT OF HIP, CROUP OR RUMP, HIP JOINT, SHOULDER

3 **4**

t is surprising how many evidences of the interior one can spot in a well-formed horse in running
rim. It is good practice to go back and forth from fig. 3 to figs. 1 & 2 for comparison purposes.
Then seek to recall the study when drawing your own horse.

5

'Pure' white horses such as the
Lipizzaner at the left may not
have the 'contour' definition, but
the correct 'mass' distribution
is terribly important. Even so,
a quick examination will dis-
close a dozen or more interior
evidences. Notice the shadow
side of the horse is against a
white background, and the light
side of the horse is against a
dark background. This treat-
ment gives more 'whiteness' to
the subject. In sketch practice,
however, it is well to use a
looser technique. See examples
of the following pages.

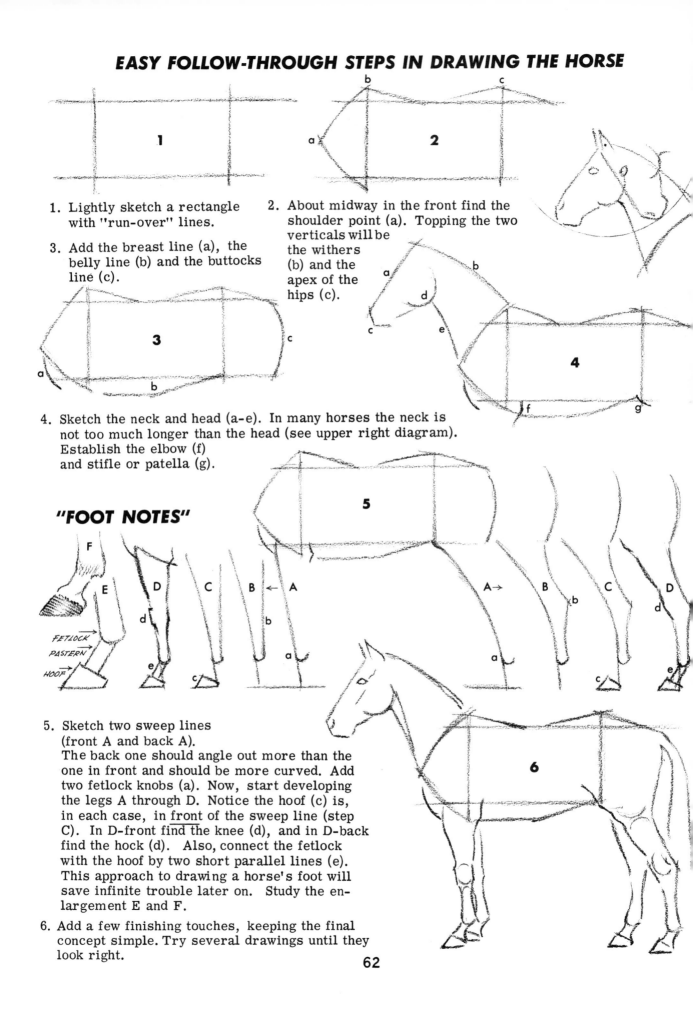

1. Lightly sketch a rectangle with "run-over" lines.

2. About midway in the front find the shoulder point (a). Topping the two verticals will be the withers (b) and the apex of the hips (c).

3. Add the breast line (a), the belly line (b) and the buttocks line (c).

4. Sketch the neck and head (a-e). In many horses the neck is not too much longer than the head (see upper right diagram). Establish the elbow (f) and stifle or patella (g).

"FOOT NOTES"

FETLOCK
PASTERN
HOOF

5. Sketch two sweep lines (front A and back A).
The back one should angle out more than the one in front and should be more curved. Add two fetlock knobs (a). Now, start developing the legs A through D. Notice the hoof (c) is, in each case, in front of the sweep line (step C). In D-front find the knee (d), and in D-back find the hock (d). Also, connect the fetlock with the hoof by two short parallel lines (e). This approach to drawing a horse's foot will save infinite trouble later on. Study the enlargement E and F.

6. Add a few finishing touches, keeping the final concept simple. Try several drawings until they look right.

CONSIDERING THE FRONT VIEW HORSE

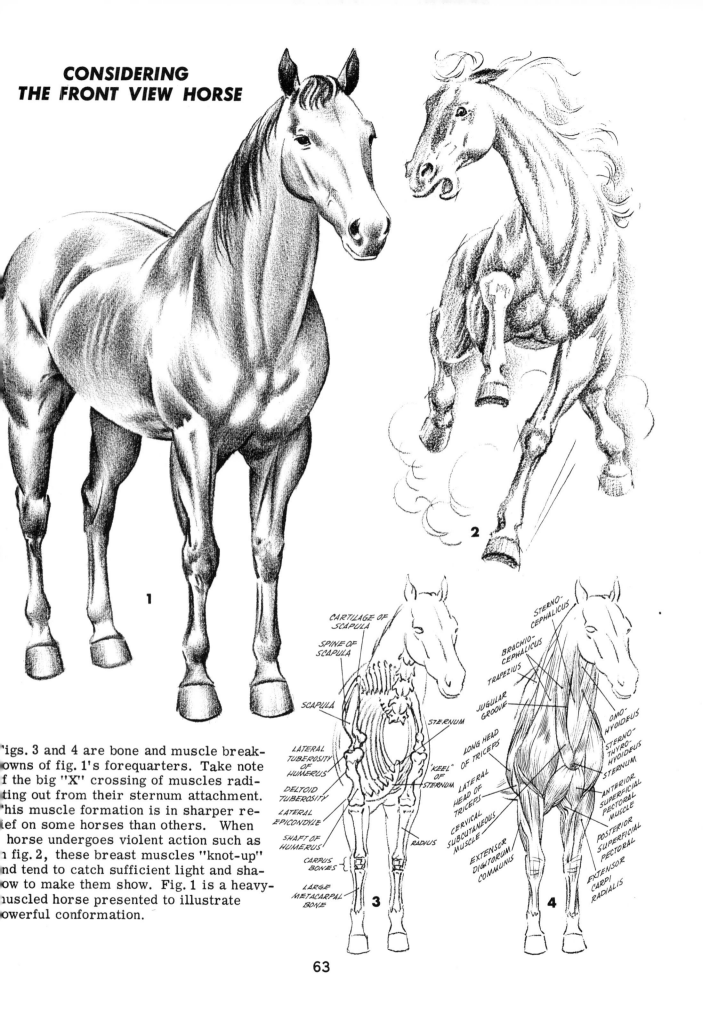

Figs. 3 and 4 are bone and muscle break-downs of fig. 1's forequarters. Take note of the big "X" crossing of muscles radi-ting out from their sternum attachment. This muscle formation is in sharper re-lief on some horses than others. When horse undergoes violent action such as n fig. 2, these breast muscles "knot-up" nd tend to catch sufficient light and sha-ow to make them show. Fig. 1 is a heavy-uscled horse presented to illustrate owerful conformation.

Fig. 3 labels:
CARTILAGE OF SCAPULA
SPINE OF SCAPULA
SCAPULA
STERNUM
LATERAL TUBEROSITY OF HUMERUS
DELTOID TUBEROSITY
LATERAL EPICONDYLE
SHAFT OF HUMERUS
CARPUS BONES
LARGE METACARPAL BONE
"KEEL" OF STERNUM
RADIUS

Fig. 4 labels:
STERNO-CEPHALICUS
BRACHIO-CEPHALICUS
TRAPEZIUS
JUGULAR GROOVE
LONG HEAD OF TRICEPS
LATERAL HEAD OF TRICEPS
CERVICAL SUBCUTANEOUS MUSCLE
EXTENSOR DIGITORUM COMMUNIS
OMO-HYOIDEUS
STERNO-THYRO-HYOIDEUS STERNUM
ANTERIOR SUPERFICIAL PECTORAL MUSCLE
POSTERIOR SUPERFICIAL PECTORAL
EXTENSOR CARPI RADIALIS

HOW A HORSE WALKS

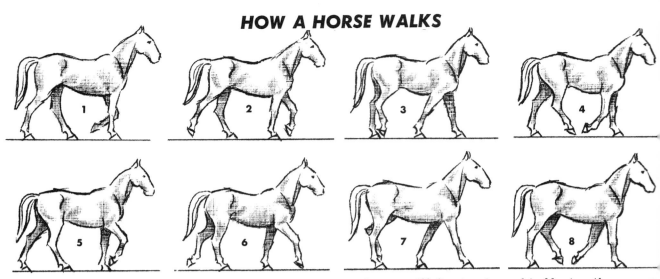

Some authorities say that from a standing position a horse will first raise a hindfoot, others say forefoot when going into a walk. The artist is more concerned about how the horse looks during th walk. If by now the student has not learned the support law regarding animals in motion mentione on p. 31, par. 2 or p. 54, par. 1, it should be reviewed. Notice how this is being illustrated in figs. & 6 and 4 & 8. In the walk two or three feet are always on the ground. A slow walk always has thr on the ground. In the fastest horse-walk it is possible that only two feet are on the ground at any time. If a horse is to be drawn to look like he is walking, there needs to be a more pronounced v tical feeling in the total of the legs PLUS the aforementioned ground contact. This doesn't mean stiff-leggedness. Compare the walk with the trot, canter and run. See how these three gaits eith have: 1. More diagonal feeling in the total of the legs, 2. More fold up or bend in the legs, or 3. More instants when the animal is completely in mid-air. For example: the back feet of fig. 1 (wa are quite like the back feet of fig. 5 (run), p. 67. But notice the difference in the front legs. The w has more of the vertical in the front legs, besides another ground contact there. The vertical tai (rather than 'flying') assists in the walk-look too.

THE TROT

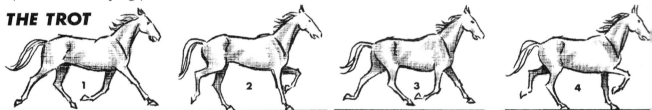

In the trot the horse is completely in mid-air twice during each cycle. Opposite legs tend to imi-tate each other. No other gait has so much symmetry. Compare fig. 1 with 3 and 2 with 4.

THE CANTER

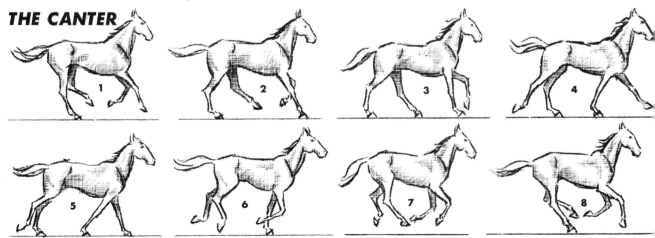

The canter is really a slow gallop. The spread of the legs is less when they're extended (compar figs. 4 & 5 with figs. 6 & 7, p. 67). When the horse is completely off the ground, the legs under the body are not so tightly gathered as in the gallop (compare fig. 7 with fig. 2, p. 67).

THE HORSE IN ACTION

2

3

4

5

6

7

Always sketch under-drawing lightly!

1

In all animals, foreshortening is a matter of: first, a seeing of the circular running proportionately through front to back; and second, a developing of the proper parts upon that circular frame. Three mediums are used on this page: pencil (figs. 2, 3 & 4), brush and ink (5, 6 & 7), and pen and ink (8). In fig. 1 is an underdrawing of the circular which has been developed in fig. 2. In each of the drawings from 2 through 8 look for the circular as it is relayed through the figures. In a finished sketch, the circle or oval, as the case may be, is not necessarily unbroken; but the form it represents is on top of the form beneath. Thus, we have solid, perspective dimension: one thing being on top of another, all of which is pictured on a two-dimensional plane.

As to the sequence in placing the circular shapes in fig. 1, it is suggested that a be done first, then b, c & d. The a is first because, in the front view position, it is the central bulk. The neck and head, which follow, will furnish us the cues as to the size of the rest of the figure. Before doing the leg circles, it is well to establish a directional line running through where the legs are to go. On this line indicate the "knobs" or joints of the legs (shaded here for emphasis), always doing the ones in front first. The knees g & h, then the hock i (the other is hidden here). Next the fetlocks j, k & l. Doing the rest of the leg parts is a matter of choice. The forearms m & n and the gaskin o; the hoofs p, q & r; or the reverse. A strike of the pencil for the hoofs is important. Lastly, the connecting lines between the 'knob' joints; the ears, eyes, and other 'accessories' to follow. Remember, always sketch underdrawing LIGHTLY.

8

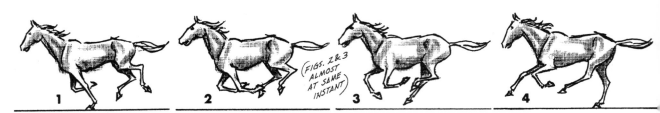

HOW A HORSE RUNS

Since the artist is called upon to draw running horses quite often, it is well to consider some of th 'rights' and 'wrongs' which help solve the problem. First of all, the fast gallop is always one and the same as the run. Above are eight phases in the gallop's cycle. Figs. 2 & 3 are off the ground (called 'total suspension'). Admittedly, the horse does not spend 1/4 his time in mid-air. But thes brief instants are of special importance to the artist. During the complete cycle of leg movement the positions which give the greatest appearance of speed are the instants when the horse is totall suspended. Most artists give priority to some phase of this suspension period when drawing a sin gle animal at top speed. Actually, the split moment of greatest speed is just when the horse thrus off from his second front foot in the cycle (fig. 1), but even that position does not look as fast in an although IT LOOKS much faster than any other position during the run where one or two feet are i contact with the ground. The reason for this is that the diagonal line running from head to hoof (fi 1) is a lunging line forward. All other phases of the run (figs. 4 through 8 and unshown instants be tween) have a leg extended either: one, forward, which by the nature of things is necessary to kee the animal from falling on his face, but carries with it a 'stiff-arming' or 'breaking' look; or two, up-and-down (fig. 8), which, being a vertical, does not denote forward speed.

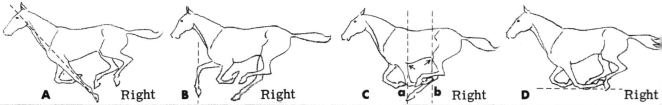

Fig. A is the instant after fig. 1 at the top of page. The front hoof has just left the ground, and the legs are "gathering" to make the "recovery" for earth contact again. Fig. B is almost simultaneous with fig. 3 top, but has a vertical (part of front leg) which slows down speed appearance. Fig. C illustrates that in a run a back hoof never gets in front of line "a"(elbow—arrow), nor does a front hoof get behind line "b"(stifle or kneecap — arrow). The horse's spine is not flexible like a greyhound or cheetah whose feet pass these dotted lines when animal is in suspension. Fig. D shows that the bottom-most parts of the legs and feet can line up some- what straight across (dotted line). In fig. E the beautifully fast ar- rangement of feet are more-or-less confined to a circle. A to E are all horses in suspension. E's head is held high. A lower head may look faster. Never draw neck parallel to ground or nose pointing straight out like a rocket

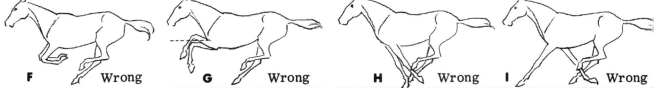

Figs. F to I are wrong and impossible in the gallop or run. Neither the front nor back legs are ever held exactly side-by-side (in this or any other gait for that matter) as we see in F's front. With a back foot in the act of coming to earth as in F, where would the front feet be? The front legs woul appear to be thrashing like spokes in a wheel (see 3 at top of page). Really one front foot has just come all the way in, and the other is in the act of going out. In G the front knee never comes abov the dotted line. In H the front legs never slant in together straight and unbent. In I both front legs would never be off the ground when separated to the limit as they are here, and the back legs woul be far to the rear if they were so separated.

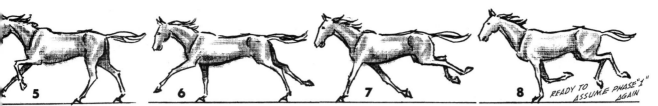

5 6 7 8 READY TO ASSUME PHASE "1" AGAIN

f the artist needs to draw a second horse running with or behind the first, then it is advisable to
hoose a position with one or two feet on the ground. One reason is for variety; the other is that
t is highly unlikely that horses side-by-side would have their legs arranged identically. Note that
he two back feet (J1) are never spread as far as the two front feet (K1) when on the ground in the

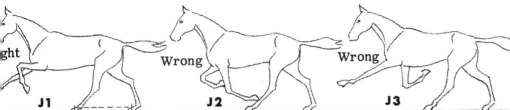

run. The front legs
of J2 & J3 are out
of order in the cy-
cle when the back
legs are thus
aligned.

When the front feet are spread and on the ground (K1), this calls for both hind legs to be out, one

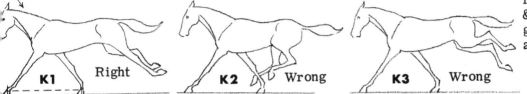

fully extended. K2
& K3 are in disa-
greement with this
alignment.

When the inner front leg, in the succession, is vertical and supporting (L1), all other legs should

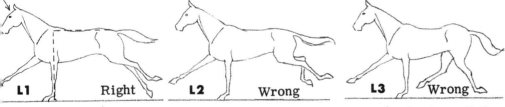

be extended. L2's
back legs are
starting to flex
prematurely, and
L3's rear legs are
out of line for this
phase in the cycle.

f the foremost of the front legs is vertical and supporting (M1), then all the other legs will be part-

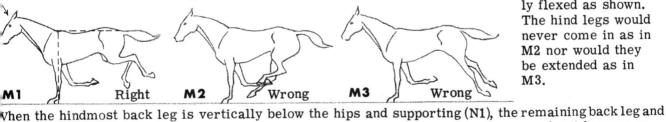

ly flexed as shown.
The hind legs would
never come in as in
M2 nor would they
be extended as in
M3.

When the hindmost back leg is vertically below the hips and supporting (N1), the remaining back leg and

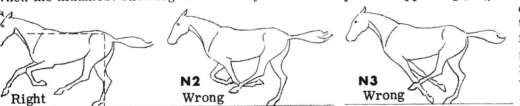

one front leg are ex-
tended toward the
front and are off the
ground. The other
front leg is flexed
with the foot flipped
inward.

When the foremost back leg is vertically below the hips and supporting (O1), the remaining back leg and

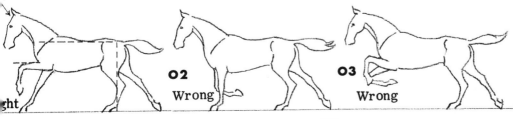

one front leg are ex-
tended outwardly
from the body and
both are close to or
in contact with the
ground. The other
front leg is flexed
with the knee raised
to its apex.

67

HELPFUL FACTS ABOUT A RUNNING HORSE

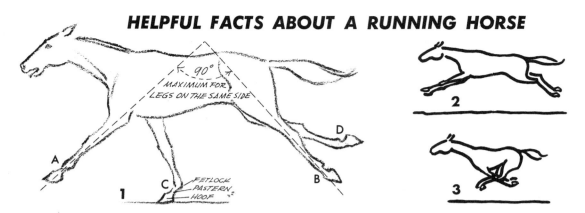

Even in the fastest run, the legs on the <u>same side</u> of a horse are never apart more than at a 90° angle (see above). When the legs are fully extended, one of the front legs is in contact with the ground. And the pastern of that weight-bearing leg is bent at the fetlock to such an extent that the fetlock may come close to touching the ground. The legs are never outstretched together as we see in some ancient paintings, fig. 2, nor are they ever parallel and crossed as shown in fig. 3.

(See p. 19)

When a horse has his legs gathered (fig. 4 white), he does not appear as long in body as when he has his legs extended (fig. 4 shaded) -- both outlines are the same horse -- see the difference in length. Actually, when a horse has his legs gathered, his whole body is higher from the ground than when he is in contact with it, fig. 5. His neck is at more of an angle, and his head is higher. His hips are more bent across the croup (see dotted line). The white and shaded horse in 5 is the same horse as in 4, but the white outline is centered (in 4 the shoulder points are placed together to show the difference in length at the rear -- also, the back line of the white in 4 is superimposed on the back line of the shaded horse. Actually, with legs gathered the back line would be as in 5). Notice the dock (or root) of the tail in 5 in relation to the hips.

Figs. 6 & 7 below and at right are multi-phase diagrams meant only to point out a few facts for the artist who intends to draw a running (or galloping) horse. In 6 the legs are fully extended. In 7 the legs are bent. Some phases of the run have combinations of these (but do not use these to pick out combinations). The extended legs are <u>never</u> above dotted lines a and b in fig. 6. When the <u>legs</u> are under the body and extended, they are <u>never</u> above <u>c</u> and <u>d</u>, fig. 6.

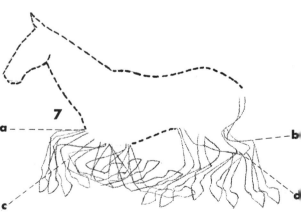

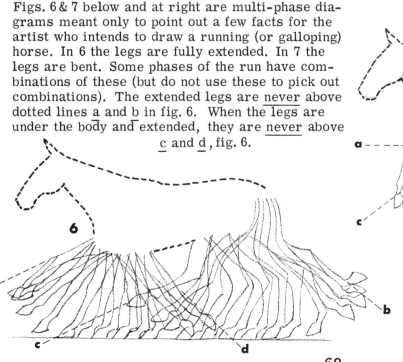

A bent leg on a running horse <u>never</u> goes above <u>a</u> or <u>b</u> in fig. 7 (this does not apply to a prancing show horse). When all the legs are <u>gathered</u> for mid air suspension, the legs are always confined between <u>c</u> and <u>d</u>.

Above are four phases of a horse's jump. Each of these may be isolated in the mind's eye if the outline is perceptively followed. When the animal leaps, the legs are parallel or more nearly parallel than in any other kind of movement. However, he may have one leg or the other leading and flexed in a slightly different manner. Directly above a hurdle or obstacle, the horse will be like fig. 3, the body parallel to the ground, and both pairs of legs will be drawn up. Then as he prepares for a landing, the front legs are extended. More often than not, he will land on one or the other of the front feet, one leg absorbing much of the shock and the other reaching for the next step because of the momentum envolved. After going over a hurdle, when the horse makes contact with the ground up front, his hind legs may still be in a tight, folded condition even as fig. 3's. If the horse is broadjumping a ditch or chasm, there is not the need for such a tight hind-leg fold to clear a bar. Yet these legs will have to fold some in order to bring them under the body, extend them and reassume their weight-bearing responsibility. Fig. 5 shows a horse and rider just after takeoff. The neck will be straighter with the body at this particular time than at the landing (see the neck of fig. 4).

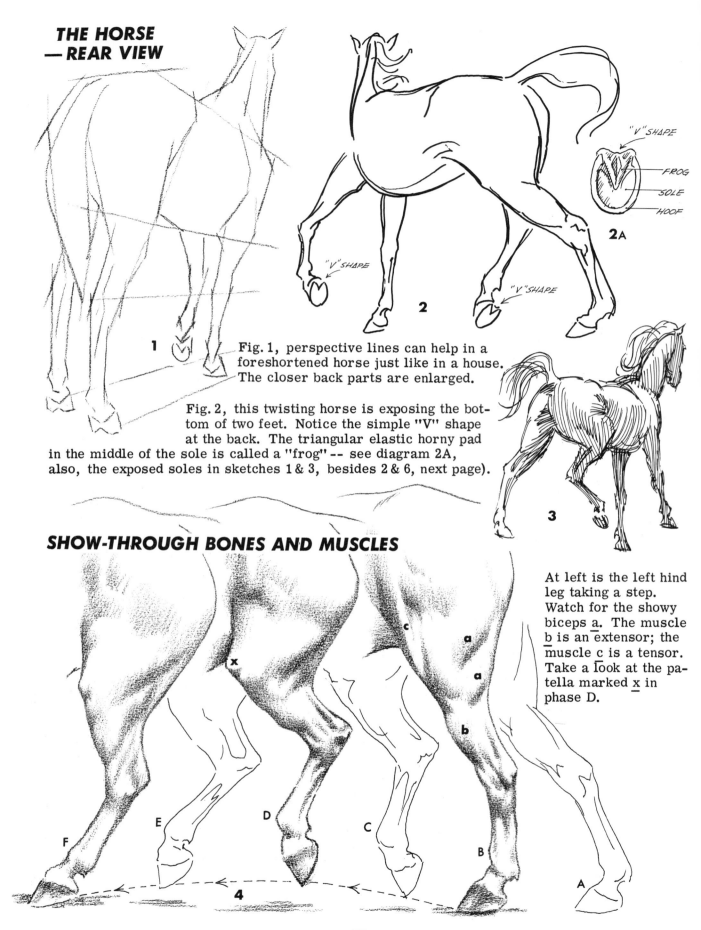

THE HORSE —REAR VIEW

"V" SHAPE
FROG
SOLE
HOOF

2A

"V" SHAPE

"V" SHAPE

1

2

Fig. 1, perspective lines can help in a foreshortened horse just like in a house. The closer back parts are enlarged.

Fig. 2, this twisting horse is exposing the bottom of two feet. Notice the simple "V" shape at the back. The triangular elastic horny pad in the middle of the sole is called a "frog" -- see diagram 2A, also, the exposed soles in sketches 1 & 3, besides 2 & 6, next page).

3

SHOW-THROUGH BONES AND MUSCLES

At left is the left hind leg taking a step. Watch for the showy biceps a. The muscle b is an extensor; the muscle c is a tensor. Take a look at the patella marked x in phase D.

c
a
a
b

x

F
E
D
C
B
A

4

A double-leg pawing of the
air has three key positions:
A, flexion; B, extension;
C, momentary relaxation.
Then the cycle repeats.

Here are various positions of a horse in vigor-
ous action. There is something forcefully over-
whelming about a thrashing horse. Perhaps it is
his size and weight plus his unpredictable flying
hoofs. Few parts of a horse look soft. Not many
animals have this look and feel
of solidness. There are so many
hard angles within his erratic
legs, and angles in art are
the opposite of repose.
Seek to register these
qualities in your more
energetic
drawings.

71

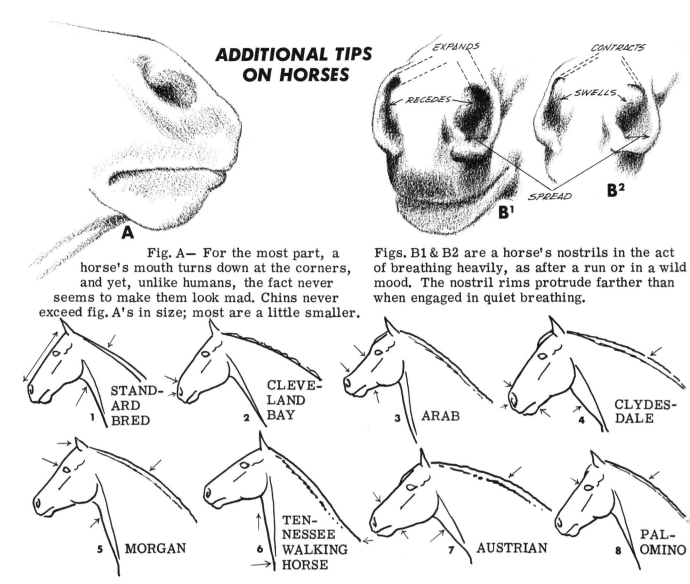

ADDITIONAL TIPS ON HORSES

A

B¹

B²

EXPANDS — RECEDES

CONTRACTS — SWELLS

SPREAD

Fig. A— For the most part, a horse's mouth turns down at the corners, and yet, unlike humans, the fact never seems to make them look mad. Chins never exceed fig. A's in size; most are a little smaller.

Figs. B1 & B2 are a horse's nostrils in the act of breathing heavily, as after a run or in a wild mood. The nostril rims protrude farther than when engaged in quiet breathing.

1 STANDARD BRED

2 CLEVELAND BAY

3 ARAB

4 CLYDESDALE

5 MORGAN

6 TENNESSEE WALKING HORSE

7 AUSTRIAN

8 PALOMINO

As an addendum to heads, several breeds are outlined above. Fig. 1 has relatively straight forehead, refined neck; fig. 2, nose slightly arched with rounded nostril; fig. 3, smaller head and muzzle, forehead to nose somewhat concave; fig. 4, wide muzzle, large nostrils, well-arched neck; fig. 5, small ears, fine eyes, crested neck; fig. 6, great breadth at base of neck, holds head high; fig. 7, heavy head, sizeable muzzle, extra thick neck; fig. 8, refined head, dark eyes, light-colored mane.

Below is a standard trotting or pacing horse (shaded) superimposed over a Clydesdale (white and in heavy outline). Notice the big draft horse's high withers which seem to be a

9

sloping part of the neck base. Also, observe his great shoulders, stocky legs and large hoofs.

Fig. 10 suggests turns of plane due to sound body physique. The dotted line traces the changes which must be felt in the contrasting values chosen by the artist regardless of the medium used.

10

THE ZEBRA'S SHAPE AND MARKINGS

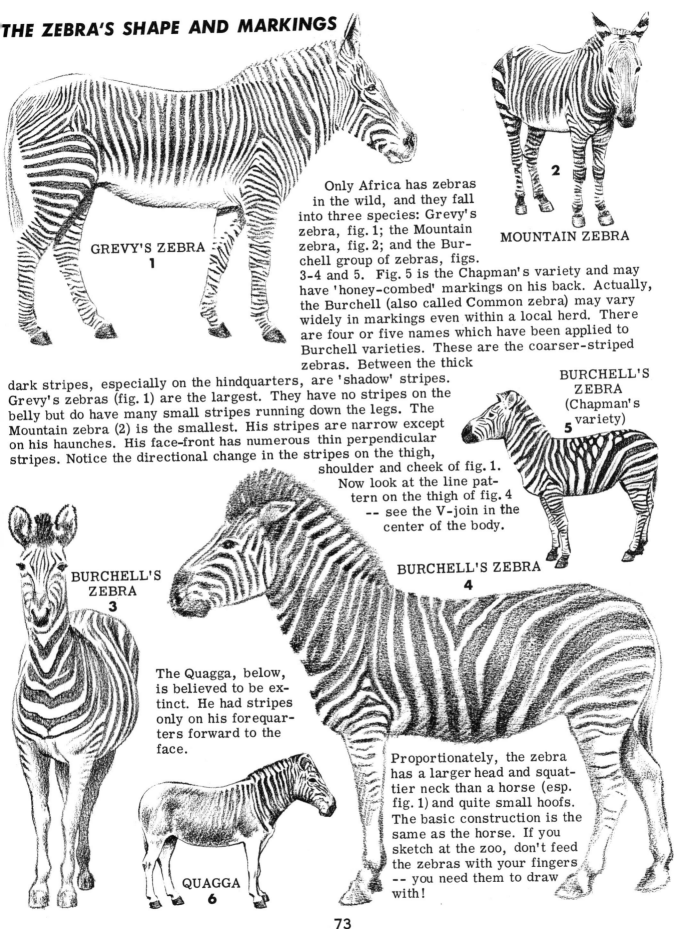

GREVY'S ZEBRA
1

MOUNTAIN ZEBRA
2

Only Africa has zebras in the wild, and they fall into three species: Grevy's zebra, fig. 1; the Mountain zebra, fig. 2; and the Burchell group of zebras, figs. 3-4 and 5. Fig. 5 is the Chapman's variety and may have 'honey-combed' markings on his back. Actually, the Burchell (also called Common zebra) may vary widely in markings even within a local herd. There are four or five names which have been applied to Burchell varieties. These are the coarser-striped zebras. Between the thick dark stripes, especially on the hindquarters, are 'shadow' stripes. Grevy's zebras (fig. 1) are the largest. They have no stripes on the belly but do have many small stripes running down the legs. The Mountain zebra (2) is the smallest. His stripes are narrow except on his haunches. His face-front has numerous thin perpendicular stripes. Notice the directional change in the stripes on the thigh, shoulder and cheek of fig. 1.

Now look at the line pattern on the thigh of fig. 4 -- see the V-join in the center of the body.

BURCHELL'S ZEBRA
(Chapman's variety)
5

BURCHELL'S ZEBRA
3

BURCHELL'S ZEBRA
4

The Quagga, below, is believed to be extinct. He had stripes only on his forequarters forward to the face.

QUAGGA
6

Proportionately, the zebra has a larger head and squattier neck than a horse (esp. fig. 1) and quite small hoofs. The basic construction is the same as the horse. If you sketch at the zoo, don't feed the zebras with your fingers -- you need them to draw with!

73

BEGINNING ELEPHANT DRAWING

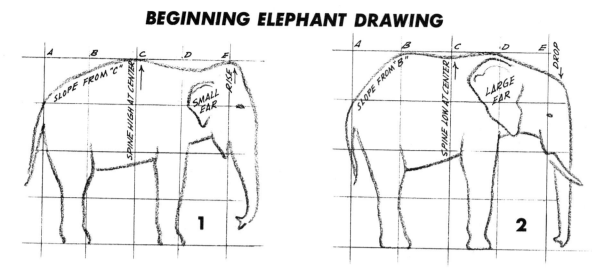

Performing elephants in the circus are nearly always the Asiatic, more commonly called the "Indian" elephant, because India is its principle homeland (outlined in fig. 1). Some zoos have African elephants as well (fig. 2). If the artist is called upon to picture an elephant as being in Africa, he should use the kind in fig. 2. The African's ear is always considerably larger.

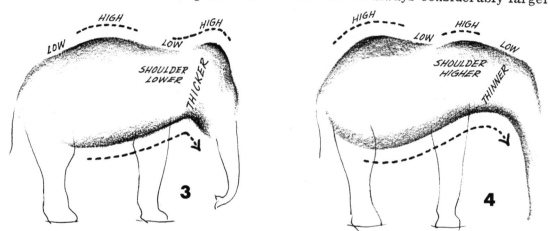

Observe the difference in the body's contour. A dead giveaway in identification is: the sweep underneath the African (fig. 4) making him look somewhat chinless, plus his thinner neck and head (sideview) when compared to the Indian's (fig. 3). Actually the African is larger and heavier than the Indian when both are full grown.

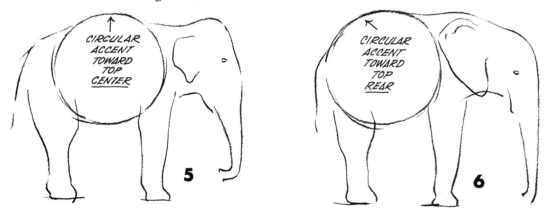

The very obvious rise of the spine in the two kinds marks an important difference to remember. Thinking in terms of a circle extending off the spine, one comes up with diagrams 5, the Indian elephant, and 6, the African elephant.

ELEPHANT HEAD — IN SEVEN EASY STEPS

1

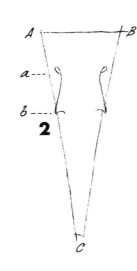

2

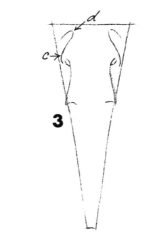

3

4

1. To draw a front view African elephant head it helps to build on a triangle with the top AB about 1/3 AC.

2. The tusk will appear at "b". Notice that AB is equal to Ab. Eyes "a" are 1/2 way between A and b.

3. There is a strong "brow" bone which protrudes above the eye "c" and a skull indention at "d".

4. The forehead protrusions above eyes "e & f" are not nearly so prominent in African as in Indian elephant. Tusks may be varying lengths.

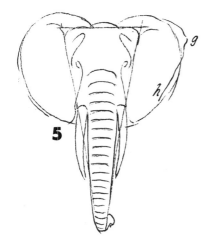

5

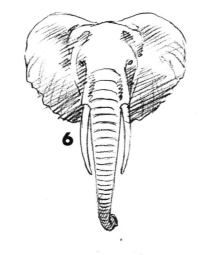

6

7

5. The ears of the African are enormous. Generally speaking they may be quite rounded at the margin or lap out at "g" and cut back slightly at "h".

6. Coarse ridgelike folds arc across the trunk with smaller krinkles or creases between. They begin a little below eyes and get closer together as they progress down trunk. The heavy ridgelike folds are omitted in Indian's trunk; his parallel folds are less deep and more numerous. The big African's ears may appear scalloped at lower half's outside edges.

7. The Indian elephant has high double dome considerably above the starting triangle line AB. His smaller ears set farther down on head. His tusks (male) are usually shorter. Female Indian hardly has tusks at all. Both male and female African elephants may have very long tusks.

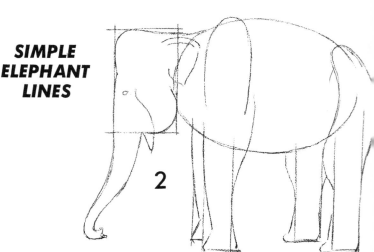

SIMPLE ELEPHANT LINES

1

2

The Indian elephant may be started with a very simple under-structure. He has been given a short neck to better support a big head and often times weighty tusks. Since the head could never reach the ground-level for feeding or drinking, he has been blessed with an extension hose made up of over 40,000 interwoven sinews and muscles. It may be lengthened to a degree or shortened at will. In fig. 2 see how the dome and jaw round out opposite corners of the rectangle. The legs are postlike to hold up his tremendous bulk. In fig. 2 notice the swing of the leg lines on either side of the fig. 1 columns. Directly above the legs are the sectional divisions of the body. In fig. 3 observe the planes. Look for and record these. Ponder the x's in fig. 3; these are highs or protrusions.

3

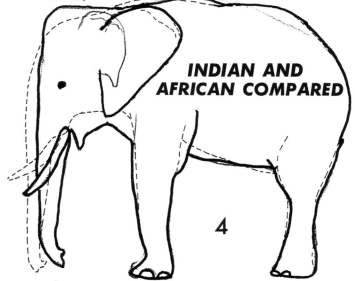

INDIAN AND AFRICAN COMPARED

4

Above is the African elephant (dotted lines) laid over the Indian elephant (pencil lines). The chief differences can be detected readily. Indian: boxed dome with smaller ears setting forward. African: a more sloping head with larger ears setting farther back. Indian: bulky-looking jaw, shorter trunk, belly line more parallel to ground. African: smaller jaw, slightly longer trunk, belly line a little more slanting toward rear legs.

TUSKS

5

Tusks, which are the upper incisors, are not always the same shape. Some have but a slight curve, others curve out then in and the tips nearly touch each other. In some elephants (from the front) the tips may be very wide spread. Frequently a wild elephant will have a broken tusk which then may be semi-rounded and polished by much grubbing and scraping. An African tusk may be 10 or 11 feet long and weigh up to 230 lbs. A relaxed trunk finds A, B & C parallel. The indention B often catches a bit of shadow. The tusk root appears <u>below</u> the eye.

(Slight single knot may show on some Africans.)

A

African elephant's ear next to body. → B
← Away from body.

C

Same ear as A & B in forward motion (at 'right angle' to body).

ELEPHANT EARS

Like on humans, elephant ears are not always shaped the same. Elephants have the most restless ears in existence. Even though their giant bodies usually move slowly, they are fidgety creatures nonetheless. Widespread ears express anger, and are accompanied by a lashing tail. Gently waving ears may express contentment. The top rim (or helix) of an Indian elephant's ear rolls over forward (especially in older animals); the top of an African's has a more voluminous roll backwards. Because of the ear's overall weight, the upper 'root' of the African's is the thickest part. Elephant men in India like rectangular ears, but usually the way they hang gives them a triangular appearance. The outer and bottom edges may become torn (see figs. 2 & 7). The corner of a young ear may flap over (fig. 4).

Indian ear attachment.

SHAPES OF ASIATIC ELEPHANT EARS:

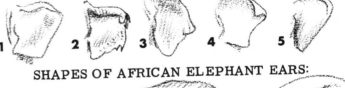

1 2 3 4 5

SHAPES OF AFRICAN ELEPHANT EARS:

6 7 8

Over-heated elephants use ears as fans in sweltering Africa.

9

10

Top view diagram of African ear attachment. Some 'roots' are farther apart than others.

A B

Big African bush elephant (broad across head & muzzle). Notice how ears & body fit in triangle.

→ Front view ears of smaller African forest elephant. They may rise upward off of head's top.

11

→ Rear view ears: Some scallop "A"; others are plain "B" (ears would match).

13

NUMBER OF TOENAILS ON ELEPHANT FEET

Front:
| 5 | 5 | 4 | 4 | 5 | 5 |

Back:
| 4 | 4 | 3 | 3 | 4 | 4 |

1

| African Forest Elephant | African Bush Elephant | Asiatic (Indian) Elephant |

There are five digits on all feet, even though there may not be that many corresponding toenails.

The elephant forever carries his own silent bedroom slippers. His footsoles are well padded with a thick elastic cushion of flesh and muscle. He really walks on the tips of his 'fingers' and 'toes'(see skeleton feet in fig. 6). His 'wrist' and heelbone are raised inside this flexible clubfoot. Yet they are close enough to the ground to be called semi-plantigrade. There is a lot of give in the foot bones (fig. 4) to compensate for the rigidity in the upper leg bones. One reason an elephant can remove his huge foot from a bog is that, by lifting, the circumference of the foot is reduced. The big Indian elephant in fig. 2 is going into a head stand. His hind legs are off the ground. Notice how his front toes swell above the nails as his weight pushes forward. The front foot is somewhat broader than the rear foot. Many animals have slightly larger front feet than back feet (like the whole dog and cat family). The bottoms of the female elephant's feet are a little more oval than the male's.

2

3

4

5

6

HORSE KNEE CAP

ELEPHANT KNEE CAP

HEEL BONE

The elephant can't spring at all. If his stride is 7', a 7 1/2' trench is impassable. The horse's leg is built like a spring (see above), but the elephant's leg bones are nearly straight up-and-down. His joints have flattened articular surfaces for carrying great weight; hence he moves less agilely.

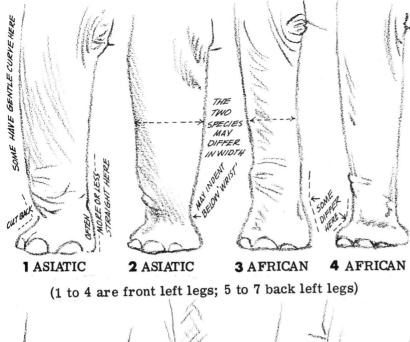

1 ASIATIC **2 ASIATIC** **3 AFRICAN** **4 AFRICAN**

(1 to 4 are front left legs; 5 to 7 back left legs)

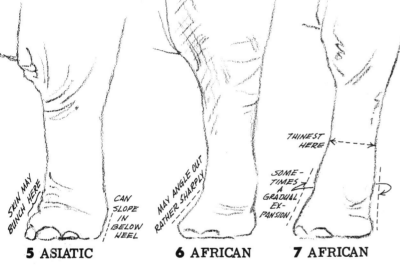

5 ASIATIC **6 AFRICAN** **7 AFRICAN**

LEG COMPARISON

Are there any differences in the legs of elephants? Since the stout, heavy bones are set nearly vertically atop each other, it would seem the limbs would be the least pliant on the outside. But such is not the case. The thick hide is still mighty loose and spongy. Whenever there is stress or strain of muscle or bone on the inside, like a suit of ill-kept clothes, the relaxed hide rumples on the outside. While all elephants' legs are quite cylindrical, the African's are a little more uniformly so, especially the front legs. At times the shape of the lower front leg and foot appear surprisingly like the little end of a wooden baseball bat (see fig. 4).

When an elephant's leg is straight, there is always some gathered skin around the joints (figs. 1 through 7). The backmost toenail may be in some cases a mere vestige overhung with cuticle (fig. 3), or it may be a fully exposed, sizeable nail (fig. 1). A closeup reveals some space between nails (see fig. 5 opposite page).

From the front, look for an overlap of line in the legs when long muscles pull at the lower leg (see checks in fig. 8). When the leg is foreshortened, the foot appears like a round platter tacked on the leg (x of fig. 8).

Simply drawn, the bags and folds of the legs are illustrated from "a" to "g" in fig. 9. Skin areas "a, b & c" roll and rumple as the monster walks. Nearly always something goes on at "d, e, f & g" in the way of surface change. There is a twist in the hinder leg, so "d" occurs. As will be pointed out later, there is a great abundance of 'extra' skin below the tail, and multiple folds may show there, "a."

ELEPHANT TRUNK, NOSE & MOUTH

At left is a closeup of an old tuskless Indian elephant. Though the trunk has thousands of wrinkles, there are no shingle-like, all-the-way-across ridges as are seen in the old African example at the bottom left (fig. 6). Notice the flabby lips beneath the sunken cheeks. The lips in fig. 2 are firm, younger lips. The double bags under the eyes are typical of many elephants. Often the wrinkles may be so pronounced that it is difficult to separate them from the bags. The only other mammal as wrinkled as an elephant is the chimpanzee.

1

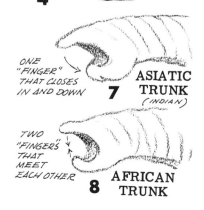

2

3 AFRICAN

A
INDIAN

B
INDIAN

C
AFRICAN

Inadequate descriptions often leave the artist in the dark about the end of the trunk. The Indian has one 'finger' or process; the African two. But the Indian has a blunt, sometimes grooved gripper below which can be flattened (figs. A & 4) or swollen (B & 7). The African's two fingers don't come at the top, but are one up and one down, and are quite similar (see C at left and fig. 8 below). Fig. 3 is also African, widened and from the front. These extensions are highly prehensile, that is, they can stretch, thin out, swell, twist, wrap around and do about anything.

INDIAN

4

They can pluck a blade of grass or assist, like a powerful hand, in lifting a gigantic load. The nostrils often show distinctly, especially from the front (fig. 3), or they may be overshadowed as in the enlargement (fig. 4). The elephant can smell better than any other animal alive.

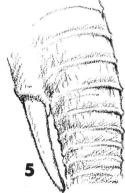

5
SECTION OF TRUNK
(Young African Elephant)

6
SECTION OF TRUNK
(Old African Elephant)

ONE "FINGER" THAT CLOSES IN AND DOWN

7 ASIATIC TRUNK (INDIAN)

TWO "FINGERS" THAT MEET EACH OTHER

8 AFRICAN TRUNK

INSIDE THE MOUTH

1

2

TWO INCISORS (TUSKS)

FOUR MOLARS

NO CANINE TEETH

TONGUE

MORE TRUNK TIPS

CONVEX TOP

TRUNK CROSS SECTION

FLAT BOTTOM

3

TWO LONGITUDINAL ROWS OF SMALL PROMINCES

FLAT BOTTOM OF INDIAN: PLAINER

FLAT BOTTOM OF AFRICAN: COARSER

4

5

AFRICAN BUSH ELEPHANT

6

AFRICAN FOREST ELEPHANT

7

INDIAN ELEPHANT

8

THE ELEPHANT EYE

Above is the Asiatic (Indian) elephant's eye showing the long and almost straight lashes which point down and out from the lid. The African elephant has larger eyes, relatively speaking, but neither species has very good eyesight. They possess a third eyelid that moves across the eyeball from the side. Since the eyes are on the side of the head, when the enraged beast charges, he goes in an arc instead of straight ahead. The African elephant rarely lies down to sleep. His Indian cousin may lie down for as much as a couple of hours a day. Both often take brief naps on their feet. Fig. 2 is a front view diagram of an Indian elephant with trunk up and mouth open. There is only one long molar tooth on each side of each jaw. They connect in a grinding position and are replaced several times from the back as they wear out. Fig. 3 is an Indian elephant with his extremely mobile trunk twisted so as to expose part of the bottom. Notice the cross section (above trunk) and the sketches of the under-surface (4 & 5). Of all the features of animal anatomy, the elephant trunk is perhaps the most amazingly dexterous.

HOW AN ELEPHANT HOLDS HIS HEAD

A word should be included on the way an elephant holds his head. The bush elephant (6) travels with his tusks more parallel to the ground than others. Certainly when he charges, the tusks are upraised. He does not curl his trunk under as the Indian (8) in a charge. All elephants rip with tusks besides using trunks as weapons. They butt with their heads in fights with each other. Female elephants have been known to nip each other's tails off, but they seldom fight.

THE ELEPHANT
—REAR VIEW

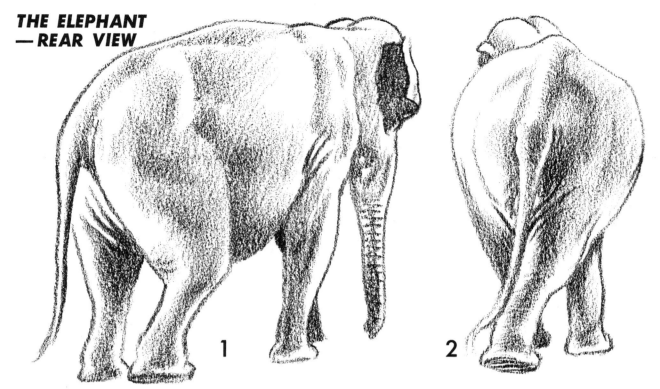

1

2

When drawing an elephant from the rear, the spine is most prominent. The leaner, more active wild elephants have even a sharper backbone, especially among the African species. Observe the Indian's spine on this page as it comes on down through the tail. The skin is looser on the hindquarters than anywhere else and is sometimes referred to as "oversized pants." Notice the big overlap of hide to the right of the tail in fig. 4. Also, it might be mentioned that at the root of the tail an extra-large widening of fat and hide often appears. The end of the tail itself may be flattened like a small paddle with long, coarse hairs coming off of it (fig. 4). Or the tail may simply end in a few straggly hairs. The tails are seldom longer than on this page. They may be shorter, a portion being lost in a fight or accident. It is always interesting to watch these giants of the animal world move their ponderous bodies about.

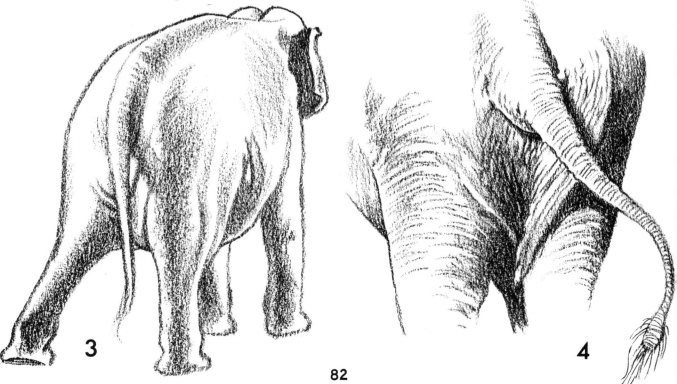

3

4

Remember, a line from the eyes runs into the trunk. If the animal has tusks (dotted), this widens his muzzle considerably.

→

1

ELEPHANT ANTICS

In drawing an elephant, keep in mind the word "bulk." It is certainly there in massive amounts; not light and airy like a balloon, but solidly heavy and loosely supple. In the circus arena they sometimes are too covered with costume. If you can, go to the zoo. Watch them sway and shift their weight about.

With your eyes examine the various bodily sections. Observe where the cylindrical legs join the barrel-like body.

2

For the painter: the typical skin color of an elephant is grayish black, but it is interesting to know that many times the color is that of the soil of the area. The big "El" is very fond of dust and mud baths.

3

The Indian elephant is lighter in color than either of the Africans. The forest elephant in Africa has somewhat darker skin than the bush elephant, also more hair, especially on chin, trunk and tail.

4

THE ELEPHANT LYING DOWN AND STANDING UP

Below is an Indian elephant in the act of lying down or rising. The head being closer is enormous. The skull and leg bones are in evidence. The resourceful trunk is completely boneless.

Fig. 2, the elephant rises on his hind legs. The knees are fairly well situated beneath the center of gravity in the immense torso.

Fig. 4 shows the elephant lying down. Notice the thickness through the mid-section, the prominent olecranon bone at the elbow and the drooping hide under the neck.

Fig. 3, if you got down on your knees and elbows, you'd be positioned like a kneeling elephant. In some respects he is quite man-like, especially through the hindquarters.

HOW THE ELEPHANT WALKS

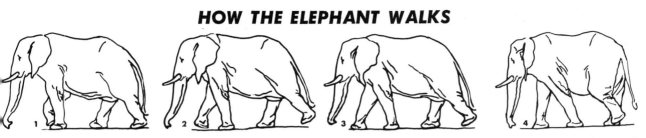

An elephant can get about only by walking. He can neither trot, canter or gallop. His accelerated walk is quite fast, however, and is called the "amble." It is a wide-stepping, gliding shuffle, and for a couple of hundred yards may equal the speed of a human sprinter. In a charging huff he might reach 30 mph. His normal walk is more like 4 mph. On this page in miniature is a short-necked, thick-trunked African elephant traveling at a fast walk. From figs. 1 to 20 he is taking one stride (or the necessary steps which are required to end up with the feet in the same position as the start).

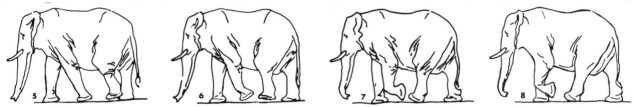

Notice again this important law which applies to the walk of most animals: If the frontmost and back-most feet are off the ground (fig. 2), the two supporting feet are always on <u>opposite</u> sides of the body. But if the two inmost feet are off the ground (fig. 6), the two supporting feet are always on the <u>same</u> side of the body. Check this out again in figs. 12 & 18.

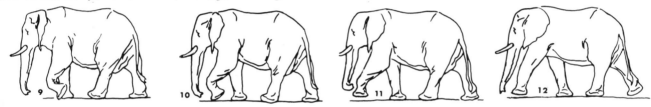

Most animals, in their faster movements, have three or all four feet off the ground briefly at some time in the stride. The elephant, who cannot jump, never has more than two feet off the ground at one time; and, in natural locomotion, they are seldom lifted very high. Check the next facts closely:

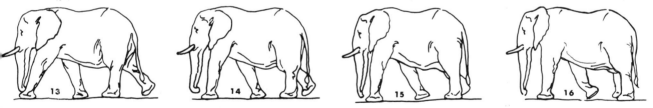

For a good part of this walking process, the feet on one side appear to move forward together, alternating with those on the opposite side. Yet, the ankle of the foot of the back limb cannot be flipped under as the 'wrist' does for the front foot; so, stiff-leggedly, the back knee brings the lower leg forward a little ahead of the front. Then, as the front foot is flipped at the 'wrist' and is brought forward, both limbs get in line once again. Thus the elephant makes his forward progress.

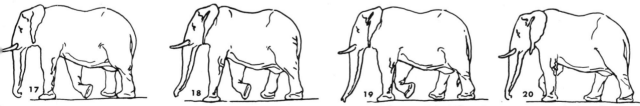

Take note that when the two inmost feet are off the ground (figs. 6 & 18), the two remaining legs of support are nearly perpendicular to the ground. When the outmost feet are off the ground (figs. 2 & 12), all the legs may be at an angle with the ground, but support is still well under the huge body. Despite his tonage, this mighty mountain of life can place his big feet with delicate deliberateness when he chooses.

WOLF, COYOTE AND FOX HEAD — STEP-AT-A-TIME

A

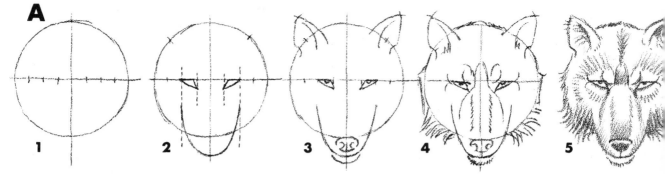

THE WOLF'S head above is broader than the coyote's below. The ears are more rounded and th[e] muzzle is heavier. An adult male wolf has more power in his jaws than any other canine. In the [a]dult wolf, the nose pad exceeds an inch in diameter; whereas it is less than an inch in the coyote. The expression may be made to look more fierce by a concentration of brow lines just over the e[yes] Sometimes the art call is for a savage creature -- this is perhaps unfair to the normal dispositio[n] the animal. The color is gray with brown or yellow tinge, but may be white or black.

B

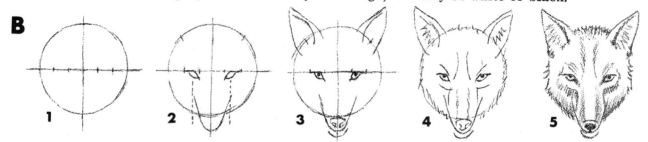

THE COYOTE'S head has more pointed features than the wolf. For the size of his head, his ears are larger, and they stand noticeably erect. His muzzle is more slender. The normal set of the ears frontview is outside the head's width; in the case of the wolf, it is within the head's width. Generally speaking, the coyote's face is more plainly colored than the wolf's. His head is withou[t] the wide shag of back-up hair which we call a 'ruff.' Ordinarily an artist doesn't draw the coyot[e] expression as sinister as the wolf's. The color is a pale brown with intermingled gray or black with white or nearly white underparts.

C

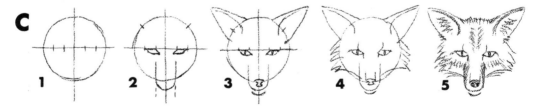

THE FOX'S head has very large ears in comparison with his head size. The muzzle is more nar-row than even the coyote. Though the nose pad appears pointed, the muzzle's sides are more parallel in construction (see fig. 2). At the cheeks there is a flare of fur. A very unusual aspect of the fox are his vertically contracting pupils. In bright light these pupils will reduce themselve[s] to up-and-down slits. Both the coyote and wolf have round pupils. The coyote does not look as u[n]kempt as the wolf. The red fox has black-rimmed ears with white inside. His face is reddish brown on top with white lower cheeks, chin and throat. He may have a black face and coat, how-ever.

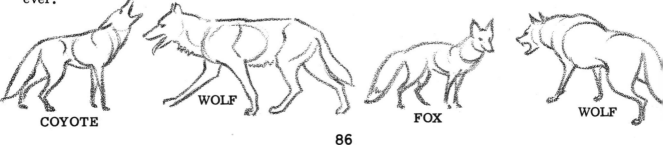

COYOTE WOLF FOX WOLF

WOLF CONSTRUCTION

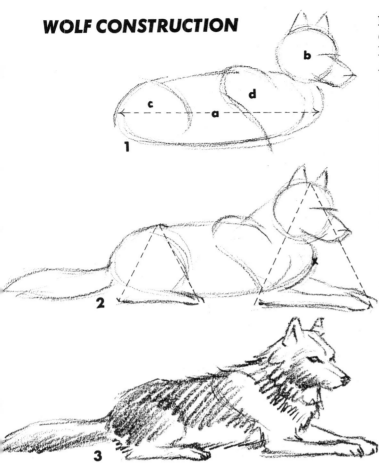

1

2

3

Before the student lies an animal. Then comes the first question: what sweeping lines will encase the major form (a)? And the sub-forms (b, c & d)?

Fig. 2 -- As the wolf or dog settles back comfortably, the artist becomes aware of a couple of simple triangles which help in the positioning of the legs. Also notice that the fur crest of the breast falls in the center of the front triangle. Not all kindred subjects will hold their heads identically. Some have the front neck line more perpendicular to the floor, but by-and-large, the simple triangle will apply.

Fig. 3 -- Learn to capture essential shading with but few lines. In the field, when one is holding a small sketch pad, this method is a great asset.

Fig. 4 -- An animal at rest is marvelously balanced with even distribution of weight. Observe the triangles' apexes and the four support points below them.

4

HAIRTRACTS

Wolf-like dogs, or we might say dog-like animals, including coyotes and foxes, since they all are so closely related, have hair tracts which are interestingly alike. This is especially noticeable in animals of similar hair-length. Softer heat-preserving fur is embedded beneath the longer rain-repelling hairs. The latter appearing predominately on the upper parts of the body. Some German Shepherd dogs possess beautiful wolf-like coats with obvious area divisions as diagramed in the rugged wolf below.

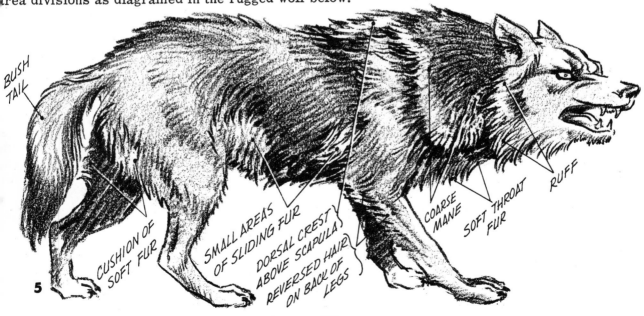

BUSH TAIL

CUSHION OF SOFT FUR

SMALL AREAS OF SLIDING FUR

DORSAL CREST ABOVE SCAPULA

REVERSED HAIR ON BACK OF LEGS

COARSE MANE

SOFT THROAT FUR

RUFF

5

HEAD AND BODY COMPARISONS

1 WOLF

In the left-hand column are comparative sketches of several related animals in the dog family. Most wolves (fig. 1) will grow larger than the average dog. A few male wolves have been recorded to be in excess of 160 lbs. Most wolves are under 100 lbs. as are most German shepherd dogs. It is a good-sized wolf which stands 30 inches at the shoulder.

Wolves' heads may take on different shapes, particularly at the muzzle. The wolf at left (fig. 1) has a narrow muzzle or snout; whereas the two heads (1a & 1b) at right have thicker muzzles. There is a slight arch in the shepherd's nose (fig. 2) that is peculiar to the breed, and his ears are larger than any of the animals on this page. The facial pattern of the wolf may be quite plain (1a), or it may be 'fancy' approaching that of the Eskimo dog (fig. 3 right). Examine closely all the eyes on this and the next page -- see how the 'regular' dog eyes are not as slanting as in the wolf, husky, coyote and fox.

The gray or timber wolf of the northlands may look stouter because of the dense fur which shields him from the cold. Northern wolves have lighter-colored coats. Southern races of wolves are smaller and weigh less. When the wolf runs, he holds his tail high (about level with his back); when he slows down, the tail drops. The husky (fig. 3 left) carries his tail curled over his back. Some wolves and huskies look exactly alike except for the tail. However, it is characteristic of most of the dog family to hold the tail up when playing.

The front feet of all these animals have five toes, the fifth being up and inside, not touching the ground. On the back foot there are only four toes. A wolf has hair between his toes that a dog does not have. Foxes have limited tree-climbing abilities denied other dog relatives. Still, all dog claws are non-retractile, unlike the cats which can pull theirs back.

The chief difference in the wolf and the coyote (4) is in the size. The latter being much smaller, averaging about 25 lbs. Page 86 cites head contrasts. Dogs will mate with wolves and coyotes and affect their appearance, but they will not mate with foxes.

In proportion to the size of the body, the fox's bushy tail is the largest. The fox's face looks a little pinched in feature arrangement. This is partially due to his extra large ears and the bush he carries for a tail at the other end. His legs are slender, however, and his feet are small. The fox comes in a great variety of kinds, colors and shades: brown, gray, blond-yellow, silver, black, white, reddish-rust and salmon-pink.

2 GERMAN SHEPHERD

3 SIBERIAN HUSKY

4 COYOTE

5 RED FOX

1a WOLF

1b WOLF

2 GERMAN SHEPHERD

3 HUSKY

4 COYOTE

5 GRAY FOX

88

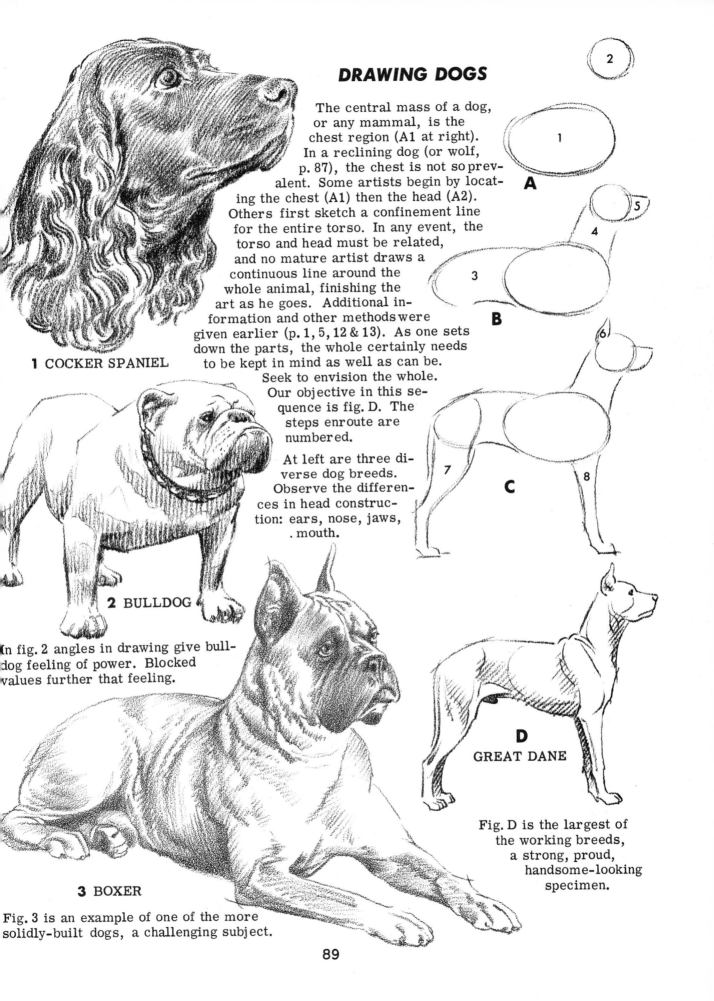

DRAWING DOGS

The central mass of a dog, or any mammal, is the chest region (A1 at right). In a reclining dog (or wolf, p. 87), the chest is not so prevalent. Some artists begin by locating the chest (A1) then the head (A2). Others first sketch a confinement line for the entire torso. In any event, the torso and head must be related, and no mature artist draws a continuous line around the whole animal, finishing the art as he goes. Additional information and other methods were given earlier (p. 1, 5, 12 & 13). As one sets down the parts, the whole certainly needs to be kept in mind as well as can be. Seek to envision the whole.

Our objective in this sequence is fig. D. The steps enroute are numbered.

At left are three diverse dog breeds. Observe the differences in head construction: ears, nose, jaws, mouth.

1 COCKER SPANIEL

A

B

C

D

GREAT DANE

2 BULLDOG

In fig. 2 angles in drawing give bulldog feeling of power. Blocked values further that feeling.

3 BOXER

Fig. 3 is an example of one of the more solidly-built dogs, a challenging subject.

Fig. D is the largest of the working breeds, a strong, proud, handsome-looking specimen.

89

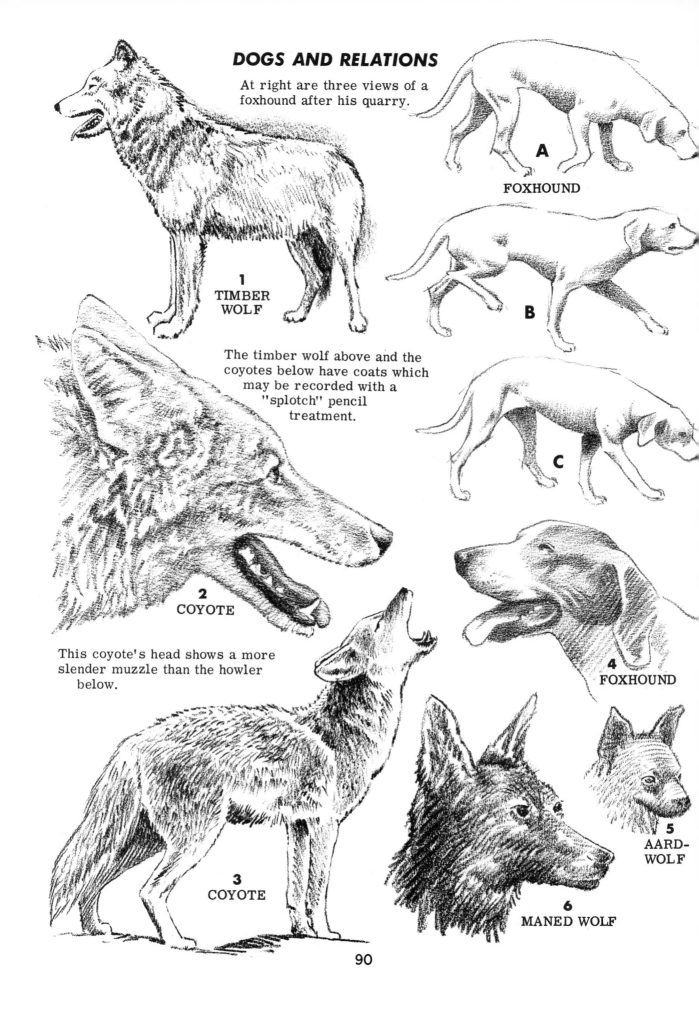

DOGS AND RELATIONS

At right are three views of a foxhound after his quarry.

FOXHOUND

A

B

1 TIMBER WOLF

The timber wolf above and the coyotes below have coats which may be recorded with a "splotch" pencil treatment.

C

2 COYOTE

This coyote's head shows a more slender muzzle than the howler below.

4 FOXHOUND

3 COYOTE

5 AARD-WOLF

6 MANED WOLF

DOG-LIKE ANIMALS

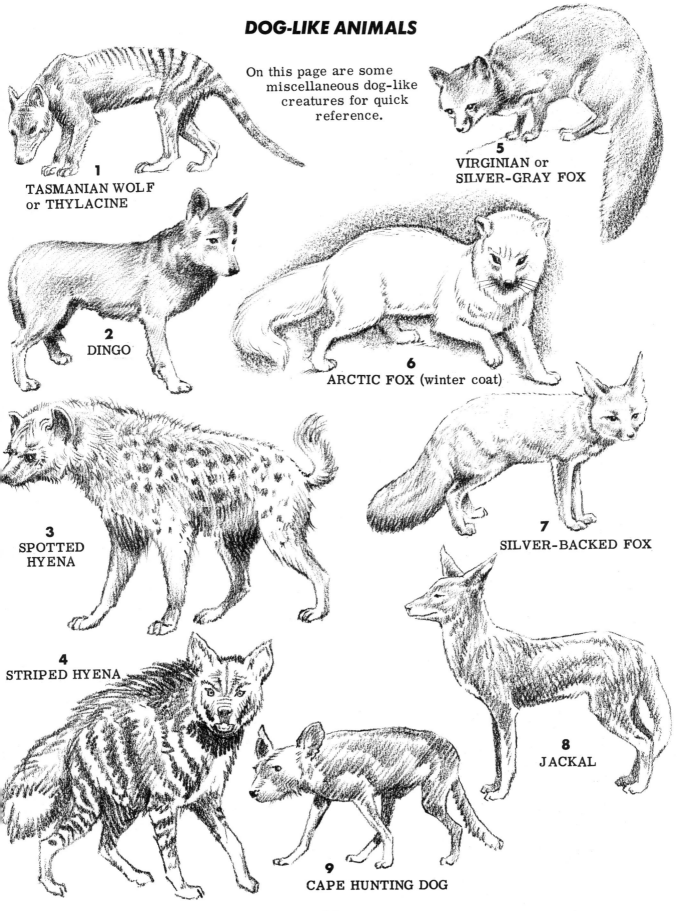

On this page are some miscellaneous dog-like creatures for quick reference.

1
TASMANIAN WOLF
or THYLACINE

5
VIRGINIAN or
SILVER-GRAY FOX

2
DINGO

6
ARCTIC FOX (winter coat)

3
SPOTTED
HYENA

7
SILVER-BACKED FOX

4
STRIPED HYENA

8
JACKAL

9
CAPE HUNTING DOG

THE BACTRIAN CAMEL

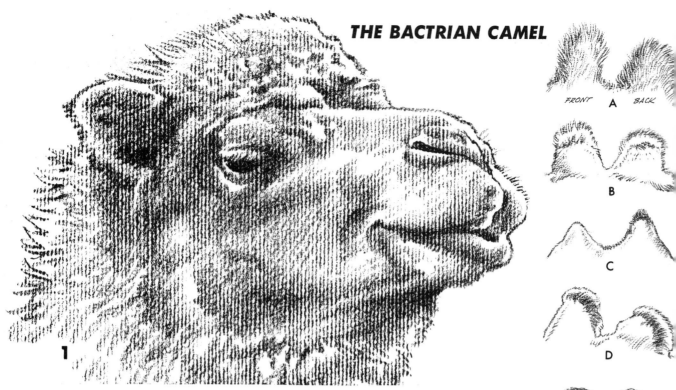

FRONT A BACK

B

C

D

E

DOUBLE-HUMP TYPE

There are essentially two kinds of camels. On this page is the Bactrian or two-humped camel typical of central Asia from Afghanistan to China. On the opposite page is the Arabian or dromedary of southern Asia and northern Africa. Fig. 1 is a close-up of the Bactrian which usually has more shag-hair about his head than his smoother-haired cousin. Camels have awning-like brows and double sets of long eye lashes to cut out sun-glare and dust. Their nostrils can be closed completely during a sand storm. The humps are not water depositories as generally believed but are made up of fatty cells in the form of food reserve. Water-storing is a stomach function. Healthy Bactrian humps are bulbous and wobbly; a healthy Arabian hump is rigid and firm.

Camels vary considerably in appearance, especially the humps and hair (the latter depending in part on the time of year -- camels undergo frightful shedding). Figs. A to E show hump possibilities differing from the humps on figs. 2 & 3 below. An abundance of hair on the humps usually calls for a corresponding quantity on the head, neck and forearm. Well-fed camels have enormous humps. After long, hard desert treks the humps may nearly disappear. A floppy, folded-over hump (E) may be partly due to old age. The shag-hair is often long and frazzled as in fig. 2 or it may be woolly and bunched as in fig. 3. Proportionately the Bactrian camel has a stockier build and shorter legs than the lankier Arabian camel.

THE ARABIAN CAMEL

A practice drawing may start with step 1 and go to step 3. In a sense, the hindquarters of a camel look rather 'stuck on' his funny frame (see figs. 1 & 2). Another good way of beginning is to roundly fashion the a-b-c sections as in fig. 4. Notice the great vertical length in the a-c leg areas. Start with b and let it overlap c more than a.

Figs. 5 & 6 are sketches of a front and semi-rear view. Observe the three body sections behind the neck. The camel in fig. 6 has a small hump, and the one in fig. 7 a medium-sized hump. A sedentary zoo camel may have a large hump that reaches to the dotted line above fig. 7.

The camel's broad-cushioned feet are two-toed, each toe having a heavy hoof-like nail. He progresses by the walk, pace and (often against his will) the gallop. His manner comes closer to a 100 percent pace, that is, both legs on the same side moving forward together, than any other animal -- so, it is quite safe to draw them that way. Fig. 8 is the skeleton showing that the vertebral spines do not go into the hump at all.

The camel is born with leathery skin pads (or callosites) at the locations marked with arrows. Since he must kneel for pack loading, these places become tough and gnarled from the harsh sand.

Underneath view of the head.

93

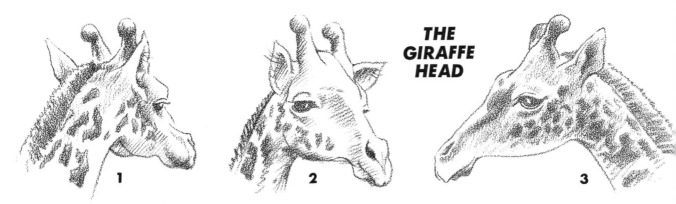

THE GIRAFFE HEAD

1 2 3

The giraffe's head has a tapering nose ending in highly flexible lips. His eyes are large and heavy-lidded possessing an undisturbed and even tenderly-expressive appearance. Both males and female have two fur-covered horns, some with a knob, others tufted. Certain giraffes have a decided hum in the middle of the forehead just below the horns. The exceptionally long neck still has only seven vertebrae, the number of all mammals, and on occasion the 'cud' may be seen strangely rising from stomach to mouth. (Also, consult fig. 5, p. 7; fig. 1, p. 15; fig. 5, p. 17)

GIRAFFE RUNNING

This gangling fellow never trots but goes from a walk directly into a rocking gallop. The gait is of such slow tempo that it resembles a movie in slow motion. Some authorities refer to this method of locomotion as the 'rack' or 'pace' for a good part of the progression has both legs moving on one side simultaneously. As the giraffe brings up a front leg, his neck and head bobble downward. His neck thus assists in the balancing process. Though his movements look clumsy enough, he still can go unusually fast -- 30 or 32 mph.

4

5

Figs. 4 & 5 represent the "stretch" or the limit of the extended legs when the giraffe is running. Figs. 6 & 7 show the legs gathered beneath the body for the brief mid-air suspension when no feet are touching the ground.

6

7

94

NOTES ON THE GIRAFFE

The giraffe is the tallest animal of them all -- as high as 19 feet. Fig. 1 is as 'short-necked' as they come. Many have longer necks than this one (see figs. 2 & 6). Diagram 1a has both the short neck and the long. For the long, widen the base of the neck and raise the withers (arrow 1). The body may be built into an equilateral triangle with the slope of the shoulders and the rump complying. The front points of the shoulders (arrow 2) jut out to a great extent.

The sharp cloven hoofs (fig. 3) sometimes measure 12 inches in width and are lethal weapons in themselves. Besides the kick, the side of the head is used like a club.

Figs. 4 & 5 show the awkward postures of the giraffe when drinking or grazing. Coat patterns are compared at bottom right on the page. The common or blotched giraffe (A & B) has ragged markings of various shapes. The reticulated (resembling net-work) giraffe has even-edged markings (C & D). The spots may be closely (C) or more widely (D) placed. In some cases the spots are lighter with a darker coloration toward center.

THE OKAPI

The okapi shown here is a relative of the giraffe. The males have small, fur-covered horns and both sexes have big ears.

(SHOULDER TOP)

A B C D

HOW TO DRAW THE HIPPOPOTAMUS

Though the hippopotamus is supposed to be more related to the pig and the rhinoceros more related to the horse, we will place them together. The reason is, if the artistic difference is established by comparison, then the student will be better qualified to draw both. The monstrous hippo is most "unbelievable" to the eye. His immense, barrel-like body is supported by short, inadequate-looking legs having feet with four toes on each. The nostrils on his bulbous, scoop-shovel muzzle stick up as do his pig-like eyes and little ears, so that these six sense organs can be above water while the vast hulk beneath remains hidden. All of the views, figs. 1 to 3, are built on a series of undergirding rings, since the hippo is such a roundly-constructed fellow. Notice the circles in the thumb-nail sketch 3a which is the base for 3b. When 'traveling through' the body think in terms of these circles. For side view see fig. 1, next page.

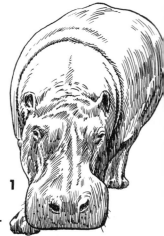

1

2

3a

3b

Rhinos have more variation than the hippo. There are three major kinds of rhinoceroses: From Asia comes fig. 4 and is called the "Great Indian" rhinoceros. Fig. 5 at right and fig. 2 next page are sketches of the "black" or long-lipped species. Fig. 3 next page is the "white" or square-mouthed rhino. The 'black' and 'white' are somewhat misleading designations since both are nearly the same brownish-gray in color, the latter being a bit paler. Both are from Africa and have two horns; fig. 4 has but one. The horns are not really bone-parts of the skull but consist of congealed hair growing directly out of the skin. These horns, like people's fingernails, sometimes take on different shapes. The horns of figs. 6 & 7 are from the heads of the black rhino. The black and white varieties do not have the unique sectional divisions of the hide which we see on the Great Indian rhinoceros at the right.

5

4

6

7

The rhino's open mouth is not nearly the chasm of the hippo's (see fig. 2). He has but three useable toes on each foot.

BUILDING ON SIMPLIFIED FORMS

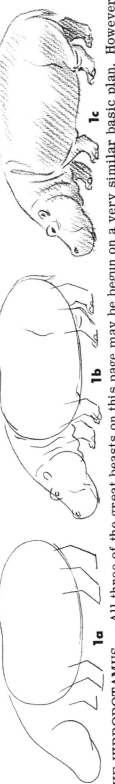

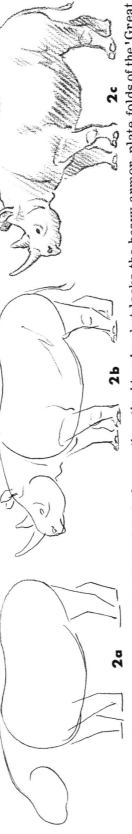

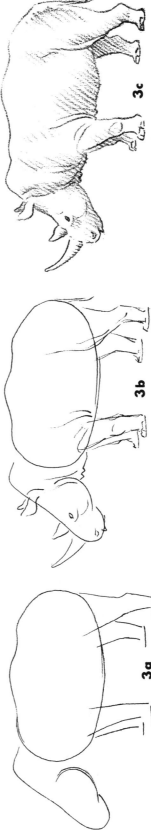

THE HIPPOPOTAMUS -- All three of the great beasts on this page may be begun on a very similar basic plan. However, the hippo has much shorter legs than the rhino. His solidly-packed body may be 14 feet long overall and weigh around four tons. Few animals have such a heavy head -- so much so that even the hippo seeks to prop it up occasionally to relieve his neck of the strain. Compare his raised eye with the rhino's lowered eye; also his small ears with the rhino's larger ears. His color is a grayish-black with a pinkish flesh tint around his facial features. Notice that folds occur at the join-points of the neck and legs.

THE 'BLACK' RHINOCEROS -- His thick skin is looser than the hippo's, but lacks the heavy armor-plate folds of the 'Great Indian' rhino. The head is relatively smaller than in 1c or 3c, is held higher, and the upper lip is prehensile, i.e., finger-like in picking up leaves and twigs. He is slightly sway-backed (not so in fig. 3 below). His head is more concave with the second horn emerging from the indention. He grows to be some 11 feet long and may stand over five feet at the shoulders.

THE 'WHITE' RHINOCEROS -- This huge juggernaut is second in size only to the elephant in land mammals. He has an extra hump in front of his shoulders, and, from that, a long sloping forehead. He often carries his threatening horns very low to the ground when he walks or runs. His mouth is broadly built for hours of grazing on the grassy plains of Africa. The additional arch in his spine is one mark of difference. All rhinos can travel at a surprising rate of speed for a short distance. It takes a good horse to overcome them. They progress by the walk, trot and gallop.

THE DEER — IN THREE FREEHAND STEPS

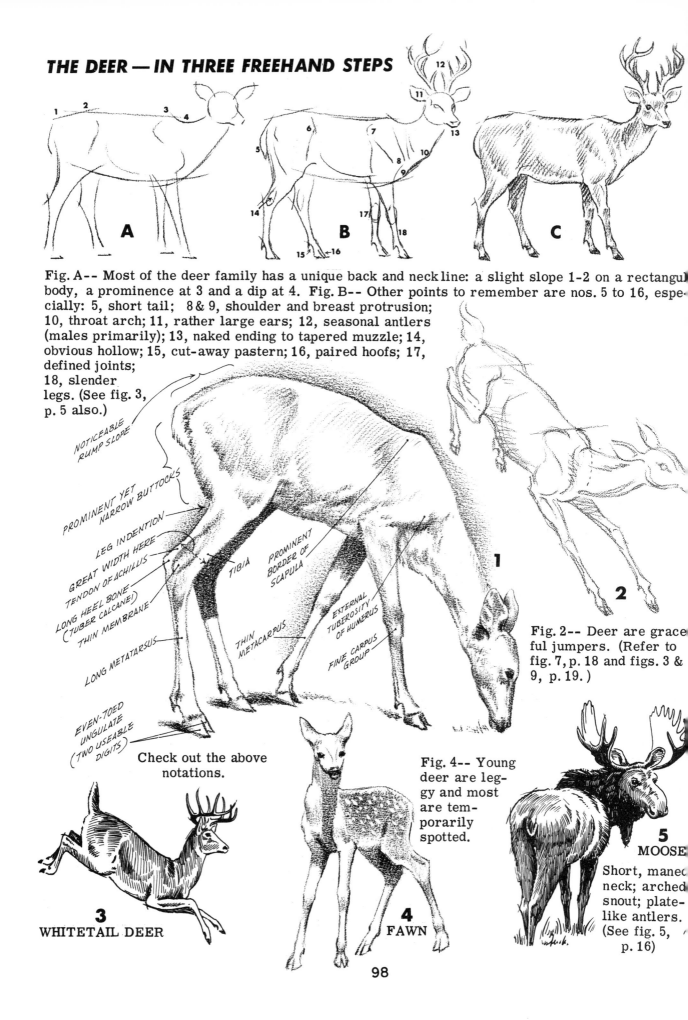

A

B

C

Fig. A-- Most of the deer family has a unique back and neckline: a slight slope 1-2 on a rectangul body, a prominence at 3 and a dip at 4. Fig. B-- Other points to remember are nos. 5 to 16, especially: 5, short tail; 8 & 9, shoulder and breast protrusion; 10, throat arch; 11, rather large ears; 12, seasonal antlers (males primarily); 13, naked ending to tapered muzzle; 14, obvious hollow; 15, cut-away pastern; 16, paired hoofs; 17, defined joints; 18, slender legs. (See fig. 3, p. 5 also.)

NOTICEABLE RUMP SLOPE

PROMINENT YET NARROW BUTTOCKS

LEG INDENTION

GREAT WIDTH HERE

TENDON OF ACHILLIS

LONG HEEL BONE (TUBER CALCANEI)

THIN MEMBRANE

LONG METATARSUS

TIBIA

PROMINENT BORDER OF SCAPULA

THIN METACARPUS

EXTERNAL TUBEROSITY OF HUMERUS

FINE CARPUS GROUP

EVEN-TOED UNGULATE (TWO USEABLE DIGITS)

1

2

Fig. 2-- Deer are grace ful jumpers. (Refer to fig. 7, p. 18 and figs. 3 & 9, p. 19.)

Check out the above notations.

Fig. 4-- Young deer are leg- gy and most are tem- porarily spotted.

3 WHITETAIL DEER

4 FAWN

5 MOOSE

Short, maned neck; arched snout; plate- like antlers. (See fig. 5, p. 16)

98

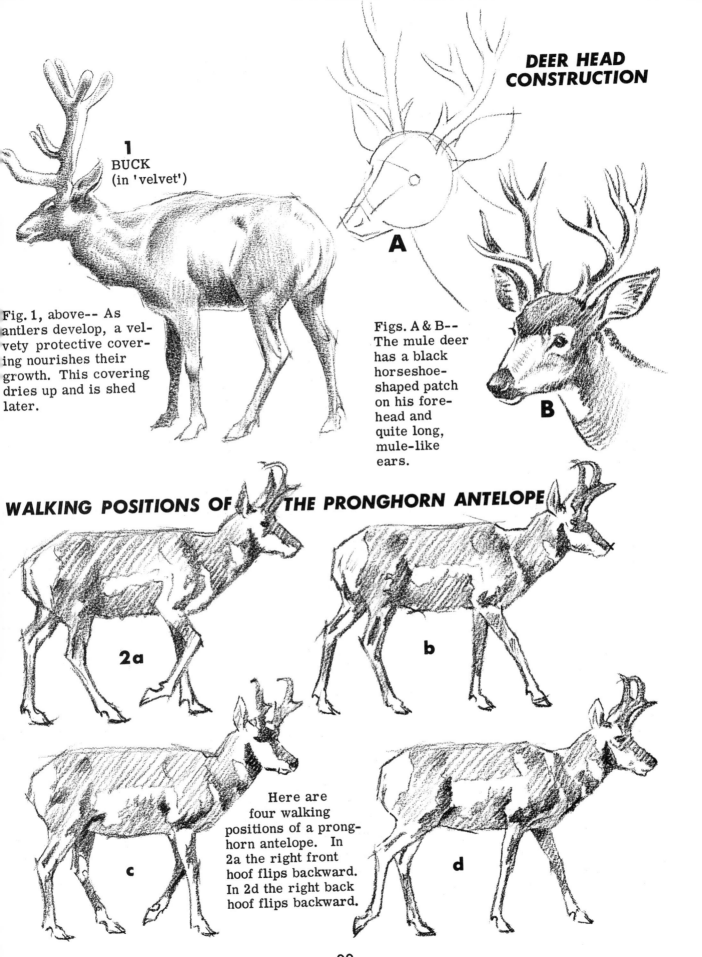

DEER HEAD CONSTRUCTION

1
BUCK
(in 'velvet')

Fig. 1, above-- As antlers develop, a velvety protective covering nourishes their growth. This covering dries up and is shed later.

A

Figs. A & B--
The mule deer has a black horseshoe-shaped patch on his forehead and quite long, mule-like ears.

B

WALKING POSITIONS OF THE PRONGHORN ANTELOPE

2a

b

c

Here are four walking positions of a pronghorn antelope. In 2a the right front hoof flips backward. In 2d the right back hoof flips backward.

d

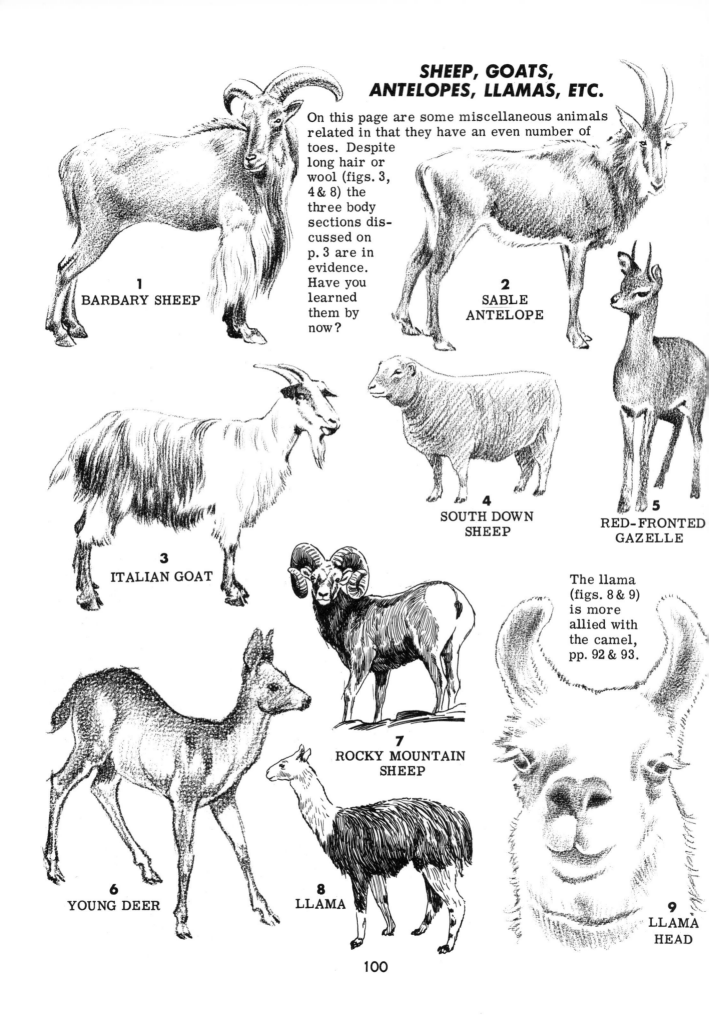

SHEEP, GOATS, ANTELOPES, LLAMAS, ETC.

On this page are some miscellaneous animals related in that they have an even number of toes. Despite long hair or wool (figs. 3, 4 & 8) the three body sections discussed on p. 3 are in evidence. Have you learned them by now?

1 BARBARY SHEEP

2 SABLE ANTELOPE

3 ITALIAN GOAT

4 SOUTH DOWN SHEEP

5 RED-FRONTED GAZELLE

The llama (figs. 8 & 9) is more allied with the camel, pp. 92 & 93.

7 ROCKY MOUNTAIN SHEEP

6 YOUNG DEER

8 LLAMA

9 LLAMA HEAD

BC CONSTRUCTION OF THE BUFFALO

The proportions of the European bison, the largest wild cattle of Europe (on p. 6), are somewhat different from the American bison or buffalo. The European version is longer with a smaller head and hump, and its back does not slope as much. Otherwise the hardy brutes are a great deal alike. A, B & C are suggested steps in drawing construction.

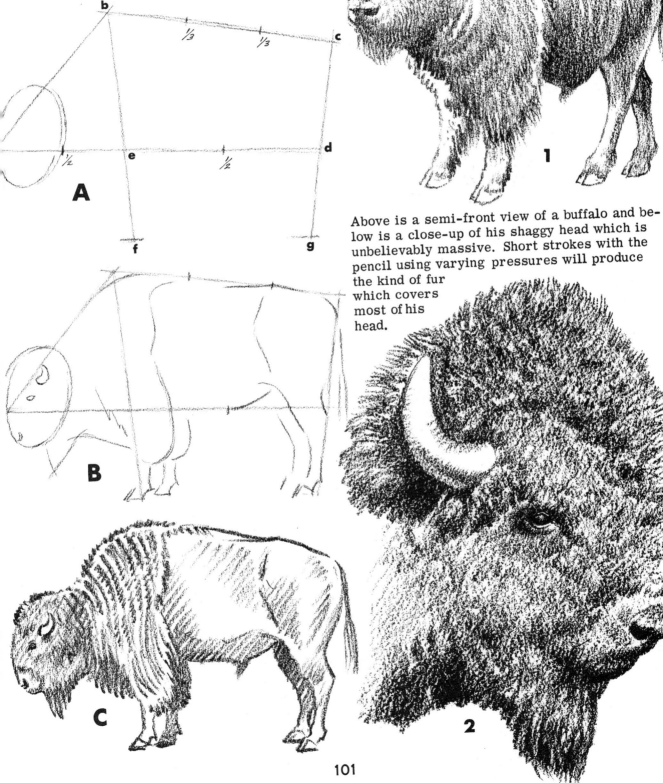

Above is a semi-front view of a buffalo and below is a close-up of his shaggy head which is unbelievably massive. Short strokes with the pencil using varying pressures will produce the kind of fur which covers most of his head.

101

DRAWING THE COW

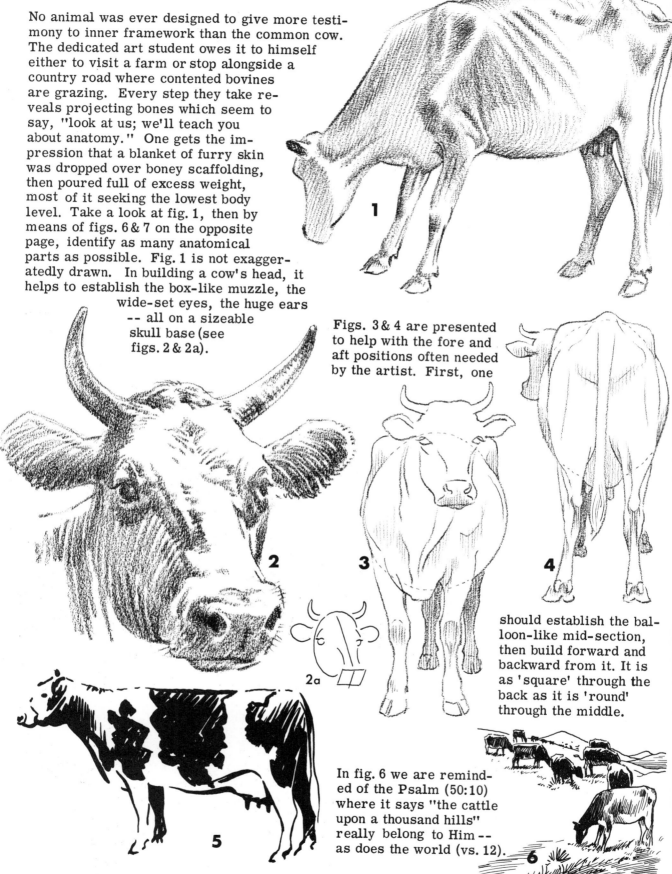

No animal was ever designed to give more testimony to inner framework than the common cow. The dedicated art student owes it to himself either to visit a farm or stop alongside a country road where contented bovines are grazing. Every step they take reveals projecting bones which seem to say, "look at us; we'll teach you about anatomy." One gets the impression that a blanket of furry skin was dropped over boney scaffolding, then poured full of excess weight, most of it seeking the lowest body level. Take a look at fig. 1, then by means of figs. 6 & 7 on the opposite page, identify as many anatomical parts as possible. Fig. 1 is not exaggeratedly drawn. In building a cow's head, it helps to establish the box-like muzzle, the wide-set eyes, the huge ears -- all on a sizeable skull base (see figs. 2 & 2a).

Figs. 3 & 4 are presented to help with the fore and aft positions often needed by the artist. First, one should establish the balloon-like mid-section, then build forward and backward from it. It is as 'square' through the back as it is 'round' through the middle.

In fig. 6 we are reminded of the Psalm (50:10) where it says "the cattle upon a thousand hills" really belong to Him -- as does the world (vs. 12).

102

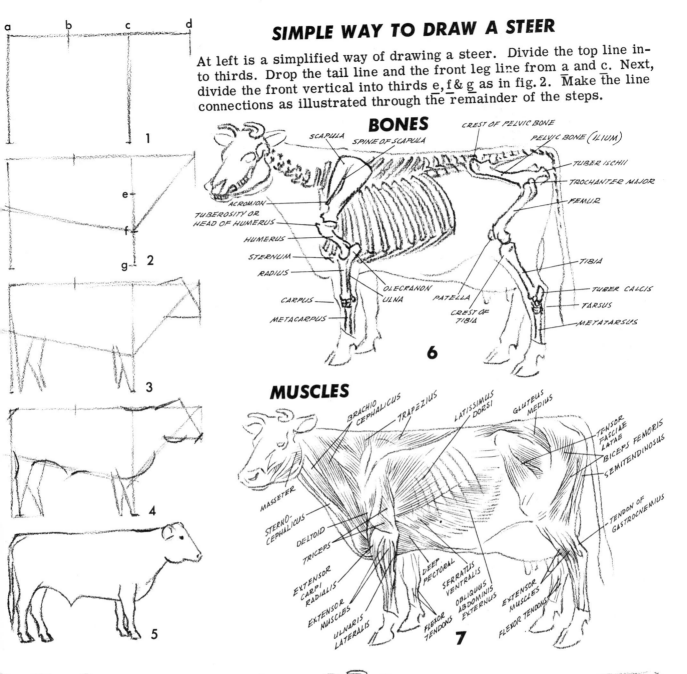

SIMPLE WAY TO DRAW A STEER

At left is a simplified way of drawing a steer. Divide the top line into thirds. Drop the tail line and the front leg line from a and c. Next, divide the front vertical into thirds e, f & g as in fig. 2. Make the line connections as illustrated through the remainder of the steps.

BONES

SCAPULA
SPINE OF SCAPULA
CREST OF PELVIC BONE
PELVIC BONE (ILIUM)
TUBER ISCHII
TROCHANTER MAJOR
FEMUR
ACROMION
TUBEROSITY OR HEAD OF HUMERUS
HUMERUS
STERNUM
RADIUS
TIBIA
OLECRANON
ULNA
PATELLA
CREST OF TIBIA
TUBER CALCIS
TARSUS
CARPUS
METATARSUS
METACARPUS

6

MUSCLES

BRACHIO CEPHALICUS
TRAPEZIUS
LATISSIMUS DORSI
GLUTEUS MEDIUS
TENSOR FASCIAE LATAE
BICEPS FEMORIS
SEMITENDINOSUS
MASSETER
STERNO-CEPHALICUS
DELTOID
TRICEPS
TENDON OF GASTROCNEMIUS
EXTENSOR CARPI RADIALIS
DEEP PECTORAL
SERRATUS VENTRALIS
OBLIQUUS ABDOMINIS EXTERNUS
EXTENSOR MUSCLES
EXTENSOR MUSCLES
ULNARIS LATERALIS
FLEXOR TENDONS
FLEXOR TENDONS

7

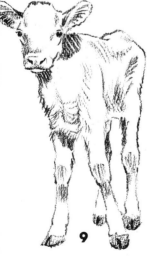

Fig. 6 above is a sketch of the heavy bone-work of the cow. Fig. 7 is the muscle structure. Fig. 8 is the surface anatomy giving evidence of the bones and muscles combined. Even though this slow-gaited animal is quite the opposite from the speedy greyhound on pages 12 and 13, it is a good exercise to compare the inner-workings of the two. What are the differences?

Months of "eating like a cow" will change the frisky calf (fig. 9) into an undisturbed, settled-down creature like patient mama.

9

8

MISCELLANEOUS 'SPLIT-HOOFED' ANIMALS

1 LONGHORN STEER

2 WILD BULL

Using the bone and muscle information on the previous page, check out these big bovine animals 2 to 6; that is, select a part, then find it expressed in the surface anatomy of these animals.

3 BULL ELAND

4 GAUR

Figs. 3 & 5 are sometimes put with the antelopes, depending on the method of classification.

5 BRINDLED GNU (Wildebeest)

6 CAPE BUFFALO

There are cow-like animals in nearly every farm or zoo. The latter often has them from various countries of the world. Get so you can readily identify the main anatomical parts for use in your drawings.

SIMPLE UNDERDRAWING
FOR THE PIG

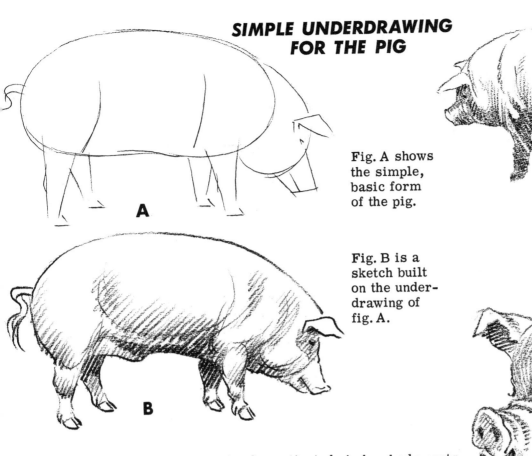

Fig. A shows
the simple,
basic form
of the pig.

1

Fig. B is a
sketch built
on the under-
drawing of
fig. A.

A

B

2

Though at first glance it seems the domesticated pig has body parts
which are all rounded at the seams, beneath this fat are true mam-
malian sections. It is a wise artist who sees faint evidence of the
sectional divisions (emphasized many times in this book), and then
increases the evidence with his pencil, ink, paint or whatever me-
dium is held by his hand. Of course it needs to be done right, and
it can be with proper observation and study.

WILD HOGS

Fig. 4 is a strong contestant for the world's
most hideous animal. Sometimes he is refer-
red to as the "animal joke" or "mistake" --
an over-sized head with bumper-like snout,
huge tusks and unsightly warts. All wild boars
are quite ridiculous (fig. 5), but they don't
seem to mind.

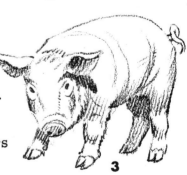

3

YOUNG PIG

4
WART
HOG

5
WILD BOAR

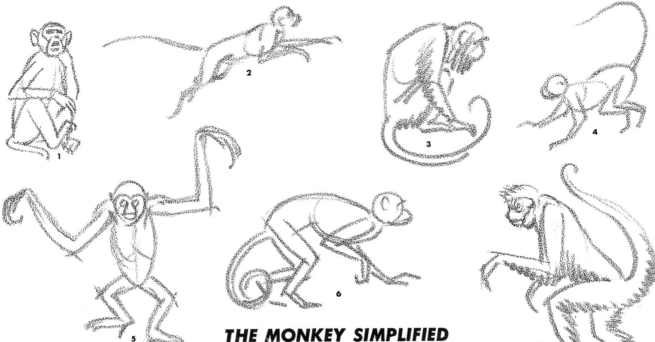

THE MONKEY SIMPLIFIED

Of all the places in the zoo, there is no more irresistibly fascinating chit-chat and "goings-on" than in the monkey cages. Monkeys are willing models and very likely will show as much interest in you as you do in them. In order to catch these sprightly creatures in pencil, it is a good idea to watch them frisk about for awhile. Positively nothing alive is so light-footed and light-handed as this amazing order of mammals. Take for example the spirited Rhesus monkey at the right who thinks it a little unfair that he too can't have a pencil and paper to draw you.

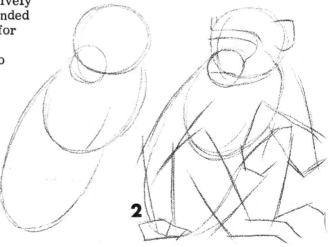

Fig. 1. First, it is well to roughly determine the head (and muzzle), chest and lower torso locations. Notice early that the head is usually positioned a little below the shoulder line. Monkey's heads are not bolt upright like on a human.

Fig. 2. Next, sketchily attach the four limbs. Give some indication as to the facial features, hands and feet. Work out none of these in detail however. It is quite all right to draw over and through any previous underdrawing. Keep your work light and flexible.

Fig. 3. Now it is time to start thinking about the particulars in the head, hands and feet. Very quickly one becomes aware of the monkey's hand-like feet.

Fig. 4. In suggesting values in pencil do not get envolved in fine hair coverings. Later, distinctness of coat may be expressed. Sketchily divide the bare and coated parts of the face and head. Keep closer body parts lighter in value; distant parts darker.

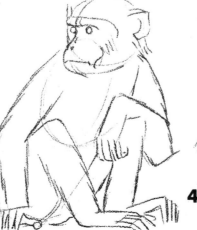
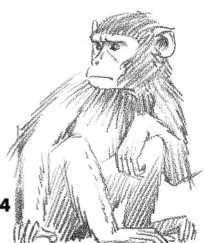

PRIMATE HEADS IN EASY SEQUENCE

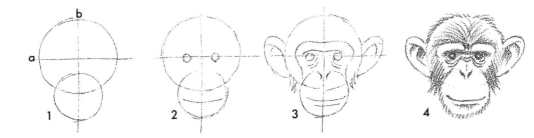

A

THE CHIMPANZEE -- Nearly all apes and monkeys have heads consisting of a rounded skull box and a fairly flat face fronted by a part-ball muzzle. More attention will be given the chimp later, but for now, compare the simple facial beginnings of these four primates A, B, C & D. Divide the main circle into fourths, then add the rounded muzzle shape as shown. The eye orbits are on the horizontal division a, fig. 2. The chimp has a low receding forehead, big brow-ridges, deep-set eyes with multi-wrinkles beneath, flat nose devoid of fleshy wings about nostrils, thin septum between nostrils, long upper lip, wide mouth slit, minimal chin, forehead-cheek-&-chin hair, and big floppy ears.

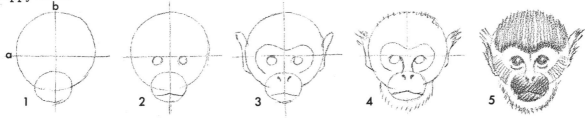

B

THE SQUIRREL MONKEY -- First of all, notice the difference in the muzzles of this head and the chimp (A1). Actually, the overall head of this fellow is much, much smaller. He has a very rounded head that is bun-shaped in the back. The eyes on his short face are below the a division. Notice the outline markings around the eyes in the fig. 3's of A, B, C & D. The Squirrel monkey has vivid contrast in his facial fur and sizeable, tufted ears.

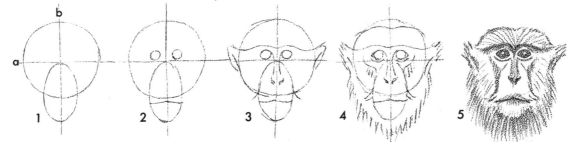

C

THE PATAS MONKEY -- His muzzle is long and thin compared with A1 and B1. Most of his nose appears to be on the muzzle shape. His orbits are above the a line. The top of his head is flattened (the main circle is cut off in figs. 4 & 5). He is a fairly large monkey with dignified mustache and chin whiskers.

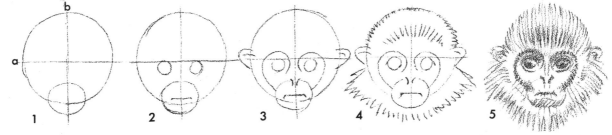

D

THE CAPPED LANGUR -- Compared to the larger circle of fig. 1, his muzzle is proportionately small. Observe that his mouth line is drawn inside the main circle. His large eyes are below the a line. The cheek pouches on this slender monkey are practically non-existent. He has a funny ruff of chin and cheek hair, and over his eyes is a bunch of stiff hairs sticking up; hence the name "Capped Langur."

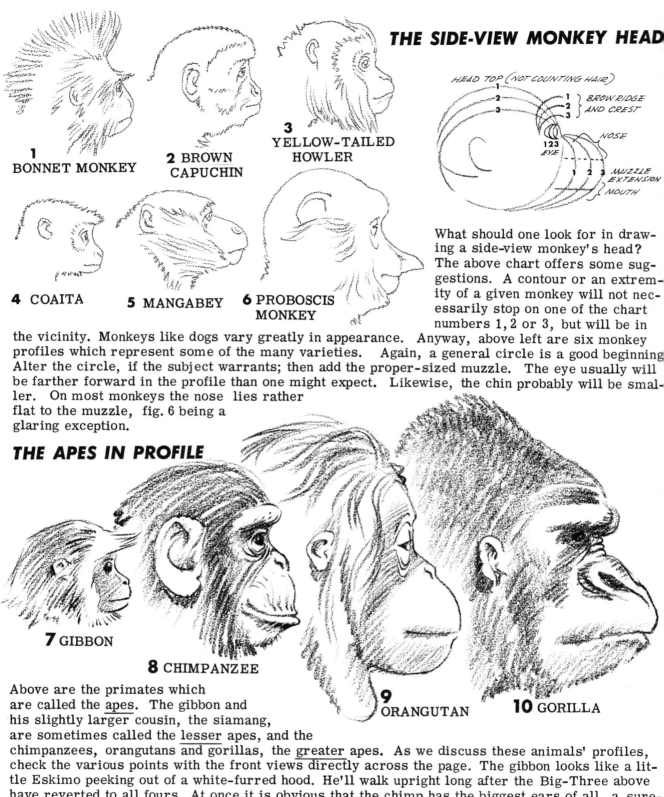

THE SIDE-VIEW MONKEY HEAD

1 BONNET MONKEY

2 BROWN CAPUCHIN

3 YELLOW-TAILED HOWLER

4 COAITA

5 MANGABEY

6 PROBOSCIS MONKEY

HEAD TOP (NOT COUNTING HAIR)

BROW RIDGE AND CREST

NOSE

EYE

MUZZLE EXTENSION

MOUTH

What should one look for in drawing a side-view monkey's head? The above chart offers some suggestions. A contour or an extremity of a given monkey will not necessarily stop on one of the chart numbers 1, 2 or 3, but will be in the vicinity. Monkeys like dogs vary greatly in appearance. Anyway, above left are six monkey profiles which represent some of the many varieties. Again, a general circle is a good beginning. Alter the circle, if the subject warrants; then add the proper-sized muzzle. The eye usually will be farther forward in the profile than one might expect. Likewise, the chin probably will be smaller. On most monkeys the nose lies rather flat to the muzzle, fig. 6 being a glaring exception.

THE APES IN PROFILE

7 GIBBON

8 CHIMPANZEE

9 ORANGUTAN

10 GORILLA

Above are the primates which are called the apes. The gibbon and his slightly larger cousin, the siamang, are sometimes called the lesser apes, and the chimpanzees, orangutans and gorillas, the greater apes. As we discuss these animals' profiles, check the various points with the front views directly across the page. The gibbon looks like a little Eskimo peeking out of a white-furred hood. He'll walk upright long after the Big-Three above have reverted to all fours. At once it is obvious that the chimp has the biggest ears of all, a sure-fire identification mark. Sometimes the gorilla ear looks a bit like a knot stuck on the head. The orang has the smallest ear relative to head size. Another observation is that the gorilla has the largest nose of all the primates. It is very wide-spread with gaping nostrils -- all of which appear to have been smashed by a brick. The orangutan has the dinkiest and flattest nose of all the three. The orang has the highest forehead of all with practically no brow ridge. The chimp and gorilla have immense brow ridges. The gorilla has rather deeply-sunken eye sockets; whereas the orang has eyes which set out flush with the upper face. Orang eyes are one of his unique features. They usually are encircled by light-colored skin, and they have a slightly (cont'd directly across page)

DIFFERENT KINDS OF CHIMPANZEES

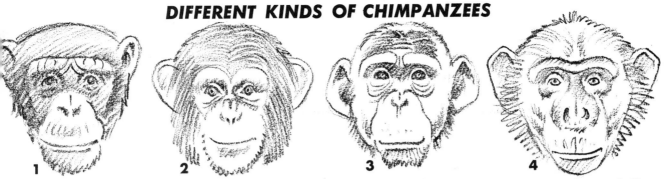

Above are four sketches of different types of chimpanzees. Like people, chimps depart from static sameness, yet they all are unmistakably chimps. Each one has big ears, heavy brow ridges, and the other individual characteristics mentioned in this section.

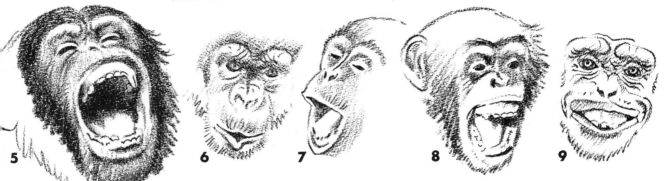

Figs. 5 to 9 illustrate the diversified expressions a chimpanzee may assume. These only begin to tell the story. He is incredibly capable of the craziest, zaniest "monkey-shine" faces imaginable. Below: figs. 10 to 13 are front views of the apes.

APES—FRONT

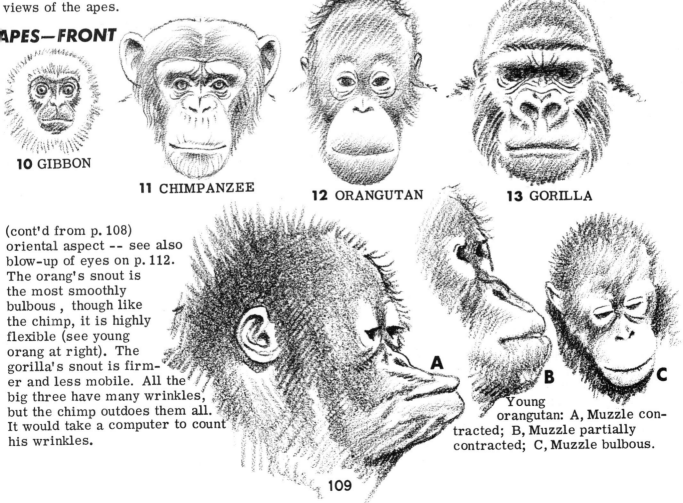

10 GIBBON

11 CHIMPANZEE

12 ORANGUTAN

13 GORILLA

(cont'd from p. 108) oriental aspect -- see also blow-up of eyes on p. 112. The orang's snout is the most smoothly bulbous , though like the chimp, it is highly flexible (see young orang at right). The gorilla's snout is firmer and less mobile. All the big three have many wrinkles, but the chimp outdoes them all. It would take a computer to count his wrinkles.

Young orangutan: A, Muzzle contracted; B, Muzzle partially contracted; C, Muzzle bulbous.

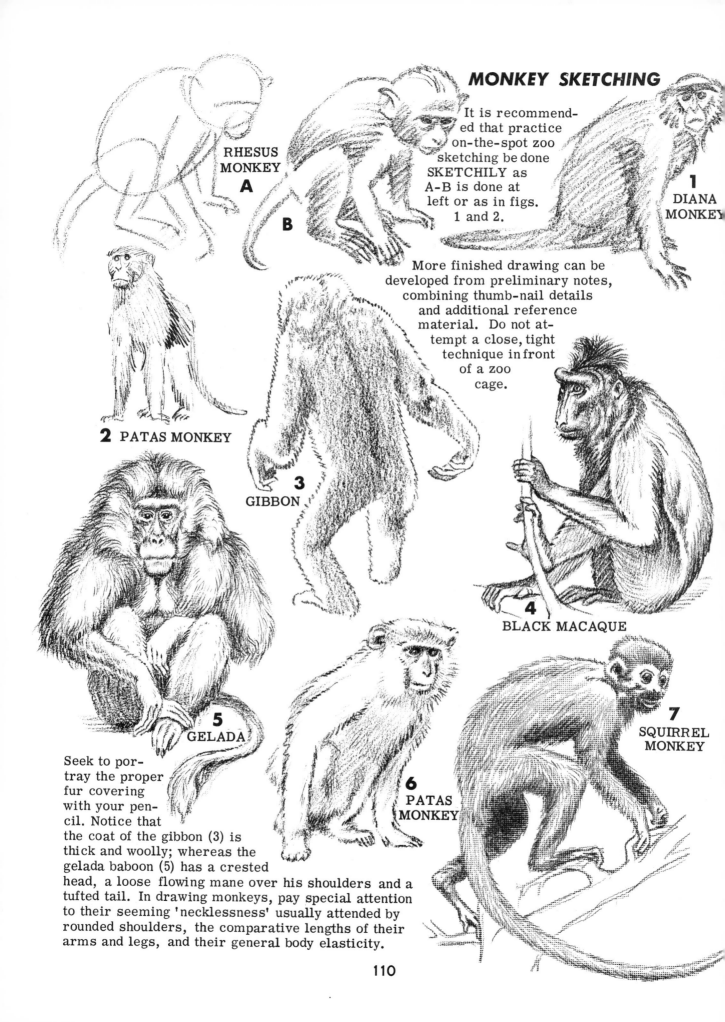

MONKEY SKETCHING

RHESUS MONKEY
A

B

It is recommended that practice on-the-spot zoo sketching be done SKETCHILY as A-B is done at left or as in figs. 1 and 2.

1 DIANA MONKEY

More finished drawing can be developed from preliminary notes, combining thumb-nail details and additional reference material. Do not attempt a close, tight technique in front of a zoo cage.

2 PATAS MONKEY

3 GIBBON

4 BLACK MACAQUE

5 GELADA

6 PATAS MONKEY

7 SQUIRREL MONKEY

Seek to portray the proper fur covering with your pencil. Notice that the coat of the gibbon (3) is thick and woolly; whereas the gelada baboon (5) has a crested head, a loose flowing mane over his shoulders and a tufted tail. In drawing monkeys, pay special attention to their seeming 'necklessness' usually attended by rounded shoulders, the comparative lengths of their arms and legs, and their general body elasticity.

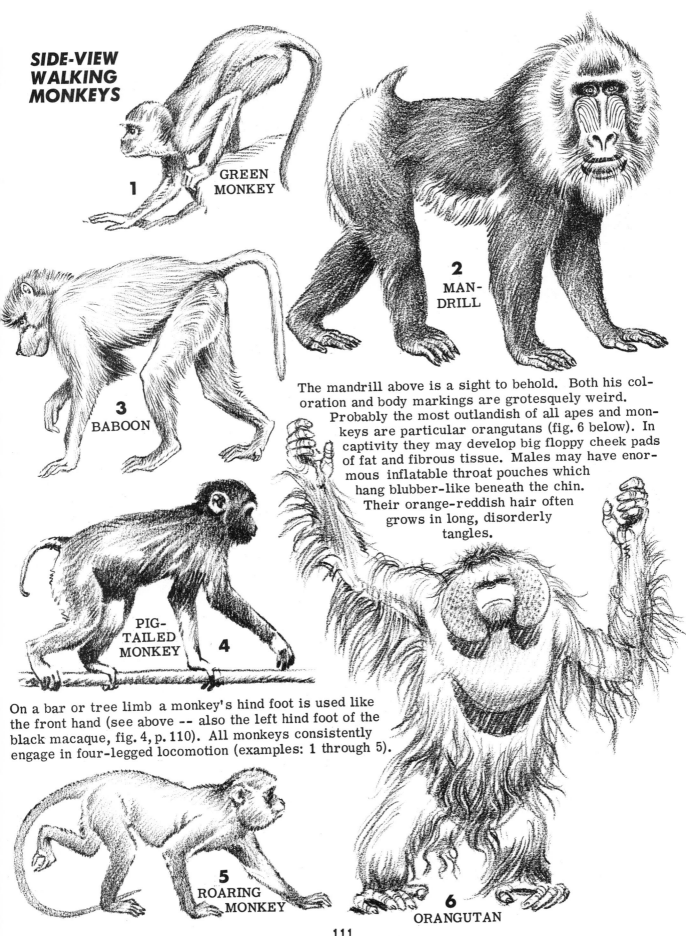

SIDE-VIEW WALKING MONKEYS

1 GREEN MONKEY

2 MAN-DRILL

3 BABOON

4 PIG-TAILED MONKEY

The mandrill above is a sight to behold. Both his coloration and body markings are grotesquely weird.

Probably the most outlandish of all apes and monkeys are particular orangutans (fig. 6 below). In captivity they may develop big floppy cheek pads of fat and fibrous tissue. Males may have enormous inflatable throat pouches which hang blubber-like beneath the chin. Their orange-reddish hair often grows in long, disorderly tangles.

On a bar or tree limb a monkey's hind foot is used like the front hand (see above -- also the left hind foot of the black macaque, fig. 4, p. 110). All monkeys consistently engage in four-legged locomotion (examples: 1 through 5).

5 ROARING MONKEY

6 ORANGUTAN

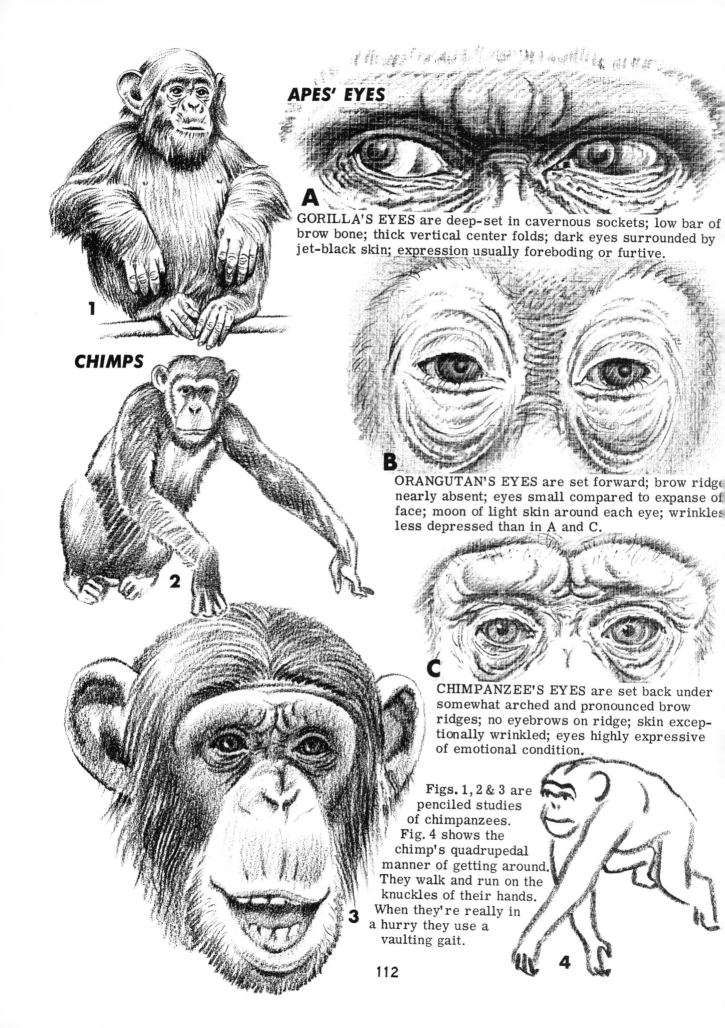

APES' EYES

A

GORILLA'S EYES are deep-set in cavernous sockets; low bar of brow bone; thick vertical center folds; dark eyes surrounded by jet-black skin; expression usually foreboding or furtive.

CHIMPS

B

ORANGUTAN'S EYES are set forward; brow ridge nearly absent; eyes small compared to expanse of face; moon of light skin around each eye; wrinkles less depressed than in A and C.

C

CHIMPANZEE'S EYES are set back under somewhat arched and pronounced brow ridges; no eyebrows on ridge; skin exceptionally wrinkled; eyes highly expressive of emotional condition.

Figs. 1, 2 & 3 are penciled studies of chimpanzees. Fig. 4 shows the chimp's quadrupedal manner of getting around. They walk and run on the knuckles of their hands. When they're really in a hurry they use a vaulting gait.

112

NOTES ON THE GORILLA

Fig. 1 is a charging gorilla. The gnarled knuckles of his broad, short hands bear much of the weight. His terribly powerful arms reach below the knees as shown in fig. 2. He has a massive chest, huge shoulders and a broad back. His very short neck limits his head movements.

The erect gorilla always keeps his knees bent. In confinement gorillas get ridiculously fat with bulging stomachs. The topknot on the head is partly a bony crest but mostly a subcutaneous growth. These great brutes make interesting subjects to draw.

1

2

3

4

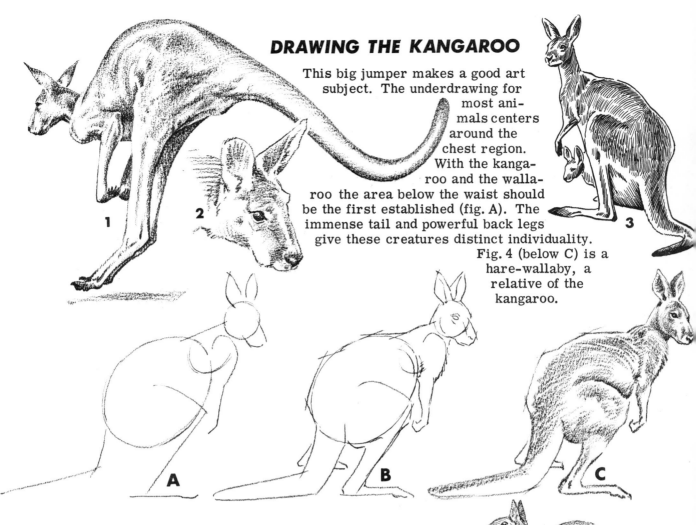

DRAWING THE KANGAROO

This big jumper makes a good art subject. The underdrawing for most animals centers around the chest region. With the kangaroo and the wallaroo the area below the waist should be the first established (fig. A). The immense tail and powerful back legs give these creatures distinct individuality. Fig. 4 (below C) is a hare-wallaby, a relative of the kangaroo.

← 4
Wallaby

DRAWING THE RABBIT

Another accomplished jumper and champion sprinter is the prolific rabbit at right. His tail is about as useless as the kangaroo's is useful. The scampering cottontail, fig. 2, has smaller ears than his big jack-rabbit cousin shown in the A-B-C sequence. His banana-like ears are his trade-mark.

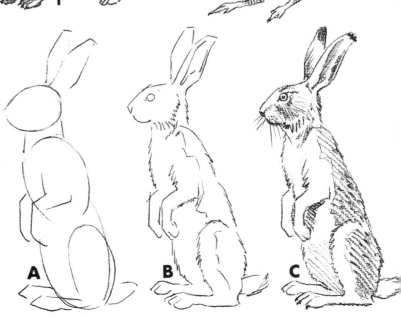

114

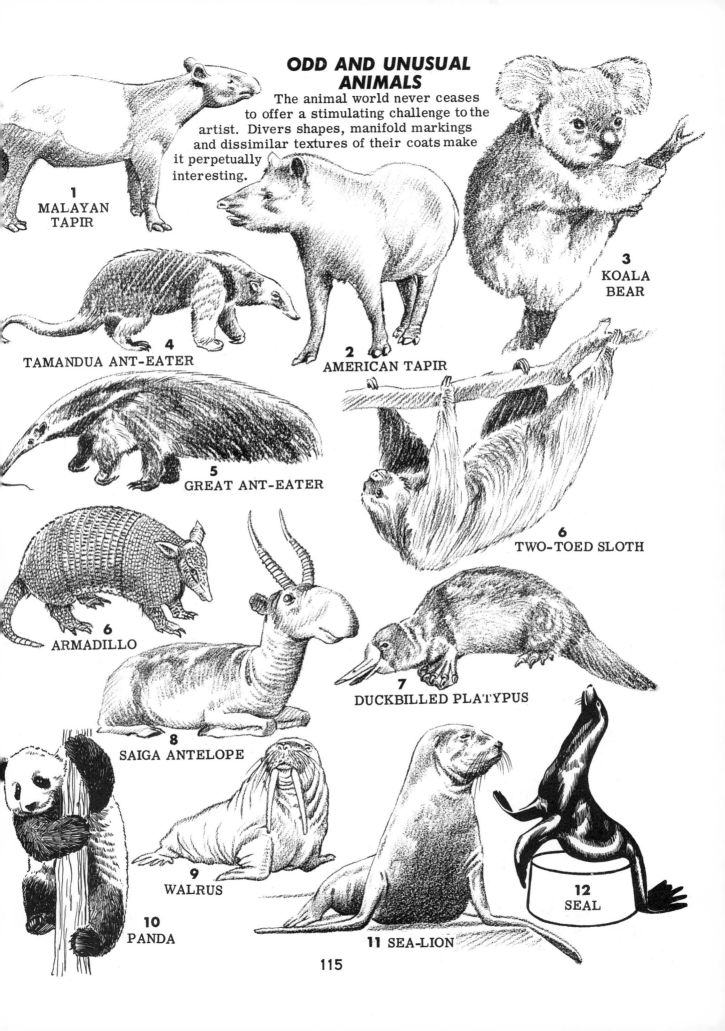

ODD AND UNUSUAL ANIMALS

The animal world never ceases to offer a stimulating challenge to the artist. Divers shapes, manifold markings and dissimilar textures of their coats make it perpetually interesting.

1 MALAYAN TAPIR

3 KOALA BEAR

4 TAMANDUA ANT-EATER

2 AMERICAN TAPIR

5 GREAT ANT-EATER

6 TWO-TOED SLOTH

6 ARMADILLO

7 DUCKBILLED PLATYPUS

8 SAIGA ANTELOPE

9 WALRUS

10 PANDA

11 SEA-LION

12 SEAL

115

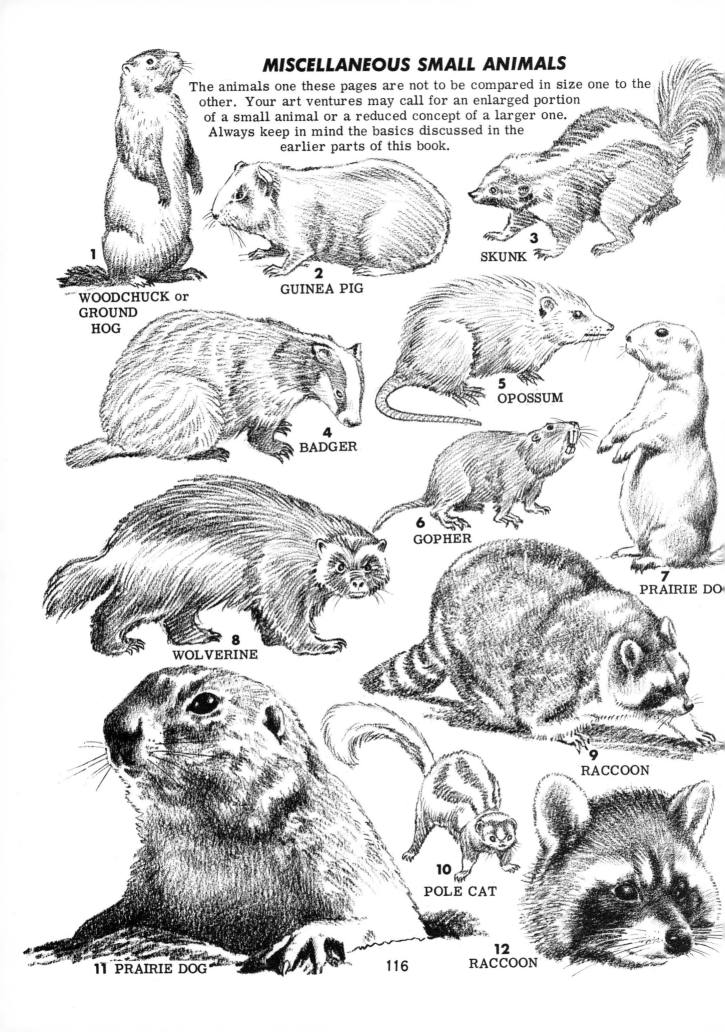

MISCELLANEOUS SMALL ANIMALS

The animals one these pages are not to be compared in size one to the other. Your art ventures may call for an enlarged portion of a small animal or a reduced concept of a larger one. Always keep in mind the basics discussed in the earlier parts of this book.

1 WOODCHUCK or GROUND HOG

2 GUINEA PIG

3 SKUNK

4 BADGER

5 OPOSSUM

6 GOPHER

7 PRAIRIE DO[G]

8 WOLVERINE

9 RACCOON

10 POLE CAT

11 PRAIRIE DOG

12 RACCOON

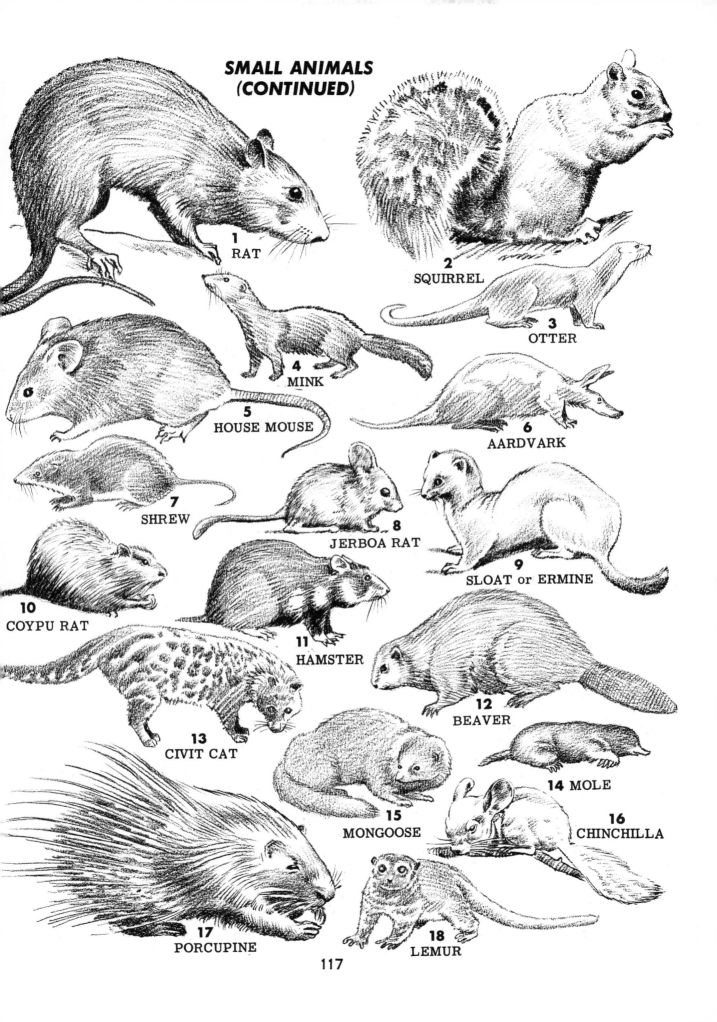

SMALL ANIMALS (CONTINUED)

1 RAT

2 SQUIRREL

3 OTTER

4 MINK

5 HOUSE MOUSE

6 AARDVARK

7 SHREW

8 JERBOA RAT

9 SLOAT or ERMINE

10 COYPU RAT

11 HAMSTER

12 BEAVER

13 CIVIT CAT

14 MOLE

15 MONGOOSE

16 CHINCHILLA

17 PORCUPINE

18 LEMUR

ANIMAL INTERPRETATION AND ABSTRACTION

After the student has thoroughly acquainted himself with the fundamentals of animal drawing, he may wish to add his own imaginativeness to his knowledge. Just how far out he goes in leaving the beaten path is up to him. There is more enjoyment in creating something completely different when one has a store of animal information within his own mind. At least some of the animal essentials should be retained for identity. Realism, however, is not necessary in an interpretation, especially an abstraction. It is suggested that a wide variety of paper surfaces and mediums enter into the experimentation. The cat's head, fig. 3, is a "portion" drawing and quite realistic. The german shepherd in fig. 4 has been done with a different kind of pencil treatment on linen paper. The deer in figs. 1 and 5 have started to leave realism's boundaries. The same is true with the big draught horse, fig. 2, the dachshund, fig. 6, and the big cat, fig. 7. Try some innovations of your own -- it is exciting and richly rewarding!

1

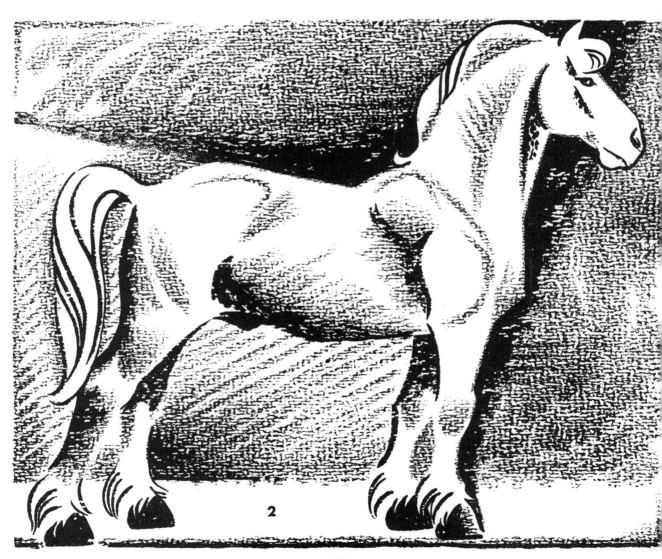

2

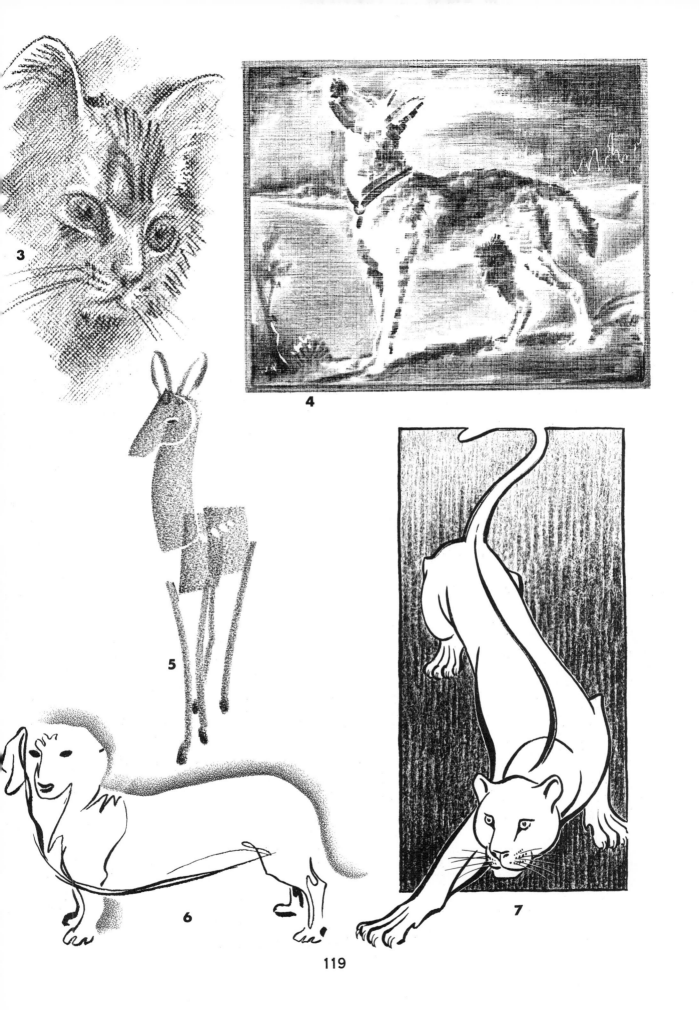

3

4

5

6

7

INDEX

The animals listed on this page are among those included in this book. For divisional treatment and drawing methods consult the Contents pages.

A

Aardvark, 117
Aard-wolf, 90
African elephant, 74-81, 85
American tapir, 115
Ant-eater, 115
Antelope, 16, 100, 115
Apes
 Chimpanzee, 107-109, 112
 Gibbon, 108-110
 Gorilla, 108, 109, 112, 113
 Orangutan, 16, 108, 109, 111, 112
Arabian camel, 2, 8, 9, 16, 17, 93
Arctic fox, 91
Armadillo, 115

B

Baboon, 10, 111
Bactrian camel, 8, 16, 17, 92
Badger, 116
Barbary sheep, 100
Bear
 Black bear, 7, 9, 14, 15, 17-19, 47-54
 Brown bear, 2, 7, 9, 14-17, 48-53
 Grizzly bear, 2, 7, 14, 15, 17, 48-53
 Himalayan bear, 52, 53
 Kodiak bear, 2, 7, 9, 14-17, 48-53
 Malayan bear, 49, 52, 53
 Polar bear, 7, 9, 10, 14-17, 48, 49, 51-53
 Sloth bear, 52, 53
Beaver, 17, 117
Bison, 6, 9, 101
Black bear, 7, 9, 14, 15, 17-19, 47-54
Blue persion cat, 25
Bobcat, 42, 45
Bonnet monkey, 108
Boxer (dog), 89
Black macaque monkey, 110
Black rhinoceros, 97
Brindled gnu, 104
Brown bear, 7, 9, 14-17, 48-54
Brown capuchin monkey, 108
Buffalo (bison), 6, 9, 101
Bull, 102-104
Bull eland, 104
Bulldog, 14, 89

C

Calf, 103
Camel
 Arabian (or dromedary) camel, 2, 8, 9, 16, 17, 93
 Bactrian camel, 8, 16, 17, 92
Cape buffalo, 104
Cape hunting dog, 91
Capped langur, 107
Cat (house), 16, 17, 21, 22, 24, 25
Cat
 General, 2, 3, 8-10, 20-22, 24, 25, 31, 40
 Bobcat, 42, 45
 Cheetah, 14, 19, 42, 44
 Clouded leopard, 42, 44
 Eyra (otter cat or jaguarundi), 42, 45
 Golden cat, 42, 45
 Jaguar, 3, 40, 42, 44
 Leopard, 21, 26, 32, 38-40, 42-44
 Leopard cat, 42, 45
 Lion, 2, 8-11, 14, 16, 17, 20-23, 28-33, 35, 40, 43
 Lynx, 42, 45
 Margay, 42, 45
 Ocelot, 42, 44
 Pampas cat, 42, 45
 Puma (cougar, panther, mountain lion) 14, 18, 19, 22, 26
 Serval, 42, 45
 Snow leopard, 40, 42, 45
 Tiger, 20, 32, 34-40, 43
Cheetah, 14, 19, 42, 44
Chimpanzee, 107-109, 112
Chinchilla, 117
Civit cat, 117
Clouded leopard, 42, 44
Cocker spaniel, 89
Couger, 14, 18, 19, 22, 26

Coaita monkey, 108
Cottontail, 114
Cow, 3, 5, 8, 16, 17, 102, 103
Coyote, 86, 88, 90

D

Deer, 5, 8, 9, 15-17, 98-100
Diana monkey, 110
Dingo, 91
Dog
 General, 5, 8, 9, 11, 14-17, 88-90
 Boxer, 89
 Bulldog, 14, 89
 Cocker spaniel, 89
 Eskimo dog, 88
 Foxhound, 90
 German shepherd, 88
 Great dane, 89
 Greyhound, 1, 10, 12, 13, 19
 Irish setter, 5
 Siberian husky, 88
Dromedary camel, 93
Duckbilled platypus, 115

E

Elephant
 General, 2, 7, 9, 10, 15, 74-85
 African elephant, 74-81, 85
 Indian (or Asiatic) elephant, 8, 74-84
Ermine, 117
European bison, 6
European brown bear, 53
Eyra, 42, 45

F

Fawn, 98, 100
Fox, 19, 86, 88
Foxhound, 90

G

Gaur, 104
Gazelle, 9, 19, 100
Gelada baboon, 110
German shepherd, 17, 88
Gibbon, 17, 108-110
Giraffe, 3, 7, 9, 10, 15, 17, 94, 95
Gnu, 104
Goat, 100
Golden cat, 42, 45
Gopher, 10, 116
Gorilla, 108, 109, 112, 113
Great ant-eater, 115
Great dane, 14, 89
Green monkey, 111
Grizzly bear, 2, 7, 14, 15, 17, 48-53
Gray fox, 88
Greyhound, 1, 10, 12, 13, 19
Ground hog, 116
Guinea pig, 116

H

Hamster, 117
Hippopotamus, 15-17, 96, 97
Horse, 2, 5, 9-11, 15-17, 19, 55-72
Horse breakdown (for divisional treatment of other animals refer to contents pages):
 Simple sections, 2, 5, 58, 62
 Proportions, 5, 58, 72
 Name parts, 61
 Bones, 60, 63, 70
 Muscles, 11, 60, 63, 70
 Legs & feet, 8, 9, 10, 15, 62, 70, 71
 Head, 15, 55, 56, 57, 72
 Eye, 17, 55
 Nose, 16, 56, 57, 72
 Mouth, 56, 57, 72
 Ear, 17, 57
 Hair, 59, 61
 Action
 Walk, 64
 Trot, 64
 Canter, 64
 Run (or gallop), 19, 63, 65-68
 Jump, 69
 Rearing, 71
House cat, 16, 17, 21, 22, 24, 25

I

Impalla, 19
Indian rhinoceros, 8, 96
Irish setter, 5
Italian goat, 100

J

Jackal, 3, 91
Jack rabbit, 114
Jaguar, 3, 42, 44

K

Kangaroo, 2, 10, 114
Koala bear, 115
Kodiak bear, 2, 7, 9, 14-17, 48-53
Kudu, 18

L

Lemur, 117
Leopard, 21, 26, 32, 38-40, 42-44
Leopard cat, 42, 45
Lion, 2, 8-11, 14, 16, 17, 20-23, 28-33, 35, 40, 43
Llama, 100
Longhorn steer, 104
Lynx, 42, 45

M

Malayan bear, 49, 52, 53
Malayan tapir, 115
Mandrill, 111
Maned wolf, 90
Mangabey monkey, 108
Margay, 42, 45
Mink, 117
Mole, 117
Mongoose, 117
Monkey
 General, 2, 3, 9, 106-108, 110, 111
 Baboon, 111
 Black macaque, 110
 Bonnet monkey, 108
 Brown capuchin, 108
 Capped langur, 107
 Coaita monkey, 108
 Gelada baboon, 110
 Green monkey, 111
 Mandrill, 111
 Mangabey, 108
 Patas monkey, 107, 110
 Pig-tailed monkey, 111
 Proboscis monkey, 108
 Rhesus monkey, 106, 110
 Roaring monkey, 111
 Squirrel monkey, 107, 110
 Yellow-tailed howler, 108
Moose, 16, 98
Mountain lion (or puma), 14, 18, 19, 22, 26
Mouse, 17, 117
Mule deer, 99

O

Ocelot, 42, 44
Okapi, 95
Opossum, 116
Orangutan, 16, 108, 109, 111, 112
Otter, 117

P

Pampas cat, 42, 45
Panda, 115
Panther (or puma), 14, 18, 19, 22, 26
Patas monkey, 107, 110
Pig, 5, 9, 16, 17, 105
Pig-tailed monkey, 111
Polar bear, 7, 9, 10, 14-17, 48, 49, 51-53
Pole cat, 116
Porcupine, 117
Proboscis monkey, 108
Pronghorn antelope, 99
Puma, 14, 18, 19, 22, 26

R

Rabbit, 17-19, 114
Raccon, 16, 116
Rat, 117
Red fox, 86, 88
Red-fronted gazelle, 100
Rhesus monkey, 106, 110
Rhinoceros
 General, 3, 8, 17, 96, 97
 Black rhinoceros, 97
 Indian rhinoceros, 3, 96
 White rhinoceros, 97
Roaring monkey, 111

S

Sable antelope, 100
Saiga antelope, 115
Sea lion, 16, 115
Seal, 115
Serval, 42, 45
Sheep, 100
Shrew, 117
Siamese cat, 21, 24
Siberian husky, 88
Silver-backed fox, 91
Silver-gray fox, 91
Silver tabby cat, 25
Skunk, 9, 116
Sloat, 117
Sloth, 115
Sloth bear, 52, 53
Snow leopard, 42, 45
South down sheep, 100
Spotted hyena, 91
Squirrel, 3, 5, 9, 15, 117
Squirrel monkey, 107, 110
Striped hyena, 91

T

Tamandua ant-eater, 115
Tapir, 115
Tasmanian wolf, 91
Thylacine, 91
Tiger, 20, 32, 34-40, 43
Two-toed sloth, 115

V

Virginian fox, 91

W

Wallaroo, 16, 114
Walrus, 115
Wart hog, 105
Weasel, 18
White rhinoceros, 97
Whitetail deer, 98
Wild boar, 3, 105
Wild bull, 104
Wolf, 7, 14, 18, 86-88, 90
Wolverine, 116
Woodchuck, 116

Y

Yellow-tailed howler, 108

Z

Zebra, 73